CÉZANNE'S COMPOSITION

CÉZANNE'S COMPOSITION

Analysis of His Form
with Diagrams
and Photographs of His Motifs

By ERLE LORAN

With a New Foreword by Richard Shiff

UNIVERSITY OF CALIFORNIA PRESS

BERKELEY, LOS ANGELES, LONDON

University of California Press
Berkeley and Los Angeles, California

University of California Press, Ltd.
London, England

© 1963, 2006 by The Regents of the University of California

Library of Congress Cataloging-in-Publication Data

Loran, Erle, 1905–
 Cézanne's composition : analysis of his form with diagrams and photographs of
his motifs / by Erle Loran ; with a new foreword by Richard Shiff.—[New ed.]
 p. cm.
 First published in 1943; 1st pbk. ed. in 1985.
 Includes bibliographical references and index.
 ISBN 978-0-520-24845-8 (pbk. : alk. paper)
 1. Cézanne, Paul, 1839–1906—Criticism and interpretation. I. Cézanne, Paul,
1839–1906. II. Title

ND553.C33L6 2006
759.4—dc22 2005056895

Manufactured in the United States of America

17 16 15 14 13 12 11
 11 10 9 8 7 6 5 4 3

TO

CLYTA

CONTENTS

PAINTINGS ANALYZED

PAINTINGS ANALYZED

CÉZANNE'S COMPOSITION: ITS CRITICISM, ITS ART

Upon graduating from the Minneapolis School of Art in 1926, Erle Loran (then Erle Loran Johnson) received the John Armstrong Chaloner Prize in a national competition. The award enabled him to travel to Paris and on to Aix-en-Provence and other Provençal locations associated with the life and art of Paul Cézanne. For more than two of his three years in France (1926–1929), Loran occupied the studio Cézanne had constructed in 1902, up a steep hill just outside Aix. Among those already living in "Cézanne's country" was Marsden Hartley, whom Loran met around the time of his arrival. Whereas many American artists and scholars joining the early wave of Cézanne enthusiasts studied his cultural legacy from a distance, Loran, like Hartley, got close and intimate. He painted where Cézanne painted and conversed with those who had observed the master's eccentricities daily: "M. Girard, who lives next door to [the studio], remembers and thinks of Cézanne, simply as a maniac. . . . Whenever I would talk about Cézanne to the Girards, the entire family would begin snickering." Beyond mere gossip, they were recalling the strange behavior to which Cézanne had subjected them. Continuing his pursuit of the firsthand, Loran tracked down Émile Bernard in Paris. In 1904, Bernard had painted beside Cézanne in the new studio. Shortly afterward, he recorded a detailed account of his experience, which he later expanded into a book.[1] By the time Loran went to France, scholars knew of Bernard as the author of a text central to the growing critical literature. But Loran's encounter was personal. For him, Bernard became a living witness, with a lively sense of irony:

> "It's perfectly true that Cézanne gave his pictures away generously, isn't it?" I asked.
> "I don't know, he never gave me any."

The Girard family's anecdotes, the conversations with Bernard, and many other documentary curiosities animate Loran's essay "Cézanne's Country," published in 1930 shortly after his return from France.[2] It constituted a fitting cultural payback for the generous grant he had received. Even now, with so much more having been said about Cézanne, Loran's essay retains the charm of its unique set of observations. Its directness, but also deep suggestiveness, accords with the ambition and the sophistication of the career that would follow. Committed to teaching, Loran wanted above all to communicate with clarity and precision. He sought to explain art to those who aspired to practice it. But he was far more the artist than the theorist or aesthetician. Given his experience with practice, he worried that his verbal precision might misrepresent the inherent mysteriousness of creativity. His dual profession—teacher and artist: art teacher—caught him in a double-bind. He was seeking a degree of clarity that threatened to obscure the fact that certain aspects of art are genuinely obscure. Explaining what he could, he took care not to imply that this was everything.[3]

"Cézanne's Country" became the leading edge of *Cézanne's Composition*, first published in 1943. The most striking characteristic of Loran's book is its analytical intensity. The second most striking characteristic is the frequency with which he warns his reader not to assume that an artist like Cézanne, working from intuition, would have looked, thought, and painted along such analytical lines (the double-bind again). Loran presented photographs of the painter's sites, graphic diagrams of his works, and a set of unusually precise definitions for the critical terminology he was employing—directing it all toward the mystery of Cézanne's art. Yet he did not presume to address why Cézanne appeared when he did, "reestablishing that formal structure which is so pronounced in the greatest art of the past." Although art historians greeted *Cézanne's Composition* warmly, Loran had made few gestures toward matters of historical causation. He attributed neither motivation nor reason to Cézanne, stopping at the point where he believed he had provided a coherent description of the extraordinary products of the painter's intuition: "[His] space illusions developed spontaneously . . . and there is no ground for believing that Cézanne would have been able to explain them . . . [He] worked by feeling and intuition; the accidental distortions arose [from the process]" (p. 77).

In Loran's estimation, Cézanne's artistic intelligence resembled "a force or law of nature"; it was "revealed through action and growth . . . something that could not be exercised at will" (p. xxv). On the significance of the master's puzzling verbalizations—possibly confused, possibly ironic—Loran was in agreement with the critic Clement Greenberg, who also rated intuition far above conceptualization and strategy when it came to attributing deep causes to forms of art. Despite their commitment to writing, both mistrusted the artist's own literary legacy. *Cézanne's Composition* impressed the likeminded Greenberg, who "for almost two years . . . delayed reviewing it," waiting until

he had assured himself that he understood it correctly. He perceived in Loran an admirable struggle to articulate principles that were "a matter of intuition and experience rather than of conscious thought."[4]

Accordingly, Loran dismissed most of Cézanne's theoretical remarks, on which many other commentators were basing their own theories of classicism, modernism, and aesthetic form: "I must confess that I have never been able to correlate Cézanne's statements of aesthetic theory into any pattern that would fit the interpretation I now give to his work . . . [his] message can be found only in his paintings, not in his words." In response to the famous statement about organizing "nature in terms of the cylinder, the sphere, the cone," Loran concluded only that Cézanne had never articulated "an intellectual theory coinciding with his creative production" (pp. 8, 10). His analyses would therefore bypass much of the documentary record, proceeding directly to the material facts. He sought "the problems of composition" as demonstrated by the paintings, principles that he believed could become "the elementary foundation for every kind of art training" (p. 133). With aesthetic appreciation as much as studio practice in mind, he extended the reach of his study: "Many of these same principles [of composition] can be applied to the analysis of masterpieces in painting, throughout history" (p. 39). Cézanne's art, the paintings themselves, would expose the core of every art of comparable stature—"permanent and recurring principles of artistic creation" (p. 4).[5]

THE PHOTOGRAPHS

Loran studied art homeopathically: to the problem of pictorial creation, he applied more depiction, though of a different sort. Photographs and (more centrally) diagrams became his means of analyzing paintings.[6] He was first in photographing Cézanne's sites systematically and first in diagramming his compositional structures in detail. When he took photographs in Provence during the late 1920s, he expected his results to demonstrate that Cézanne remained close to a model in nature, that he was less of an intellectualizing abstractionist than other commentators had been arguing. Text appended to one of the site photographs in "Cézanne's Country" states that the image would "show how Cézanne derives his modulating and plane building from the subject [in nature] and not according to a priori theories."[7] In 1943, however, *Cézanne's Composition* put the matter otherwise: "The most significant facts are those revealing difference between Cézanne's space and the space in nature" (p. 5). Loran remained convinced that Cézanne had no conscious theory, but he no longer believed that the structure of nature had guided the painter's compositional structure, whether consciously or not. Instead, composition derived from within the practice of picture-making, from within painting as a medium: "The photographs of motifs have supplied factual evidence to support the contention that Cézanne did not always permit his volumes to expand according to nature, but almost invariably controlled and flattened foreground volumes in order to maintain balance on the picture plane" (p. 131).

To explain Cézanne's process, Loran used active verb forms. Readers of such direct, affirmative prose are likely to attribute more conscious intention to the painter than the writer was imputing. True, the text states that Cézanne "controlled and flattened" forms "to maintain balance"; but this is merely Loran's way of describing the *effect*, not its cause. The effect, the material condition that Cézanne created, brings with it the "effect"—that is, the appearance—of its own pictorial cause. The result of this cause-effect logic, Loran implies, is what we now discern in Cézanne: "balance on the picture plane." This is why the majority of his pictures work so well as fully resolved aesthetic statements, even given aspects of the depiction that remain incomplete by conventional standards, and even if the artist would have described his intentions otherwise.

Loran understood how complicated the application of language to visual experience becomes, for the manner of describing a set of effects implies the nature of their causation. The analytical method itself must incorporate a subtle play of conscious intention and unconscious result. Today's reader should regard the differences revealed to Loran by his photographs (as well as by those John Rewald began taking in 1933, which also appear in *Cézanne's Composition*) as differences that the photographer's interpretive efforts brought into focus.[8] Like the painting process and its verbal description, the photographic process (in both recording a view and interpreting it) is far more actively subjective than passively objective. Its desired effects imply a corresponding set of meaningful causes. Whatever Loran may have concluded about the causal factor in Cézanne's art—and whatever we may now conclude—his visual documents retain unique value because the more remote painting sites had hardly changed when Loran visited them. Perhaps the photographs, as images of nature constructed to parallel the paintings, provide as good a starting point for analysis as anything else, for all beginnings must be arbitrary. At the very least, they show that rock formations strange enough to have been inventions of a strange mind are hardly inventions. They were attractions or appeals to Cézanne's imagination—aspects offered by the chosen site and accepted by the artist (p. 70).

Among points still debated is Loran's conclusion that, given the photographic evidence, Cézanne often enlarged and flattened distant objects (p. 131). Naturally enough, Loran sought to take his photographs from as close to the painter's plein-air position as he could, determining it by studying the view Cézanne represented and assessing the terrain. He worked from a position that would allow him to contain within the framing edge of his view-finder all of the elements included in the corresponding painting. A certain warning, a commonplace of visual and optical

theory, would apply here: vision framed by photography does not accord with vision framed by painting, even if both mediums are left to operate as "naively" as possible in the hands of the same person. We cannot assume that a photograph framed to correspond with an existing painting establishes a consistent standard of "truth" for every aspect of that same depiction.

By coincidence, Beaumont Newhall, curator at the Museum of Modern Art, New York, stated this argument in 1942, shortly before Loran completed his text. Loran referred to it, only to reject it. Newhall: "Photographs specially taken for [comparative] purpose are necessarily under the immediate influence of the respective paintings. . . . Their validity . . . is questionable."[9] Loran: "[Newhall's] objection . . . does not seem to bear any particular relation to my original motives for taking the pictures." Loran dismissed Newhall's admonition without offering much in return, stating merely that he took his photographs for "recording the subjects at the very places from which Cézanne painted them" (p. 5). Yet his many detailed analyses imply a more extensive response. He himself noted the discrepancy between how a landscape feature appears in a photograph and how it may appear to the eye *as a result of its emotional bearing*. If an imposing appearance is an illusion in relation to the standard set by the camera, it nevertheless amounts to valid experience. With respect to what one photograph shows, Loran observes: "Cézanne has more than doubled the size of [Mont] Sainte Victoire. The illusion of magnificent height which Cézanne has achieved through these measurable plastic means is akin to the exaggerated sense of its height that one has on actually seeing it—as I had when I first discovered the motif. But the photograph of the motif utterly fails to suggest the grandeur, the massiveness, of this luminous white mountain."[10]

Loran's reasoning retains the complexity of his visual observations (another double-bind, it seems). To the enlarged scale that Cézanne apparently applied to his mountain, he imputes a disregard for "the rules of scientific perspective"—simply put, this is how a painter makes a significant feature of the landscape "look big." As big as what? Here, without calling attention to it as such, Loran realizes that the pictorial problem acquires a psychological dimension: "How can the forms in the far distance [in any view] be made to maintain the importance they have in the mind and feeling of the spectator? By avoiding aerial perspective and fuzziness of contour (Impressionism), and by drawing the forms in the distance with the force and clarity used in foreground forms. . . . [Furthermore,] by *tilting up* the back planes vertically, instead of allowing them to fall back on a diagonal plane" (p. 61).

In effect, Cézanne's representation of the mountain becomes the record of a mental vision, a subjective response to the artist's on-site experience. By Loran's reasoning, the terms of this rendering are nevertheless objective and can be conveyed through principles of the sort to be derived from Cézanne's exemplary practice (which for the painter remain unconscious as he works [p. xxiii]). A photographic record, established after the fact, as if it were the projection of an independent mind, might or might not agree with the pictorial evidence of an artist's mental impression. But the photograph aids the analytical process significantly by establishing a base of comparison—albeit, like any base of comparison or any beginning, an arbitrary one.

The most recent study of Cézanne's paintings in relation to photographs of the motifs, Pavel Machotka's *Cézanne: Landscape into Art* (1996), has the disadvantage of decades more of changes having occurred at the original sites; but it has the distinct advantage of the availability of more refined cameras and film. In some instances, Machotka improved on Loran's results by adjusting the standpoint to get a picture closer to Cézanne's own. Yet the usual objection still applies: the existing work of art is determining the appropriateness, even the "truth" of the photograph, which in turn is being used to demonstrate the relative "truth" of the painting. Machotka's attention to this intractable problem leads him to be restrained in criticizing his predecessor: "The photographs taken together tell us that Cézanne transforms his pictorial space only when he believes the needs of the composition dictate it . . . Loran may be right in saying that the mountain was enlarged, but it is difficult to know by how much."[11]

There can be no absolute right and no absolute wrong in applying photographic evidence to the evidence of painting, so long as one qualifies one's claims (as Loran did, progressively, from edition to edition). His primary concern was to expose the structure or internal order of Cézanne's pictures, and he could pursue this question apart from the degree or character of their resemblance to their presumed models in nature. Imagine Cézanne facing a broad, extended vista: he paints the distant mountain so that it seems to rise and loom over the vegetation of his immediate foreground; he seems to condense the spatial difference and flatten the pictorial effect he was observing. Imagine, furthermore, that from the same location a camera lens records the mountain as smaller relative to the vegetation, restoring a familiar effect of perspective recession, with the additional effect of suggesting that there might be something artificial or art-like about Cézanne's pictorial flattening (as Loran inferred from his photograph). Given the comparison, should we conclude that Cézanne transformed the relations that nature and human vision offered him? It would not be unreasonable. But we might just as well conclude that human vision and camera vision are fundamentally different. In the latter case, the camera itself becomes responsible for the apparent discrepancy or transformation.

Reading Loran's text today, we must realize that neither conclusion bears on Cézanne's composition as composition, especially by the terms of Loran's mid-twentieth-century analysis, which isolated pictorial vision from other

forms of visual experience. As Loran understood them, composition and fidelity to appearance are separate matters. Painters who wished to respect *both* a normative view of nature (the camera view) *and* the conceptualized flatness of the material picture surface (the "picture plane") could chose views that naturally look flat or those that logically lend themselves to a flat presentation (perhaps an urban scene with interlocking planes of building façades, or a seascape with a very high horizon). In Loran's opinion, this was the obvious route to modernism in art, implied by the theoretical articulation of the problem—an approach taken by many of the cubists and abstractionists who followed Cézanne. A good part of the older master's greatness lay in his having proceeded without relying on the more modern solutions. In a way that acknowledged the materiality of his medium, he continued to grapple with the fundamental problem of representing the illusion of spatial depth (nature's experiential truth). Yet each of his compositions preserved the picture plane as the ultimate point of pictorial reference (painting's experiential truth).[12] Cézanne succeeded through his process, rather than by applying a theory. As Loran conceived this enterprise, it was pragmatic, not idealistic.

The way Loran handled the question of fidelity to nature—which evolved over the years, as he became ever more engaged with abstraction—was only one of the points with which his reviewers contended. Some also objected to the emphasis he put on line with respect to a painter better known for modulating color: "Line must be understood as the basic instrument for Cézanne's construction of form and space," Loran writes (p. 132), and he presented an unusually liberal sense of what might count as "line," such as the optical edges created by juxtaposed strokes of color. What appeared as color to others, looked like line to him. Yet he never ignored the way that Cézanne's use of color might structure an image, discussing this with great sensitivity (pp. 30, 65). Realizing that his definition of line struck many readers as extreme, Loran moderated his language for the 1946 edition of *Cézanne's Composition:* "It is quite possible there is overemphasis [on linear] clarity and power" (p. xxiii). What the first edition refers to as "large silhouettes" and "outlines" in a still life, becomes in the second and third editions "outlines and [color] contrasts at the contours." In the same context, Loran noted a significant linear feature that other critics were ignoring—faint "pencil and colored outlines" that underlie Cézanne's compositions. The first edition asserts that "every picture" reveals this feature, whereas the second edition refers to "most pictures" (p. 40). The important thing, however, is that pencil markings are indeed there to be seen: proof of a certain involvement with line on the part of Cézanne and evidence of the thoroughness of Loran's visual investigation.

THE DIAGRAMS (HOFMANN)

For the 1950 printing of *Cézanne's Composition* Loran added a specific acknowledgment to Hans Hofmann and his book *Search for the Real,* which appeared in 1948, bringing to the American public principles that Hofmann had been espousing for decades.[13] Although already a fully mature artist and teacher, Loran devoted six weeks to attending Hofmann's Eighth Street school in 1955, an indication of the respect he granted to this inspired pedagogue, "the greatest . . . in 100 years."[14] Greenberg shared that opinion, which he had occasion to express privately in a letter to Loran in 1944 and publicly in an article of 1945, both written during the period when he was mulling over *Cézanne's Composition* before venturing its review: "This writer [Greenberg] . . . owes more to the initial illumination received from Hofmann's lectures than to any other source. . . . His painting [asserts] that painting exists first of all in its medium and must there resolve itself before going on to do anything else."[15] Loran and Greenberg held Cézanne and Hofmann in common esteem.

The synchrony of this parallelism is not exact. Hofmann had an impact in Berkeley before he did in New York, and Loran completed *Cézanne's Composition* before having a clear sense of Hofmann's teachings.[16] In any event, a certain Hofmann-effect permeated the Berkeley painting program before Loran joined it in 1936 and even before Hofmann himself arrived in 1930, on his first visit to the United States. By that year, the Berkeley faculty included Worth Ryder (hired in 1927), as well as John Haley and Margaret Peterson O'Hagan (both hired in turn by Ryder); all three had been Hofmann students in Munich during the 1920s. At Ryder's invitation, Hofmann came from Germany to Berkeley to teach the summer terms in 1930 and 1931. As a student in Minneapolis, Loran's primary mentor was Cameron Booth, who as a teacher happened to share Hofmann's concern for compositional structure; Booth had his own period of study with Hofmann, but only after Loran left for France. This pattern of coincidence and near-coincidence meant that when Loran joined the Berkeley faculty, he was among sympathetic colleagues who shared his developing interest in composition and had a penchant for the use of explanatory diagrams. Their diagramming had been encouraged by Hofmann's custom of marking out vectors of compositional force on the "picture plane." He would draw arrows directly on a student's work to indicate the implied motion he perceived— a device that Loran too employed in his teaching, and that became central to the expository dynamics of *Cézanne's Composition.*[17]

To be sure, there were other precedents for diagramming pictorial problems. The most celebrated was Thomas Hart Benton's series of articles on the "Mechanics of Form Organization in Painting," beginning November 1926.[18] In Loran's view, however, Benton had been concerned to show that the proper model for painting was form

as it appeared in three-dimensional sculpture; he failed "to bring to the fore the problem of organizing the total space with regard for the [two-dimensional] picture plane" (pp. 3–4). Loran had himself published a diagram in an essay of 1931, illustrating the formal organization of a painting attributed to the School of Ucello. He argued that the flat, planar features of the landscape bore more compositional significance than the many volumetric forms of the human beings included in the scene. The modern artist could learn from this work not only by organic imitation ("Simply copying out the forms and the skeleton of the design for the joy of doing it") but also by pursuing diagrammatic analysis ("The way the great form [of a rock] takes its place in space should be easy to follow with the diagram").[19]

Whether by direct exposure, indirect transmission, or parallel channels of reasoning, Loran shared much of his vocabulary with the terms Hofmann developed through teaching. He defined the "picture plane" as "the area upon which the artist draws or paints . . . a flat surface having only two dimensions." "Negative space" was "the three-dimensional depth, the volume of air or empty space, within which the solid or positive volumes of a picture are organized" (p. 17).[20] His fundamental sense that a painting must establish "the surface itself as a structure" (p. xxi) corresponds to one of Hofmann's dictums (eventually published in *Search for the Real*): "The act of creation agitates the picture plane, but if the two-dimensionality is lost the picture reveals holes and the result is not pictorial, but a naturalistic imitation of nature."[21] Hofmann's "negative space," whether representational or abstract, would have to acquire something of a positive force, fully integrated into the structured picture plane. Otherwise, it would reduce to a (naturalistic) "hole," an airy emptiness—space without a sense of physical atmosphere or light to enliven it.

As if to demonstrate this very point, for the third edition, Loran provided a supplemental example from among Cézanne's late unfinished landscapes—a particularly colorful work, but at so early a stage of its genesis that most of the surface remained blank and "negative." He commented: "[Cézanne's] remarkable achievement was to make the unpainted areas or negative space seem active and interchanging with the positive planes of green and blue. The effect of density, of activating the total volume of space, occurs even at this early stage of developing a painting" (p. 128).[22] The unfinished landscape validated Loran's conception of negative space as "a concrete and essential part of the structure" (p. 23). His analysis implies that Cézanne's patches or planes of color activated positive and negative areas simultaneously, so that the painting was at every moment spatially integrated, even "complete" in its pictorial effect—regardless of its apparent incompletion. Loran's own manner of composition appears to have followed the precepts he developed. From early works that resemble Cézanne's way of constructing a surface of parallel, planar strokes (*Still-life*, c. 1926–27), he moved on to compositions in which a series of planes appear to fall back from the immediate foreground without receding into significant depth or giving the impression of any spatial "holes" between them (*Hillside Houses*, 1936; *Henry Kaiser's Miracle Shipyard*, 1942).[23]

Independently, but no doubt encouraged by the example of Hofmann, Loran developed an early appreciation of his contemporaries in the New York School (he was one year younger than de Kooning, two years younger than Mark Rothko). In 1950, he stated that his own watercolor technique "owes a debt to Impressionism and even to contemporaries like Jackson Pollock."[24] By 1963, he was exhibiting large, colorful abstractions, relatively expressionistic in character, composed of layers of flat washes.[25] In his capacity as an exhibition reviewer, he often described technical aspects of his fellow California painters in terms of what had been happening in New York.[26] Commenting on the abstractionism of Elmer Bischoff and David Park in 1949—their "handling, smearing, splotching, piling up of the pigment surface"—Loran was reminded of "the ferocious attack evident in the pigment application" of Pollock. He perceived that "this emphasis of the surface itself . . . is a new, almost unconscious biological reaffirmation of the primacy of the two dimensional picture plane in painting. Before any separate shapes emerge one assumes that the whole pictorial surface has been brought to life spontaneously, as an entity, with richly loaded colors and textures."[27] Here Loran clearly privileged an undifferentiated totality, as opposed to an assemblage of compositional parts. He appreciated the paintings of his San Francisco contemporaries for the intuitive dynamism they seemed to incorporate, an effect best understood—or rather, felt—"as an entity."

This was Loran's honest response, even though the very same paintings might, like Cézanne's, have been masking the kind of "internal structure" and "abstract order" that his analytical mode of investigation was designed to expose.[28] To look at a painting and then talk or read about it, or to talk or read about a painting and then look at it—such experience, the substance of art criticism, is jarring and disjunctive. In a certain sense, the method of *Cézanne's Composition* worked against its author's artistic instinct, which valued the whole far more than the parts. Ultimately, the most sophisticated critic of Loran's method was Richard Wollheim, who argued that a diagram could depict either the "two-dimensional picture-plane" or the representational "three-dimensional scene," but could not "function simultaneously as both"; to experience this integrative condition, "we have to go back to the painting itself."[29] Loran, as much as Wollheim, knew this. But wherever there are creative and experiential mysteries, it is just as much a feature of human instinct to desire to explain them. Artist and critic can be one and the same—a divided soul.

ABSOLUTE GOOD: CÉZANNE, LORAN, LICHTENSTEIN

> We can learn many valuable principles of composition from great artists, but there is no system; there are no mechanical rules. My Cézanne diagrams are merely an attempt to penetrate the mystery of these underlying principles. They are not rules.
>
> —ERLE LORAN, 1963[30]

> There is nothing wrong with making outlines of paintings. I wasn't trying to berate Erle Loran because when you talk about paintings you have to do something. . . . Cartoons are really meant for communication. You can use the same forms, almost, for a work of art.
>
> —ROY LICHTENSTEIN, 1967[31]

When Loran reviewed Bischoff and Park in 1949, relating the feel of their technique to Pollock, he appended a bit of social critique already familiar to supporters of modern art: "The appearance of most of these pictures strikes deep at the primitive in all of us . . . the sheer joy of manipulating matter. . . . Modern man is so unhappy with most of his world, what could be more magnificent than to discover a world of expression that would compare in directness, simplicity and power with the totemic symbolism and artistic wonder of primitive art?"[32] Loran perceived in the New York and San Francisco manifestations of abstract expressionism an especially pronounced immersion in materiality. Like Hofmann or Greenberg, he associated materiality with the most worthy examples of modern painting, those that preserved the status of the picture plane. And like Pollock and de Kooning, or like Barnett Newman, he recognized that a materialistic pictorialism countered the conformism and dulled sensibility of postwar American culture.[33] He stated in 1963: "Serious, ennobling art means too much to man in this automated world. He needs the look and the feel of something sensitively made, by hand."[34]

Loran shared this opinion of the perils of industrialization and standardization with many other American artists of his generation, which set them all on a collision course with the pop art movement that was to come. It was not so much the look of this art that irritated, for most of his contemporaries were amused, even if withholding approval; what galled was the social stance taken by the proponents of pop, both artists and critics. In December 1962, Leo Steinberg captured the essence of the conflict at a symposium convened to discuss the emergence of a troubling practice: a number of young, but well-credentialed painters and sculptors had adopted the imagery and graphic methods of popular, commercial culture. Steinberg gave a generational accounting of the situation. First, the avant-garde of the early twentieth century had sought "to outrage or needle the bourgeois"; the final manifestation of this approach was surrealism. Then, the abstract expressionists followed by patently ignoring bourgeois tastes and desires; they shifted practice from transgressive confrontation to detached alienation. But now a new generation was taking a third way, seemingly aiming "to out-bourgeois the bourgeois." This represented a dramatic turnabout, performed in the name of art as opposed to politics or protest, and neither an attack nor an escape. If anything, it seemed to reflect a disturbing level of satisfaction with industrialized society as it was. Steinberg continued: "Lichtenstein and certain others treat mass-produced popular culture [comics, advertisements, art books: all mass-produced through industrialized printing] as Duccio would treat the Madonna, Turner the Sea, Picasso the Art of Painting—that is to say, like an absolute good. . . . Pop art [has] pushed [its] subject matter to such prominence that [it becomes] absolutely at one with the form."[35] Andy Warhol would soon remark: "The things I want to show are mechanical. Machines have less problems. I'd like to be a machine, wouldn't you?"[36]

Lichtenstein readily acknowledged that he derived his subjects from industrialized objects and borrowed his graphic style from the industrial process. He nevertheless had his limits: "I like the style of industrialization but not necessarily the fact. I am not against industrialization, but it must leave me something to do."[37] His position let stand a traditional sense of creative invention. He would make a personalized art from the products and style of modern industry, just as (we might say) Cézanne made a personalized art from the nature in Aix that surrounded him, his everyday domestic environment, and the picture plane before his eyes. With this attitude, in 1962 Lichtenstein converted two of Loran's diagrams into paintings of his own, titling them *Portrait of Mme. Cézanne* and *Man with Folded Arms* (cf. pp. 85 and 91). Some critics regarded the result as a creative "transformation" (a term favored at that moment), while others, like Loran himself, called it "copying," a case of plagiarism.[38] To attend to the vastly increased scale of Lichtenstein's image, as well as to variation in the quality of its line: this was to see difference, transformation. To focus on the literal content of the image and its internal proportions: this was to see sameness, copying.

There may have been something more offensive to Loran than "copying"—the implication of a category shift that he would never have abided. Lichtenstein titled his "copy" *Portrait of Mme. Cézanne*, yet Loran's diagrammatic images of human figures are in no way "portraits," regardless of the status of the corresponding paintings by Cézanne. Nor would Loran consider them to be interpretive portrayals of the actual paintings, which would make them portraits at one remove. Instead, whether the image evoked a portrait, a still life, or a landscape, he called each

of his drawings "Diagram." At times he drew two or more diagrams to explain a single painting, since he intended each to demonstrate a particular structural feature. Collectively or separately, they convey the look of a painting about as much as a plastic globe conveys the appearance of the planet Earth. Loran's drawings were "ugly as sin," a sympathetic reviewer wrote, assuming that this had been the creator's intention—to discourage direct comparison "of the works with the diagrams."[39] Loran referred to his illustrations as "modest," and later added: "I didn't think they were bad [drawings], but I didn't make them because they were artistic; I made them just to make things clear and understandable."[40] By elevating the title from "Diagram" (in a book) to *Portrait of Mme. Cézanne* (in a gallery), Lichtenstein lent aesthetic status to a mere expository aid, raising a cultural challenge that extended well beyond the issue of "transforming" or "copying" a model.

Why would Lichtenstein have chosen Loran's work as a suitable model to begin with? Following Steinberg's logic, a diagram might belong to the class of images for which the "subject matter [is] absolutely at one with the form." Because a diagram is designed to function as the most patent, unambiguous representation, its form *is* its subject. To take a diagram as a subject suited to art is to challenge the tradition of art-as-engagement with an act of nonengagement, for a diagram requires no translation, no interpretation, no transformation. From Loran's position, not only had the diagram he invented been reused without permission, but the act could not be excused on the grounds that it supplied a needed commentary.[41] He had designed his diagrams as self-evident explanations of themselves. They were their meaning.

The potential offense goes still deeper. Steinberg suggested that, in welcoming "mass-produced popular culture" as proper subject matter, Lichtenstein accepted it as an "absolute good." Living within the society of consumerism, the pop artist was at home and perfectly comfortable, set "to out-bourgeois the bourgeois." Lichtenstein's subject matter may have done for him what the contents of a Provençal kitchen or the contour lines of Mont Sainte-Victoire did for Cézanne: these inanimate familiarities—the most ordinary aspects of experience—made a sensitive artist's daily existence bearable, despite the tensions and anxieties of modern social life. We might say that for Cézanne, a parasol pine, a jar of olives, or a plate of apples was an "absolute good."

Lichtenstein substituted Donald Duck and romance comics for Cézanne's pines, olives, and apples. He also realized that he could substitute Picasso: "Picasso has become a kind of popular object—one has the feeling that there should be a reproduction of Picasso in every home."[42] By this reasoning, Lichtenstein could substitute Loran's diagrams for Cézanne's actual paintings, not because resemblance justified the switch (he could see there was little), but because, like Picasso, *Cézanne's Composition* had itself become "a kind of popular object." In fact, it belonged "in every home" of the social class positioned to appreciate what Lichtenstein was doing—those who cared about art enough to stay informed about Cézanne, Picasso, and even pop. These were the very people who had admired *Cézanne's Composition* and brought its diagrams into their living rooms. Lichtenstein's practice implied that Loran had fallen victim to the accessibility of his diagramming and expository prose, just as Pollock posthumously fell victim to the material appeal of his expressionistic intensity, not to mention the tragedy of his life. The cultural products of Loran and Pollock had this in common: it was their fate to develop into popular icons.

Was Loran then guilty of the aesthetic crime he had always feared—domesticating Cézanne for the public by explaining his art too thoroughly? His thinking (as well as Lichtenstein's) was far more sophisticated than indicated by most later accounts, which fixate on the inherent reductiveness of diagramming, its inadequacy in relation to an actual painting.[43] This is a point on which Loran would readily concur—therefore, something of a nonissue. At the time of the pop art controversy, he perceived the multiple ironies of his situation vis-à-vis both Lichtenstein and Cézanne. Given that the pop artists had quickly succeeded in the marketplace by making their product easy to understand, Loran wondered whether these admittedly talented individuals could now return to risking serious art, having gained a cushion of financial security.[44] Pop was not all bad. It might lead naturally to something good. Proclaiming his (limited) appreciation of it, Loran associated pop with Marcel Duchamp and other artists who "sensitize our capacity for perception." Eliminating strategic differences, he discerned a trace of pop even farther back: "Didn't Cézanne [make] monumental masterpieces out of the most ordinary objects and subjects?"[45]

Regardless of the generation gap they epitomized in relation to social issues, Loran and Lichtenstein held very similar beliefs about what an artist should do. In his own estimation, Lichtenstein "copied" only to create a tension: "The closer my work is to the original, the more threatening and critical the content. However, my work is entirely transformed in that my purpose and perception are entirely different [from what generated the source]."[46] He soon realized that "transformation"—the term with which supporters defended him, and which in turn offended Loran—was "a strange word to use. It implies that art transforms. It doesn't, it just plain forms. Artists have never worked with the model—just with the painting. . . . [Cézanne works] with paint, not nature; he's making a painting, he's forming."[47]

Here Lichtenstein not only justified his use of sources as instances of pictorial originality, he also reached the position already belonging to Loran, who—within the same year, 1963—compared Cézanne's creative intelligence to "a force or law of nature . . . revealed through action and growth" (p. xxi). Just as "action and growth" are inher-

ently transformative, so they might be manifested in "making a painting, [in] forming." Lichtenstein's language meshes with Loran's.

Loran said in 1931 that artists benefit from "simply copying out the forms and the skeleton of the design for the joy of doing it."⁴⁸ He and Lichtenstein were alike in understanding that painters rarely copy to make duplicates. Instead, they copy to acquire the qualities of the model—or, even more, to assimilate something of the pictorial process, its engrossing physicality. The two artists shared in what was most natural to them, the practice of painting itself, which Loran called, in 1949, "the sheer joy of manipulating matter."⁴⁹ This was their absolute good.

Richard Shiff
Austin, Texas
September 2005

NOTES

1. Loran cites the first edition of Bernard's book, *Souvenirs sur Paul Cézanne* (Paris: Société des trente, 1912); see *Cézanne's Composition*, 2. (Subsequent page references to Loran's text appear in the body of this introduction.) The first edition of *Cézanne's Composition* was published in 1943. A second edition appeared in 1946, with some slight, but significant revisions, and a third edition, containing more extensive revisions and supplemental material, in 1963. A succession of printings within editions introduced emendations, such as an acknowledgment to Hans Hofmann in the 1950 printing of the 1946 edition. I am grateful to Ruth Schorer-Loran and Karl Kasten for generously providing information on Erle Loran's life and career. For essential aid in documentation, I thank Joy Weiner, reference specialist, Archives of American Art, Smithsonian Institution, New York office, and Charlotte Cousins and Adrian Kohn of the Center for the Study of Modernism, University of Texas, Austin.

2. Erle Loran Johnson, "Cézanne's Country," *The Arts* 16 (April 1930): 544–45, 550. On Monsieur Girard, see also *Cézanne's Composition*, 136. By the time of Loran's stay in France, Bernard had become disenchanted with Cézanne and his art; hence, the demeaning tone of his remarks (cf. Émile Bernard, "L'Erreur de Cézanne," *Mercure de France* 187 [1 May 1926]: 513–28). On Bernard and others who provided direct witness accounts of Cézanne, see *Conversations with Cézanne*, trans. Julie Lawrence Cochrane, ed. Michael Doran (Berkeley: University of California Press, 2001).

3. Convinced that he had developed an effective way of conveying the principles of painting, Loran also risked didacticism. Richard Diebenkorn, a Berkeley student during the early 1940s, stated that Loran's "book and [classroom] teaching were one and the same . . . he had really ironclad theory, primarily—almost exclusively—based on Cézanne" (Richard Diebenkorn, oral history interview by Susan Larsen, 1 May 1985, tape recording and transcript [tapes 1, 2], Archives of American Art, Smithsonian Institution).

4. Clement Greenberg, "Review of *Cézanne's Composition* by Earle [*sic*] Loran" (1945), in *Clement Greenberg: The Collected Essays and Criticism*, ed. John O'Brian (Chicago: University of Chicago Press, 1986–93), 2:47. Around the time of Greenberg's review, he not only referred to Cézanne's artistic "insight" as "unconscious" but also attributed his degree of creative originality to a "psychotic" mentality (Greenberg, "Review of Exhibitions of Paul Gauguin and Arshile Gorky" [1946] and "Henri Rousseau and Modern Art" [1946], in ibid., *Collected Essays and Criticism*, ed. O'Brian, 2: 78, 94).

5. Similarly, Loran wrote elsewhere: "The one certainty is that no painting, ancient or modern, has achieved significance that does not contain in its internal structure the elements of abstract order" (Erle Loran, "The Watercolor Series," *American Artist* 14 [March 1950]: 52). Loran's insistence on the existence of creative (and, in turn, evaluative) principles that could be applied across the spectrum of the Western tradition of art met resistance from otherwise appreciative reviewers; see, e.g., Robert Goldwater, review of *Cézanne's Composition*, by Erle Loran, *Art Bulletin* 27 (June 1945): 161. Loran reiterated his position in 1981, objecting to the notion that the concept of the "picture plane" had limited application: "The stupid idea still persists among art historians and critics that the emphasis on the picture plane was something that was just a style during the period of Abstract Expressionism and that's now passé. . . . [It] pertains to all painting of all times" ("Interview with Erle Loran, June 18, 1981" [interviewer, Herschel Chipp], Oral History Collections, Archives of American Art, Smithsonian Institution, microfilm reel 3198).

6. At times he rendered a photograph diagrammatic by making linear tracings of selected features. The surfaces of photographs appended to the typescript draft of *Cézanne's Composition* reveal the marks of such tracing (Erle Loran Papers, Archives of American Art, Smithsonian Institution).

7. Loran, "Cézanne's Country," 529.

8. As examples of Rewald's use of site photographs, see John Rewald and Léo Marchutz, "Plastique et réalité: Cézanne au Château Noir," *L'Amour de l'art* 16 (January 1935): 15–21; John Rewald, "As Cézanne Recreated Nature," *Art News* 43 (15–29 February 1944): 9–13; John Rewald, "The Last Motifs at Aix," in *Cézanne: The Late Work*, ed. William Rubin (New York: Museum of Modern Art, 1977), 83–106. Rewald inclined toward seeing more sameness than difference in the comparisons.

9. Beaumont Newhall, "Photography as a Branch of Art History," *College Art Journal* 1 (May 1942): 87–88. See also E. H. Gombrich, *Art and Illusion: A Study in the Psychology of Pictorial Representation* (Princeton: Princeton University Press, 1961 [1960]), 65–66.

10. My own experience in viewing Mont Sainte-Victoire is that it changes dramatically in apparent size, depending on the atmospheric conditions.

11. Pavel Machotka, *Cézanne: Landscape into Art* (New Haven: Yale University Press, 1996), 3, 98.

12. Perhaps Loran's most direct statement of the issue comes in his conclusion (p. 133), where he quotes André Lhote's reference to "this double necessity [from which] most of the inventions in the art of painting are born." On Lhote, see n. 18, below.

13. Hans Hofmann, *Search for the Real, and Other Essays: A Monograph Based on an Exhibition, Covering a Half Century of the Art of Hans Hofmann, Held at the Addison Gallery January 2–February 22, 1948* (Andover, Mass.: Addison Gallery of American Art, Phillips Academy, 1948). Loran makes textual references to Hofmann on pp. 1 and 21, n. 1.

14. Erle Loran, letter to Sam Sabean, 29 November 1955, Erle Loran Papers, Archives of American Art, Smithsonian Institution. Sabean was an old friend from the Minneapolis School of Art and the first to inform Loran of Hofmann's ideas ("Interview with Erle Loran, June 18, 1981").

15. Greenberg, "Review of an Exhibition of Hans Hofmann and a Reconsideration of Mondrian's Theories" (1945), in *Clement Greenberg: The Collected Essays and Criticism*, 2: 18; see also "The Present Prospects of American Painting and Sculpture" (1947), ibid., 2: 169–70. In his letter, Greenberg alluded to attending "four lectures by Hans Hofmann in 1939"; they helped him immensely, "not so much by what was actually said as by the emphasis and tendency" (Clement Greenberg, letter to Erle Loran, 1 February 1944, Erle Loran Papers, Archives of American Art, Smithsonian Institution).

16. For Loran's sense of the timing of Hofmann's influence, see "Interview with Erle Loran, June 18, 1981."

17. On Hofmann's style of teaching, the Berkeley faculty, and painting in the San Francisco region, see Karl Kasten, "Hans Hofmann, Berkeley, and New York," www.calartalumni.org (accessed 12 July 2005); Susan Landauer, *The San Francisco School of Abstract Expressionism* (Berkeley: University of California Press, 1996), 30, 37.

18. For a typical Benton diagram, see Thomas H. Benton, "Mechanics of Form Organization in Painting, Part II," *The Arts* 10 (December 1926): 341. Diagrams are also found in André Lhote, *Traité du paysage* (Paris: Floury, 1939), 43, 187, a book Loran cited with approval (pp. 32–33). As for Benton, Loran disapproved of his regionalist style, which he considered doubly reactionary: aesthetically, it turned its back on the achievements of the modern Europeans; politically, it was chauvinistic and isolationist ("Interview with Erle Loran, June 18, 1981").

19. Erle Loran Johnson, "An Artist Goes to Italy," *The Arts* 17 (May 1931): 554.

20. For the analogous definitions, see Hans Hofmann, *Search for the Real and Other Essays*, ed. Sara T. Weeks and Bartlett H. Hayes, Jr. (M.I.T. Press, 1967 [1948]), 71.

21. Hofmann, "Excerpts from the Teaching of Hans Hofmann," in *Search for the Real*, 65. Greenberg, reviewing Loran, wrote analogously of "the unity of a picture that constitutes its virtuality as a successful work of art" ("Review of *Cézanne's Composition* by Earle [sic] Loran," in *Clement Greenberg: The Collected Essays and Criticism*, 2: 48).

22. Objecting to the terminology of "positive volumes and negative space," the painter Karl Kasten, Loran's former student and Berkeley colleague, suggested instead the more integrative notion of "density of space," which he associated with the writings of Maurice Raynal (Karl Kasten, conversation with the author, 8 July 2005). Apparently, Loran adopted Kasten's term in changes made for the third edition.

23. For reproductions, see, respectively, Forbes Watson, "Exhibitions," *The Arts* 17 (February 1931): 351; www.calart.com, for *Hillside Houses* (accessed 17 August 2005); Alfred M. Frankfurter, "The Artists for Victory Exhibition: The Paintings," *Art News* 41 (1–14 January 1943): 12.

24. Loran, "The Watercolor Series," 61.

25. See James Monte, "Erle Loran, De Young Museum," *Artforum* 1 (May 1963): 12. Loran maintained collegial relationships with many members of the New York School, thought of himself as an abstract artist who merely happened to work from nature, and regarded abstract expressionism as "a highly structured kind of art." During the 1950s, he invited New York painters to teach at Berkeley, in part to compete with the neighboring California School of Fine Arts (now the San Francisco Art Institute), which had Clyfford Still on the regular faculty and Rothko and others as visitors ("Interview with Erle Loran, June 18, 1981").

26. For example, Erle Loran, "San Francisco," *Art News* 51 (December 1952): 40.

27. Loran, "San Francisco," *Art News* 48 (September 1949): 52. Loran's review also featured paintings by Hassell Smith; but these, he noted, were marked by simple, relatively clear contours. On the careers of Bischoff, Park, Smith, and other painters who figure in Loran's reviews, see Landauer, *The San Francisco School of Abstract Expressionism*.

28. For the quoted phrases, see Loran, "The Watercolor Series," 52.

29. Richard Wollheim, *On Formalism and its Kinds* (Barcelona: Fundació Antoni Tàpies, 1995), 24–25.

30. Erle Loran, letter to the editor, *Artforum* 2 (November 1963): 60.

31. Roy Lichtenstein, in John Coplans, "Talking with Roy Lichtenstein," *Artforum* 5 (May 1967): 36.

32. Erle Loran, "San Francisco," *Art News* 48 (September 1949): 52.

33. Compare, for example, Barnett Newman, "Art of the South Seas" (1946), in *Barnett Newman: Selected Writings and Interviews*, ed. John P. O'Neill (Berkeley: University of California Press, 1992), 102: "Without any attempts at illusion, working directly, using the plastic means per se, the primitive artist gives us his vision, complete and with candor. . . . [So do artists of] a new movement that has arisen here in America [using] the techniques of modern abstract art."

34. Erle Loran, "Cézanne and Lichtenstein: Problems of 'Transformation,'" *Artforum* 2 (September 1963): 35.

35. Leo Steinberg, in "A Symposium on Pop Art," ed. Peter Selz, *Arts Magazine* 37 (April 1963): 40. The Museum of Modern Art, New York, sponsored the symposium.

36. Andy Warhol, quoted in *Time* 81 (3 May 1963): 69.

37. Lichtenstein, in Coplans, "Talking with Roy Lichtenstein," 34.

38. Both sides of the issue are represented reasonably accurately in Loran's own account, for he believed that the stupidity of the opposing view spoke for itself: Erle Loran, "Pop Artists or Copy Cats?" *Art News* 62 (September 1963): 48–49, 61; see also "Symposium on Pop Art," ed. Selz, 36–44. Loran discussed the same issues in a simultaneous publication, in this instance stressing the gap in aspiration and ambition between the generations of abstract expressionism and pop: Loran, "Cézanne and Lichtenstein: Problems of 'Transformation,' " 34–35. Loran's typescript draft for "Pop Artists or Copy Cats?" (Erle Loran Papers, Archives of American Art, Smithsonian Institution) includes additional scathing remarks ultimately edited out either by himself or by Thomas B. Hess at *Art News*, to whom the submission was addressed. Loran initially gave it the ironic title "Collector Purchases 'Portrait of Mme. Cézanne' by Roy Lichtenstein"—ironic, because "by Roy Lichtenstein" was immediately followed on the typed page with a certification of authorship, "by Erle Loran," which could be read as stating that the purchased painting by Lichtenstein was actually by Loran.

39. Philip Leider, "Books: *Cézanne's Composition* by Erle Loran," *Artforum* 2 (November 1963): 55.

40. Loran, "Pop Artists or Copy Cats?" 48; "Interview with Erle Loran, June 18, 1981." The typescript draft for "Pop Artists or Copy Cats?" refers to "unambitious" instead of "modest" diagrams.

41. Loran had the general counsel for the Regents of the University of California address a formal complaint to Lichtenstein (letter from Thomas J. Cunningham to Roy Lichtenstein, 21 October 1963, Erle Loran Papers, Archives of American Art, Smithsonian Institution); he considered bringing a suit on the grounds of a violation of the university's and his copyright but was dissuaded by Karl Kasten and other friends (Karl Kasten, interview by author, 8 July 2005; see also Alfred Frankenstein, "UC Painter and 'Piracy,' " *San Francisco Chronicle*, 30 August 1963). Lawrence Alloway, an early champion of pop art, incorrectly states that an actual suit was decided in the courts in Lichtenstein's favor (Lawrence Alloway, *Roy Lichtenstein* [New York: Abbeville, 1983], 46).

42. Lichtenstein, in Coplans, "Talking with Roy Lichtenstein," 36.

43. As an example of this type of commentary, see Rosalind E. Krauss, *The Optical Unconscious* (Cambridge, Mass.: MIT Press, 1993), 103.

44. Loran ventured this not entirely sarcastic notion in the typescript draft for "Pop Artists or Copy Cats?"

45. Erle Loran, letter to the editor, *Artforum* 2 (November 1963): 60.

46. Roy Lichtenstein, in John Coplans, "An Interview with Roy Lichtenstein," *Artforum* 2 (October 1963): 31.

47. Roy Lichtenstein, in G. R. Swenson, "What Is Pop Art?" *Art News* 62 (November 1963): 62.

48. Loran, "An Artist Goes to Italy" (cited n. 19 above).

49. Loran, "San Francisco" (cited n. 32 above).

PREFACE TO THE THIRD EDITION

IT IS JUST twenty years ago that *Cézanne's Composition* was first published, and naturally a change in my approach to some of the paintings has taken place. Without disturbing the original layout of the book, I have incorporated a number of revisions that make the present edition more contemporary with my current ideas. In the past fifteen years, particularly in America, we have seen a development in abstract painting that has gone so far beyond the clear construction of obvious shapes and forms still dominant in the art of Picasso, for example, that it has seemed to represent a radical break with tradition. In my opinion we can find the most illuminating precedents for recent abstract painting in the late works of Cézanne. Cézanne climaxed his career by shifting flat color planes around so freely that he often left nature far behind, to arrive at an abstract synthesis of pure color planes. These planes or patches of color were brushed with the most expressive and fascinating stroke ever seen. The meaning of the stroke and the emphasis on the material of paint and color were all directed toward establishing the surface itself as a structure. This structure of color planes is what appears, more and more, to be Cézanne's most personal contribution to art. You could take away all the superimposed lines, and the great lesson for painting would remain. There are not many paintings that reveal this concept, and the nearest approach originally illustrated in this book is seen in Plate XXVI. However, as I originally insisted, the lines that we do see make the final statement about forms and space relationships clear. Now, with the publication of the Third Edition, a new color reproduction offers further explanation of the final phase of his work in Plate XXXIX.

If Cézanne had actually left out linear definition in these late paintings, the recognition of natural objects would be lost and we would see a transposition of all the elements into a new kind of abstract space. Such an abstract space would transcend the effect of gravity and create relationships suggesting movement and depth without negating the dominant presence of the plane of the surface itself. This would be a form of nonobjective art, one aspect of which has been familiarly designated in America as Abstract Expressionism. It would appear that Kandinsky and Analytical Cubism came very close to this aim, but only in the past fifteen years have we seen the final departure from solid objects which has allowed a suspension of all volume and space into a vertical dominance of interchanging movements that go in and out, up, down, and across the picture plane. No one to my knowledge has suggested that Cézanne actually achieved this kind of solidity and density of space, but he certainly anticipated it. Simply take out the line drawing in many of his latest oils and water colors, and it is all but completely revealed. The new color reproduction, Plate XXXIX, with diagram, should illustrate the whole concept very clearly.

I realize how many important aspects of Cézanne's art have not been touched upon in the present work although some of them were discussed in the Preface to the Second Edition. Cézanne's early work is bypassed partly because there were no motif photographs to explain it. All Cézanne's early work is strangely moving even at its worst. The man's inner turmoil and anxiety are what dominate in the early years; the mature artist so thoroughly conceals his psychological problems that we can only think of the new and complete world he has formed. It is a monument in the history of great names and personalities, and yet it goes beyond the personal and seems to become a whole era or civilization in itself. The Freudian concept of art as the sublimation of our more primitive urges is clearly illustrated.

Another problem has haunted me ever since the publication of this book: the nature of Cézanne's intellect. I have gone to great pains to point out and reiterate throughout the text that the ideas about composition expressed here do not correspond with conscious formulations of Cézanne's which can be verified by statements he made and letters he wrote. Writers like Leo Larguier who knew Cézanne during the last years of his life confirm the impression that Cézanne was intellectually undisciplined and remarkable for making wild self-contradictions. But when we behold the paintings, we are impressed with the thoughtfulness and the logic of every procedure he followed. It is a work of supreme intelligence, but we must look only at the painting to arrive at such a conclusion. The intelligence we perceive is like a force or law of nature that is revealed through action and growth. Like the relentless revolutionary momentum of his art, going like a tide against his personal need to be understood and accepted, his intelligence too was something that could not be exercised at will. It revealed itself in the process of work and cannot be measured by ordinary standards.

ERLE LORAN

PREFACE TO THE SECOND EDITION

A FEW misconceptions about *Cézanne's Composition* may appropriately be pointed out with the printing of this second edition. It is not a book of criticism in the traditional sense; the aim is to present facts about space composition that have not hitherto been explained in any book. Although an explanation of Cézanne's exact procedure in painting is given in Section IV (pp. 25–33), the diagrams are not primarily concerned with this matter. Compositional problems of a broader scope constitute the various sections of the book; Cézanne is merely convenient to use as the fountainhead for modern concepts of space organization.

When Cézanne is compared with earlier masters the comparison is only a general one. I regret having used the word "classic" because I am not concerned here with the usual meaning of the word. It appears in only a few sentences, where it implies sound compositional structure and nothing more. In this sense Cézanne, Giotto, and other Renaissance painters certainly reveal classical structure.

Criticism has been voiced of my strong emphasis of the linear structure in Cézanne's painting, as if I had meant to imply that Cézanne started a painting with a completely planned outline drawing. In order to correct this misapprehension, certain changes are now made in the explanation accompanying Plate I, Diagram I (p. 40). Obviously, Cézanne's line is unlike that of Renaissance painters in quality and appearance; but so much of the criticism in other books on Cézanne has tended to constitute a denial of the existence in his work of any linear structure whatever that in my own book it is quite possible there is overemphasis of its clarity and power. The tenuous and segmented character of Cézanne's line, particularly as we can observe it in water colors and unfinished oils, points to the fact that alterations as well as constant reinforcements of the line were made during the process of painting. In this process of painting with small color planes and of superimposing lines over them as the composition developed and progressed, Cézanne was radically unlike Renaissance painters. But in the end, when the painting was completed, its basic linear structure was there just as positively as in Renaissance painting, although its character and appearance are radically different. The novelty of Cézanne's line-and-color synthesis is implied throughout my diagrammatic analyses, especially when the Cézannean sources for Dufy's open-color system are noted. As a painter and teacher I do not advise starting a painting with an outline drawing, nor do I recommend the use of Cézanne's minute color planes; I prefer an approach to composition through the combination of large color areas.

A few readers have erroneously thought that my exclusive concern with form in Cézanne's painting indicated that I meant to deny the existence of feeling and intuition. A more careful reading would show that I do not even attribute to Cézanne a consciousness of many of the theoretical concepts explained in this study. I have confined myself to expounding demonstrable facts and concepts because I have always looked for them in books about painting and, like many others, have found them elusive. Here, the aim is to address artist, student, scholar, and layman who seek a nomenclature for painting and a concept of space composition. What I have learned about these principles of composition has been of inestimable practical value to me as a painter and teacher. But, being primarily a creative artist, I know from experience that there is nothing more mysterious and intangible in human experience than the creative process. To enter this field of art criticism would involve an application of discoveries in psychoanalysis, aesthetics, and various religious concepts of the immortality of the soul. These are fascinating subjects, but the present work confines itself to demonstrable concepts about form, color, and space; my aim is to use a consistent nomenclature that may be used by others in freer critical interpretations of many kinds of art. In too many books on art the reader can never be certain even of the bare meaning of words and phrases. The intentional limitations of the work in hand should not be regarded as a denial or refutation of other approaches to art.

ERLE LORAN

ACKNOWLEDGMENTS

I wish to express my gratitude to the many persons who have encouraged me during the preparation of the present study; especially to Stephen C. Pepper and Lesley Byrd Simpson for valuable aid and criticism, Frederick C. Clayton for editorial and other help, Alfred H. Barr, Jr., for many kind services and helpful criticism, Edgar Taylor, Glenn Wessels, and Walter Horn for detailed and invaluable criticism and suggestions, and Samuel Sabean and Leah Rinne Hamilton for valued encouragement and suggestions. Meyer Schapiro has been most coöperative in showing me notes from the German of Novotny.

I am indebted to John Rewald, Lionello Venturi, and Jerome Klein for their generous coöperation in lending many photographs, and to Miss Etta Cone for the privilege of including among the illustrations a color plate from her Cézanne landscape. Mrs. Adelyn Breeskin has also been helpful. Mr. Harold A. Small, Editor of the University of California Press, has rendered invaluable service in his painstaking and thoughtful editorial revisions of my text.

I owe a debt of thanks, moreover, to my colleagues Margaret O'Hagan, John Haley, Worth Ryder, and Karl Kasten as painters and teachers; my association with them has stimulated my search for the aims and values represented in my study of Cézanne.

I should like to add the name of Cameron Booth, my first important teacher, to this list. Most of the ideas dominating *Cézanne's Composition* were formulated long after my student days with Mr. Booth, but I owe my respect for positive, graphically demonstrable ideas about composition in general to his early influence.

The publication costs of this book have been met in part by a subsidy from the American Council of Learned Societies (Carnegie Corporation), and I am sincerely grateful for this aid.

And now, after the appearance of Hans Hofmann's book, *Search for the Real*, general acknowledgment should be made to that great teacher of painting. In 1955 I had the stimulating experience of being a student in Mr. Hofmann's art school for six weeks. His ideas about space composition have been so widely disseminated by former students that anyone searching along similar lines necessarily owes a great deal to him.

E. L.

I. INTRODUCTION

THE DISCOVERY OF CÉZANNE'S MOTIFS. The photographic material for this study was collected when, for more than two years, I lived in Cézanne's studio in Aix-en-Provence, painting in the Cézanne country and taking snapshots whenever I came upon motifs of Cézanne's paintings. Of course, the photographs collected in this casual manner, though adequate for a younger painter who was trying to solve the mysteries of Cézanne's form, are not presented here as examples of professional photography; nevertheless, they should serve the purpose for which they are intended.

Since the appearance of a preliminary article, "Cézanne's Country," which I wrote for *The Arts* (April, 1930), several writers in France, among them John Rewald and Lionello Venturi, have explored the same country for the purpose of taking photographs of Cézanne's motifs, and they have used them in numerous articles and books. John Rewald and Fritz Novotny have acknowledged that "Cézanne's Country" was the first revelation of Cézanne's motifs. I am very grateful to Mr. Rewald for making available to me certain photographs for the present volume, particularly those for the motifs from La Roche-Guyon and Le Ferme à Montgeroult.

The wide interest shown, and the extensive use subsequently made of the method of pictorial comparisons employed in that initial article in *The Arts,* were indications of a need for more specific explanations of plastic form.[1] Encouragement and prodding by people who remembered "Cézanne's Country" persuaded me that the remaining photographs ought also to be presented, accompanied by diagrammatic analyses. The diagrams here shown explore many aspects of Cézanne's form, particularly those which can be clarified by reference to the photographs of his motifs. No doubt this diagrammatic approach may seem coldly analytical to those who like vagueness and poetry in art criticism. To those who want pleasant reading and rhapsodical flights of the imagination, I can only recommend the essays of Meier-Graefe and Elie Faure.

There are many solid books of biography and criticism on Cézanne, the most recent of which is John Rewald's.[2] Mr. Rewald's book, together with the collection of Cézanne letters[3] edited by him, offers definitive information about Cézanne's life and the art world of his time. Gerstle Mack's scholarly biography[4] is the best to be found in English. As for Cézanne's paintings, the great Cézanne catalogue compiled by Lionello Venturi[5] is an indispensable reference work; and Dr. Albert C. Barnes's recent volume[6] is a serious analytical study of Cézanne's form. Fritz Novotny, of Vienna, has written a penetrating book[7] based upon comparisons between the paintings and John Rewald's photographs of the motifs. No earlier book is so well remembered as Roger Fry's sensitive, deeply felt criticism and analysis, *Cézanne: A Study of His Development*.[8] These books cover the subject so thoroughly that there is no immediate need for further biographical or literary studies about Cézanne.

Complete diagrams explaining Cézanne's formal structure, however, have not so far appeared in book form. To my knowledge, nothing has been published that makes space organization in any art completely understandable in diagrammatic terms. The photographs of the actual motifs of Cézanne's paintings offer an unusual opportunity to present concrete examples that will help to reveal exactly what is meant by the "organization of space"; and that is the purpose of the present study.

It is difficult to find helpful precedents for the work in hand. Sheldon Cheney's *Expressionism in Art,*[9] based in part on the theories of Hans Hofmann and Glenn Wessels, explains the space problems of modern art more thoroughly than any other I have read, and the books of Albert C. Barnes[10] have made a very great contribution to the understanding of form in painting; but detailed diagrams are essential if these ideas are to become concrete and usable to a reader. Most of the diagrams that have been published follow generally the basic theory known as "dynamic symmetry." Those of J. W. Powers,[11] for example, deal with two-dimensional construction and pattern displacements; and Gino Severini, the Italian Futurist painter, has written a book[12] that attempts to reduce composition to an exact, mathematical system.

[1] For explanation of plastic means, see Glossary, Diagram II (p. 17).
[2] *Cézanne. Sa Vie, son œuvre, son amitié pour Zola*, Albin Michel, Paris, 1939.
[3] *Paul Cézanne. Correspondance*, Grasset, Paris, 1937.
[4] *Paul Cézanne*, Alfred A. Knopf, New York, 1935.
[5] *Cézanne*, Paul Rosenberg, Paris, 1936.
[6] *The Art of Cézanne*, Harcourt, Brace, New York, 1939.
[7] *Cézanne und das Ende der wissenschaftlichen Perspektive*, Anton Schroll & Co., Vienna, 1938.
[8] Hogarth Press, London, 1927.
[9] Liveright, New York, 1934.
[10] Especially *The Art in Painting,* Harcourt, Brace, New York, 1926.
[11] *Eléments de la construction picturale aperçus des méthodes des maîtres anciens et des maîtres modernes*, Aux éditions Antoine Roche, Paris, 1932.
[12] *Du Cubisme au classicisme*, J. Povolozky, Paris, 1921.

One of the most profusely illustrated books dealing with geometric shapes and two-dimensional constructions is that by Ernst Mössel.[13] Georges Seurat has left an account of his theories of composition,[14] but unfortunately without explaining that he was concerned with the deep-space problem. The most revealing book written by an artist-teacher is *Traité du paysage,* by André Lhote.[15] Lhote comes to mind, before any other artist-teacher, as a direct follower of Cézanne. His book gives the clearest explanation of the essence of Cézanne's form that I have read, although Cézanne is but one of many painters upon whom Lhote bases his concept of form. Nevertheless, the diagrams which appear in Lhote's book are fragmentary; his tendency is to overemphasize light-to-dark, warm-to-cool gradations.

There is a somewhat fantastic book on El Greco by the Danish painter, J. F. Willumsen,[16] containing numerous diagrams intended to show that El Greco's understanding of three-dimensional space organization was confused. It is amusing to discover some of the unintentional slips El Greco did make; however, on the whole the book displays not El Greco's but the author's miscomprehension of pictorial space. Willumsen's contention is that El Greco occasionally revealed the traits of a naïve, two-dimensional approach to form, supposedly found in Byzantine icon painting, a stylistic tradition that El Greco learned in his youth. It is the misfortune of art education today, both in the teaching of art history and in the practice of painting, that this falsely realistic approach to space, as typified by the attitude of Willumsen, who presupposes a scientific perspective as the necessary foundation for all truly three-dimensional painting, still persists on a wide front in our universities and schools of art. An excellent historical work in which Byzantine space is analyzed with clarity and understanding is the recent book by Miriam Bunim.[17] The entire field of pictorial space, from the Ancient to the Renaissance period, is described with a knowledge of the actual methods of drawing that have been employed to effect various illusions of space.

Had the leaders of the great traditions of the past given us more records, explaining their methods in diagrams or words, succeeding generations of artists and historians might have been spared much time wasted in blind alleys. Alberti[18] and Piero della Francesca[19] wrote treatises; but perspective, and not composition, was their problem. Cennino Cennini's handbook[20] also deals with perspective and technical methods, but without explaining composition. The most famous treatise on painting is that found among the writings of Leonardo da Vinci.[21] It may seem heretical to remark that the principles laid down by Leonardo are not acceptable to the modern painter, but it is merely factual to assert that Cézanne, in his work, though not always in his statements (as we shall see later), relegated almost the whole of Leonardo's system to the dead past. Leonardo's *Trattato* is a vast storehouse of factual knowledge about optics and methods of arriving at a scientifically accurate representation of a multitude of forms in nature, but several centuries of the dull and accurate painting that followed the adoption of mechanical perspective, plus the recent decades since the discovery of photography, have convinced the creative artist of modern times that pictorial creation is no longer to be judged by mechanical precepts of accuracy. When Cézanne said, "Today a painter must discover everything for himself, for there are no longer any but very bad schools, where one becomes warped, where one learns nothing,"[22] he was really delivering a blow at Leonardo's treatise, for the traditions of art teaching in France are closely linked to the *Trattato.* In 1648, when the Académie Royale de Peinture et Sculpture was opened, the treatise was the first book consulted in setting down the principles of teaching the fine arts.[23] Again, in 1853, a commission of painters including Ingres, Delacroix, Flandrin, Meissonier, made a report entitled *De l'enseignement du dessin dans les lycées* (1853), issued under the auspices of the Ministry of Education by Félix Ravaisson, which contains the following recommendation: "J'aurai recours surtout à l'autorité des grands maîtres dont les doctrines sur la théorie et la pratique de l'art et sur la manière de l'enseigner se sont conservées jusqu'à nous, et particulièrement de Léonard de Vinci."[24]

That same Academy tradition persists today in many places, and it still prescribes drawing from antique casts, mechanical imitation of light and shade, the use of mechanical perspective, including linear and aerial perspec-

[13] *Vom Geheimnis der Form und der Urform des Seins,* Deutsche Verlags-Anstalt, Stuttgart and Berlin, 1938.
[14] Lucie Cousturier, *Seurat,* G. Crès, Paris, 1926, p. 13.
[15] Floury, Paris, 1939.
[16] *La Jeunesse du peintre El Greco,* G. Crès, Paris, 1927.
[17] *Space in Medieval Painting and the Forerunners of Perspective,* Columbia Univ. Press, 1940.
[18] See William M. Ivins, Jr., "On the Rationalization of Sight," *Papers* of the Metropolitan Museum of Art, No. 8, New York, 1938, for translations from Leon Battista Alberti, *Della pittura libri tre* (1435–1436).
[19] *Petrus pictor Burgensis de prospectiva pingendi ...* veröffentlicht von Dr. C. Winterberg, Strassburg, 1899.
[20] *Il libro dell'arte* (*A Craftsman's Handbook*), trans. D. V. Thompson, Jr., New Haven and London, 1933.
[21] Jean Paul Richter, ed., *The Literary Works of Leonardo da Vinci,* Oxford Univ. Press, 1939.
[22] Bernard, *Souvenirs sur Paul Cézanne,* Chez Michel, Paris, 1912, p. 116.
[23] Richter, *op. cit.,* Vol. I, p. 10.
[24] *Ibid., p.* 11.

tive, as described by Leonardo, and a medical approach to anatomy. What could a Cézanne expect to learn from such a system! The *Trattato* contains mainly these mechanical systems and devices; I can find in it nothing that pertains to composition and the organization of color and space as Cézanne was seeking those elements.[25]

None of the foregoing is intended to be a condemnation of Leonardo's masterful painting. The contention is that Leonardo does not offer an explanation of his own painting so far as design and composition are concerned. For all the rules offered by Leonardo, one might conclude that Cabanel, Bouguereau, and Meissonier were the acme of artistic achievement!

There have been other treatises by painters, for example the *Treatise on Human Proportion* by Albrecht Dürer, 1523,[26] which was followed in 1538 by Schön's *Studies*,[27] in which the human figure is reduced to cubistic volumes in order to explain methods of foreshortening and perspectival space location. These few records indicate that the early masters had their minds on problems of structure, but they do not explain composition and the methods of organizing volume, space, and color.

In 1893 a book appeared that is an outstanding contribution to our knowledge of space composition. *The Problem of Form*,[28] by the Munich painter and sculptor Adolph Hildebrand, gives a thorough explanation of his own concepts of composition, which are based on a study of the masters of the past. His book is apparently not widely known, although presumably certain teachers have derived from it their concept of classical form and an interpretation of modern Abstract art as well. The Hildebrand concept of parallel planes and controlled space may too easily be made to serve as a dogmatic measuring rod by which any and all works of art may be critically estimated. Some painters and teachers appear thus to have used it with dogmatic exclusiveness—and by so doing they have underestimated the expressive qualities of many great painters. But it does happen that for the work of Cézanne the Hildebrand principles generally hold true. In fact, the photographs of motifs and diagrams of Cézanne's paintings are a confirmation of the basic space theories explained by Hildebrand. It should be mentioned, however, that Hildebrand appears to be entirely unconcerned with the important elements of design and decoration. Had there been more books like *The Problem of Form*, and had there been explanatory diagrams in the text of that book, the vague thinking that characterizes many among our contemporary critics and painters who are seriously interested in solving the problems of their profession might have

been avoided. Several authors have explored composition with the aid of diagrams,[29] but with the exception of André Lhote no one besides Hildebrand seems to have been aware of the necessity of controlling and unifying the total space in relation to the picture plane, and Lhote offers no diagrams to explain this profoundly complex problem. Here we are reminded of the diagrams of Thomas Hart Benton.

Serious consideration must be given to the diagrammatic studies made by Benton in *The Arts* (November and December, 1926, January and February, 1927). As far as they go, these diagrams provide the clearest explanation of certain aspects of composition that I have ever seen. Mr. Benton describes not only decorative problems, but also many different qualities and potentialities of line, for example the opposition of static and dynamic, static and swirling, lines. He describes methods by which space and volume may be created with planes, and he lays stress on the importance of chiaroscuro. Three-dimensional space and movement in accordance with the devices of scientific perspective are also demonstrated, but without mention of the attendant dangers and difficulties. There are some interesting diagrams showing volumes that revolve around a central axis (a problem that will prove important here in the analysis of Cézanne's form). There are also some excellent diagrams of El Greco and Rubens. But the keynote of Mr. Benton's approach to painting is found in his statement that, "in three-dimensional painting, sculpture offers the technical precedent." He gives no hint of understanding the nature of the picture plane,[30] the architectural absolute so faithfully and masterfully preserved by all the old masters he analyzes. Furthermore, Benton never meets the problem of controlling movement, of organizing three-dimensional space illusions so that they achieve balance in relation to the two-dimensional picture plane.[31] Indeed, these essays by Mr. Benton are a revealing explanation of the disturbing effects to be observed in his own paintings, and in those of certain other famous American painters,

[25] Kenneth Clark, in his *Leonardo da Vinci*, Macmillan, New York, 1939, says (p. 75): "For that side of painting which consists in the harmonious composition of proportionate parts Leonardo gives no rules."

[26] *Vier Bücher von menschlicher Proportzion*, Nürnberg, Hieronymus Formschneider for Dürer's widow, 1528.

[27] *Unterweissung der Proportzion und Stellung der Possen*, Nürnberg, 1538.

[28] *The Problem of Form in Painting and Sculpture*, trans. Max Meyer and R. M. Ogden, G. E. Stechert, New York, 1932.

[29] A few books exploring various plastic problems with diagrams are: Daniel Catton Rich, *Seurat and the Evolution of "La Grande Jatte,"* Univ. of Chicago Press, 1935; Ralph M. Pearson, *Experiencing Pictures*, Brewer, Warren and Putnam, New York, 1932; Morris Davidson, *Painting for Pleasure*, Hale, Cushman and Flint, Boston, 1938; Maitland Graves, *The Art of Color and Design*, McGraw-Hill, New York, 1941; Adolfo Best-Maugard, *A Method for Creative Design*, Knopf, New York, 1926.

[30] See Glossary, Diagram I (p. 17).

[31] See Glossary, Diagram VII (p 20).

too. It is true that Rubens, El Greco, Tintoretto, indulged in violence, bombast, and muscular heroics, as many of their latter-day American admirers have done; but in contrast to the work of these same Americans, the deep-space-volume compositions of the earlier masters are balanced. Generally speaking, their paintings "hold to the wall."

Other American writers using diagrams in their books make a valuable contribution to the understanding of drawing and composition; but, like Benton, they fail to bring to the fore the problem of organizing the total space with regard for the picture plane.

CÉZANNE'S FORM AS REVEALED BY PHOTOGRAPHS AND DIAGRAMS. This is not the place for a detailed critique of contemporary American painting, the most promising school of painting in the world today. The difficult problems that we American artists face should be traced back to the art academies, which remain so steadily in the nineteenth-century groove. Cézanne, it is true, has been partly incorporated into this academic pattern; but it is usually his pleasing way of wiggling the brush, his modeling with color, that have been admired or imitated, and these traits have been superimposed upon nineteenth-century traditions. The traditions persist today, particularly in the life class, where convention dictates, for instance, that a strongly modeled figure be placed in the middle of a sheet of white paper. Usually the figure is modeled in a sculptural way, without regard to the flat picture plane or the picture format.[32] In many art schools painting also is approached in somewhat the same manner. Individual volumes are strongly modeled and richly colored. There is no understanding of the problem of relating the volumes to the negative space,[33] the distance between and the space surrounding the volumes. The picture plane and the picture format are a vague mystery. I know something about this academic tradition, for as a painter I have been struggling against its pernicious effects for years.

What we lack is an understanding of the few basic principles that can be regarded as "constants" in the entire history of pictorial creation. With the acceptance of certain recurring principles as the foundation of great art, a more dependable approach to creation, as well as to teaching and criticism, will become possible. The diagrams of Cézanne's paintings offered here are an effort in that direction, and they are presented with the conviction that the same principles can be applied to the art of many different periods. I am well aware that many critics and art historians regard the idea of "constants," that is, the concept of a basic continuity of aesthetic and formal principles in art, as un-

tenable. One characteristic of such thinking can be seen in the type of archaeologist, for example, who is unable to perceive that Picasso has borrowed wholesale from Greek painting. Other types of historians, interested in iconology and literary records, have little interest in the work of art as an object affording aesthetic pleasure. Still others, approaching art with the concept of Marxian economic determinism, refuse to look for standards of good and bad art and find interest only in the phenomenon of motivation and change in artistic standards, from period to period.

As for me, I concur with those painters and teachers who, to give a concrete instance, might show examples of Egyptian, Greek, Cretan, Byzantine, Persian, Oriental, and Renaissance art to illustrate a basic principle of light-and-dark pattern or positive and negative shapes. Works of art from all these periods could be shown to have a direct relation to the kind of light-and-dark pattern that is found in modern Abstract art. Standards of taste and judgment are yearly being acquired by large numbers of interested students who learn to distinguish the tawdry and commonplace from the classical and formally perfect examples of art throughout history. The modern artist has dismissed, by putting them into practice, all argument about the soundness of the foregoing ideas on art. For several decades, now, he has taken the liberty of learning how to draw and compose by studying and borrowing ideas from the high periods in all art, as far back as prehistoric cave painting. The larger purpose of the present book may be viewed as a search for these permanent and recurring principles of artistic creation.

As a teacher of drawing and painting, and through association with well-informed painters, I have acquired certain convictions about plastic form. It has already been suggested that these concepts have been based on many different kinds of art: Egyptian, Greek, and Byzantine; individual masters like Giotto, Titian, El Greco, Cézanne, Picasso—and many more. But my convictions about Cézanne's composition have been strengthened by a comparative study of his paintings in relation to the actual motifs found in the countryside of Aix.

It should not be assumed, however, that my understanding of Cézanne's methods has been based solely on a study of these motifs. The discussion below, "Introductory Analysis of a Still Life" (pages 39–43), is the kind of diagrammatic analysis that could be made for all the paintings illustrated, and no reference to the original motif or subject is necessary. The photograph became important in connection with particular problems of Cézanne's form, such as perspective, scale, and the general reorganization of natural

[32] See Glossary, Diagram I (p. 17). [33] See Glossary, Diagram II (p. 17).

space. Photography can record the normal, factual vision of the world more accurately than other mediums, and the photographs used for the present study were taken solely for the purpose of recording the subjects at the very places from which Cézanne painted them. The objection of Beaumont Newhall, that "photographs specially taken for such a purpose are necessarily under the immediate influence of the respective paintings,"[34] does not seem to bear any particular relation to my original motives for taking the pictures, much less to the work in hand.

As a young painter passionately devoted to the art of Cézanne, I was first of all bent on seeing what Cézanne's country looked like. While most of Cézanne's paintings conveyed a luxuriously satisfying illusion of nature, certain others, perhaps still more fascinating, were more difficult to identify as landscapes related to the objective world. When I finally arrived in Aix-en-Provence in 1927, my curiosity about the sources of Cézanne's austere and original forms was soon to be satisfied. At first, I was overwhelmed by the mere discovery of motifs; later, I thought it might be valuable to make a photographic record of all the motifs I could find. For many of the photographs presented here, a Brownie 2A was the instrument used. If I were to go over the same country today, using the most modern equipment in lenses and filters, I would be able to take photographs that would put far more emphasis on the problems that are subjected to detailed analysis in the present work. It would be legitimate to do so, because the arguments made here are intended to hold good for the reader who may some day explore for himself the countryside near Aix where the motifs are to be found.

At the time the photographs were taken, the primary objective was to show how closely Cézanne followed nature, because at first it seemed an astounding revelation that the paintings were so much like the subjects. But now, after many years of thinking about the problems of space organization, it seems to me that the most significant facts are those revealing difference between Cézanne's space and the space in nature.

What the photographs of the motifs certainly do show, then, is first of all that Cézanne always worked from nature. Sometimes his paintings are so easily traced to the subject, as in Plate XXXIV, that one could say he was pretty much an objective painter. And yet, this same painting is definitely Cubistic in form and might well have served as one of the examples upon which the Cubists based their point of departure! It should be possible to arrive at equally factual and simple conclusions in connection with most of the comparisons illustrated here. In the study of modern art it seems valuable to be able to establish such simple and primary facts. Before the discovery of Cézanne's motifs, it was not possible to do so. As for any photographic comparison that is open to question, I shall make an effort to point out whatever deceptive aspect is present in the photograph of the subject. In general, the photographs are simply offered as the best available means of conveying to the reader what every person of normal vision knows about nature.

More important questions are: How much did Cézanne interfere with or distort nature? Did Cézanne follow the laws of scientific perspective, or did he boldly disregard them and even, at times, put them in reverse? Did Cézanne manipulate scale to suit the requirements of his composition and to achieve effects of grandeur and monumentality; or did he merely represent what he saw, depending on a careful choice of subject matter to offer him his composition? In general, what is it that takes place when three-dimensional configurations in nature are transposed by the creative artist and made to function on the two-dimensional picture plane? These questions can usually be answered by a careful analysis of the paintings themselves, without any direct reference to outside facts, written or photographic; but with the factual evidence supplied by the photographs of the subjects one is able to arrive at conclusions more demonstrable than would otherwise be possible.

My contention is that these are problems of great importance, containing implications that go beyond the analysis of Cézanne as an individual artist. In fact, the ultimate purpose of the present study is far removed from anything that could be described as an effort to grasp "the painter's individual style."[35] The superficial aspects of Cézanne's style are already widely recognized and there is no immediate need for further critical studies in that direction. The aim of the work in hand is to establish the beginnings, at least, of a few general principles of drawing and composition that can be applied to creative work, teaching, and criticism in general. Because Cézanne is the father of modern art, it is in his work that we may expect to find such principles.

[34] "Photography as a Branch of Art History," *College Art Journal* (New York), May, 1942.
[35] *Ibid.*

II. CÉZANNE AS THEORIST AND ARTIST

CÉZANNE'S POSITION IN THE HISTORY OF ART. Only thirty-five years after his death, it already seems fitting to approach the problem of Cézanne's art in the spirit of making further examination of a long-established master. Early in the present century the painters in the vanguard were beginning to regard Cézanne as a tame old grandpapa. Picasso refers to him in a letter as "that Harpignies of genius."[1] He was a fine apple-painter, they thought, but one couldn't go on doing that sort of thing. We shall probably be closer to the truth in refusing to regard Cézanne as a mere precursor of Abstraction or any other post-Cézannean development. Assuredly Cézanne now has his own secure place as one of the classical figures, and in that sense he stands alone, complete and final, in the company of Giotto, Titian, El Greco.

CUBISM AND THE LEGEND OF HIS INCOMPLETENESS. I should say that the legend of Cézanne's incompleteness, of his being a mere precursor, was a good deal due to statements he made himself. The Cubists, no doubt, have leaned heavily on his remarks to Emile Bernard: "I am the primitive of a new art. I feel that I shall have followers."[2] On the strength of such remarks, of course, the Cubists could easily justify their opinion of Cézanne as a mere beginner, one who shyly pointed the way to higher, more advanced ideals.

On another occasion, Cézanne said to Emile Bernard: "I have never been able to realize. Ah, if only I could have done so! But another will accomplish that for which I have vainly used my powers."[3]

Though it is certainly doubtful that Cézanne would have welcomed a development like the later phases of Abstract art, the early period of Cubism was specifically an outgrowth from his form. (See Plate I, Diagram VIII.) The Cubist phase was not merely eclectic, a formula based entirely on Cézanne's system of painting; the early Cubists arrived at their form through a close observation of nature or the subject. The shattered, interpenetrating, intersecting planes, and the gradations of dark to light, were based on a careful analysis of the subject. In such analysis they were also followers of Cézanne's ideology of art, which prescribed that creation must be based on the contemplation of nature. Pablo Picasso and Georges Braque initiated this period as early as 1907. By 1913 the analytical, or Cézannean, phase of Cubism was over. After that time, Abstract art was no longer to bear any resemblance to Cézanne's painting, although a more and more intellectual interpretation was to be made of his distortions, the shifting of eye levels, and so on. Soon it was the academic painters who began to use Cézanne's method of rendering volumes with color planes, but with little understanding of his composition.

A BRIEF SUMMARY OF CÉZANNE'S FOLLOWERS. The present study is concerned almost exclusively with the analysis of Cézanne's composition at its full flower, and no consistent effort will be made to trace Cézanne's own development nor to examine the influence he has had on modern painting. It is well recognized that his influence on the entire world of modern art has been enormous. Among painters who have shown varying degrees of indebtedness to Cézanne are: Renoir, Van Gogh, Gauguin, Picasso, Matisse, Rouault, Modigliani, Vlaminck, Segonzac, Derain, Friesz, Gleizes, De la Fresnaye, Lhote, Braque, Soutine, Dufy, Delaunay, Dufresne, Gromaire, Pascin, Utrillo, Hofer, Kokoschka, and others.

A good number of painters continue to work in the Cézanne tradition today. In France there is André Lhote, who remains obsessed with Cézanne's "passages" and gradations of color. In his oil paintings the German-American Lyonel Feininger has never ventured far afield from a system of intersecting, interpenetrating planes with color changes suggestive of Cézanne's. In America, Andrew Dasburg and Henry Lee McFee must be praised, particularly for their earlier work. Both have made a serious study of Cézanne, and both have experimented successfully with various aspects of Cubist and Abstract art. In later years, McFee has become more conservative, being noticeably timid about using the forceful, superimposed line of his master; while Dasburg, with lagging productivity, remains definitely fixed in the Cézanne tradition. Dasburg, perhaps more specifically than any other widely known painter, is a follower of Cézanne. When he is at his best, his work has great distinction. Well-known academic painters like Eugene Speicher, Leon Kroll, and Maurice Sterne owe their best qualities to Cézanne. There in brief, and without mentioning a host of younger men who have been under the influence of the painters mentioned, is a summary of

[1] See *Creative Art,* June, 1930, for Picasso's pungent letter.
[2] Bernard, *Souvenirs sur Paul Cézanne,* p. 110.
[3] *Ibid.,* p. 112.

Cézanne's specific "followers." Would he acknowledge their productions as that "new art" which he foresaw? No doubt he would have recognized his influence over these artists, but perhaps he would have been disappointed to see what an academic tradition it has created. I fear also that he would not have been able to accept the unmodulated color areas in the Abstract art of Picasso and Braque. However, disregarding what Cézanne might have thought, there will be references, in connection with certain diagrams and illustrations in this book, to the relation between Cézanne's basic plane organization and that of the Abstract artists, who use no gradations.

THE CONFLICT BETWEEN CÉZANNE'S PAINTINGS AND HIS STATEMENTS. So much attention has been given to the theories Cézanne expressed in letters and reported conversations that it seems timely to examine them more closely in relation to his work. It is a common psychological failing to see, hear, find, only that which will fortify one's preconceived view or wish, and to black out what may contradict it. The critics have got themselves into an unnecessarily difficult tangle by trying to understand Cézanne's work in the light of his statements. It is easy to choose isolated comments of his and to extend their meaning to fit concepts that possibly were unknown to him. The Cubists and the Abstract artists have done so. Even die-hard Impressionists and academicians believe they are following his words. It may be valuable, therefore, to piece together the pattern of what Cézanne wrote and said—in other words, what we may call the expression of his intellectual, theoretical understanding—and compare it with the only thing that really counts, his own painting.

First of all, I must confess that I have never been able to correlate Cézanne's statements of aesthetic theory into any pattern that would fit the interpretation I now give to his work, the interpretation exemplified by the various diagrams I have prepared for this book. During the years when I was struggling to understand some of the elements of Cézanne's form, I eagerly attempted to match his paintings with his theories. I realize now that the task was a hopeless one; for I found arguments both for and against the view I finally arrived at through analysis of his work alone.

HIS STATEMENT ABOUT PERSPECTIVE. The widely discussed statement in a letter to Emile Bernard, dated April 15, 1904, has been utilized as an intellectual springboard for Cubism and Abstraction: "Interpret na-

ture in terms of the cylinder, the sphere, the cone; put everything in perspective, so that each side of an object, of a plane, recedes toward a central point."[4]

Now, the extraordinary influence that Cézanne has had on Abstract art is markedly bound up with his abandonment of scientific perspective. Cézanne eliminated destructively converging lines, as well as lines that would seem to expand out of the picture plane or beyond the confines of the picture format. His planes move around in the picture space without coming to a dead stop; actually, they are *not* directed "toward a central point." Thus, if Cézanne had said, *Create deep space by making the planes rotate or move around a central point, back and forth in space, without destroying the picture plane,* his dictum would more nearly have expressed the present-day theory of Abstract art; and, incidentally, it would have been more truly descriptive of Cézanne's own form. But notice that he said an object should be so presented that "each side recedes toward a central point." (The "cylinder, sphere, cone" part of the statement will be discussed later.) Taking literally the part of the quotation just repeated, one might suppose that he meant to create the sort of funnels and dead ends in space that can be found in so much second-rate painting based on scientific perspective.[5] Quite to the contrary, Cézanne's space is compensated, balanced, related to the picture plane; and thus often rotates *around,* not toward, a central point. I do not see how we can interpret his statement as anything but a contradiction of his work. In a letter to Emile Bernard dated July 25, 1904, he makes the point even more definitely in the spirit of scientific perspective when he says: "The contours of objects recede toward a *center placed* at our horizon."[6]

It is difficult to understand why Cézanne should have spoken in this way. Possibly he was trying to formulate his thoughts in deference to Emile Bernard, who had very definite ideas about perspective as practiced by the great Renaissance masters.[7] Possibly the statement was a mere cliché, culled from Cézanne's past training in conventional art schools. In any case, since Cézanne's space does not work in accordance with his formula, we ought completely to disregard the statement, except to note that it represents his failure to work out an intellectual theory coinciding with his creative production.

[4] *Ibid.,* p. 67.

[5] See Glossary, Diagram V (p. 20).

[6] Bernard, *op. cit.,* p. 73. (Italics in all quoted passages are mine.)

[7] Bernard says (*op. cit.,* p. 117): "Le géométral établit les rapports de hauteur, de largeur, de profondeur; le *perspectif* écrit les contours selon l'éloignement, par rapport au spectateur. Ces deux derniers sont mathématiques, soumis à des lois invariables."

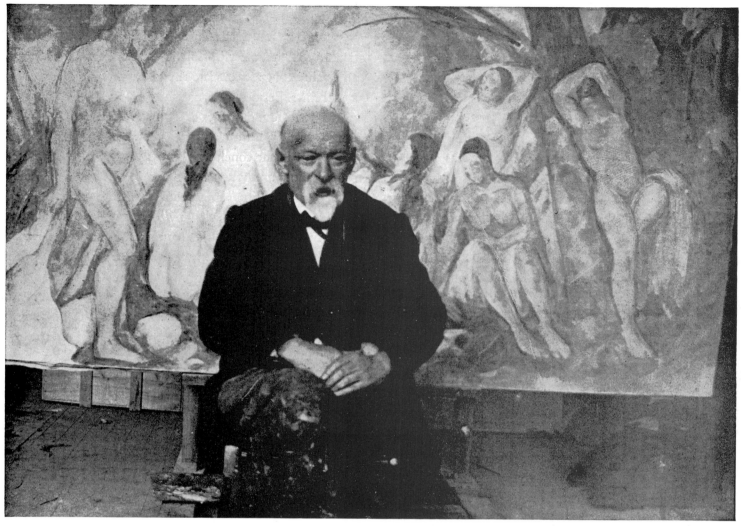

Cézanne seated in front of "The Bathers," 1905

THE CYLINDER, SPHERE, AND CONE. To return to the more famous "cylinder, sphere, cone" part of the first letter: Cézanne explained it again in a conversation reported by Emile Bernard: "The study of art is very long and badly conducted. Today a painter must discover everything for himself, for there are no longer any but very bad schools, where one becomes warped, where one learns nothing. One must first of all study geometric forms: the cone, the cube, the cylinder, the sphere. When one knows how to render these things in their form and their planes, one ought to know how to paint."[8]

We are reminded of the difficulties Cézanne had to surmount in acquiring for himself a control of the plastic means[9] that no other painter of his time knew how to teach him. But the value of the teaching formula he propounds here, when it is interpreted literally, as so many American painters and teachers have done, contains elements of the greatest danger. Obviously it has directed attention to the necessity of basing a composition on the relations between simple, geometric shapes. We should not assume, however,

that Cézanne could ever have conceived of the idea of making a picture out of triangles, circles, and squares. Those contemporary "nonobjective" painters who do so, using geometric shapes as sterile subject matter, achieve a variety of drygoods-store decoration that would have outraged Cézanne. The serious Cubist and later Abstract painters set about to understand Cézanne's painting first; they added to it a quite new conception of space, in which cylinders and cones, as such, are of little importance. Ironically, a most extensive application of the dictum has been carried out in the academic art schools. There the formula is followed as though it said: "Learn to render isolated objects, conceive of them in a sculptural sense; when you can render solid objects, you can paint pictures." I do not exaggerate; this crude conception of form is widely accepted today. Unfortunately, it is exactly what Cézanne recommended if the quotation mentioned is taken literally. But his own painting is a different story. There we can see what profound importance attaches to the arrangement of volumes in space,

[8] *Ibid.*, p. 116. [9] See Glossary, Diagram II (p. 17).

the control of the negative space, both in depth and in surface pattern.[10] These elements of spatial organization are the real message he has left; and that message can be found only in his paintings, not in his words.

OVEREMPHASIS OF THE IMPORTANCE OF CÉ-ZANNE'S COLOR MODULATIONS. In addition to this preoccupation with rendering geometric forms, there is the unending concern with the method of achieving the solid-volume effect. Again, we can blame Cézanne's own words for the attaching of too much importance to modeling as it relates to space and volume. According to the painter Louis Le Bail, Cézanne said: "Modeling, there is only that; one ought not say to model, but to modulate."[11]

By "modulate" Cézanne meant, of course, to change the color as the object turns away from the light, going from warm to cool. The confusion over the function of these modulations has been extensive. The conclusion often reached is that Cézanne replaced linear drawing, as used traditionally, by the creation of volume-space relations with his color-modeling system. Another familiar quotation that tends to add to the confusion reads, "Contrasts and harmonies of tone—there you have the secret of drawing and modeling!"[12] Again, "The form and contour of objects is given to us by the oppositions and contrasts which result from their individual coloration."[13]

There is nothing original about these ideas, nor anything complex in their meaning. Indeed, they have become the heritage of the most old-hat academicians. Following such a system of modeling, either in value or color, and throwing the outer border of a volume that has been modulated to a dark, cool color against a neighboring volume so that it meets at its light, warm side, renders unnecessary the superimposing of a line at that point. (See Plate I, Diagram VIII.) The system, as it pertains to black-and-white modeling, came into use with chiaroscuro; it is still the favorite device of objective, realistic painters. Cézanne sounds like some kind of academician himself when he states, to the befuddlement of both critics and artists, "Pure drawing is an abstraction."[14]

Perhaps we owe all this confusion in some measure also to Emile Bernard, who, besides publishing many of the paradoxical statements of Cézanne, was able to add to them nothing but his own intellectual confusion and, with that, his abysmal misinterpretation of Cézanne's paintings. It was Bernard who said, "As for style and drawing, Cézanne intended to make them develop out of the color itself."[15] Obviously, pure line is an abstraction, to which it is not necessary to resort when a contrast in color or value makes

two planes clearly distinct and separate. It is true, of course, that there are large numbers of paintings by Cézanne, particularly landscapes with foliage, in which color contrasts and value contrasts obviate the need for more than occasional lines. Besides, no artist has ever exploited the device of "lost and found" edges to a greater degree than he did. Hence there is little wonder that both writers and artists have come to the conclusion that Cézanne, in some mysterious manner unknown to earlier masters, "drew with color and avoided the line." Presumably, the idea is that the space moves back and forth solely by force of the color modulations. Meier-Graefe said, "Cézanne removed all linear contours," and "positively constructed the whole picture with tones."[16]

Following is a confused statement that might be used to fortify the denial of line and overemphasize the tonal qualities, the modeling. This letter, part of which is almost incomprehensible, was addressed to Bernard in 1904: "This is absolutely indisputable—I am very positive: an optical sensation is produced in our visual organ which causes us to classify the planes represented by color modulations into light, half-tone, or quarter-tone. (Light then does not exist for the painter.) Inevitably, while you proceed from black to white, the first of these abstractions being like something to lean on, for the eye as much as for the brain, we flounder, we do not succeed in mastering ourselves, in ruling over ourselves."[17]

Cézanne was indeed floundering here, even as he occasionally did in his painting, when the sensations or nuances of color and value distracted him from the perfect union of drawing and color that characterizes his best work. There is no question here of minimizing the *relative* importance of modeling and color modulations in Cézanne's work. The question is whether the volume and space depend *entirely* on modeling, or whether the volume and space are based structurally on line drawing to which modulations have been added. The means I have chosen for arguing this problem are the diagrams that accompany the illustrations. If the diagrams have any value at all, they will surely make it evident that *the fundamental spatial relations remain clear when all modeling is eliminated and when the basic planes are established only with outlines.*

When this fact is understood, the modulations are seen simply as an aid to the effect of three-dimensionality, a

[10] See Glossary, Diagrams II (p. 17) and III (p. 18).
[11] Rewald, *Cézanne*, p. 403. [12] Bernard, *op. cit.*, p. 37.
[13] Rewald, *op. cit.*, p. 400. [14] *Ibid.*, p. 399.
[15] Bernard, *op. cit.*, p. 149.
[16] Julius A. Meier-Graefe, *Cézanne*, tr. J. Holroyd-Reese, Ernest Benn, London; Scribner's, New York, 1927, p. 55.
[17] Bernard, *op. cit.*, p. 74.

counterpoint of stepped-back, overlapping planes; they are a superstructure of gorgeous color that depends, absolutely, upon firmness at the contours. Whether the contour is made firm, though not necessarily sharp, with an arbitrary superimposed line, or whether it simply developes out of a contrast in color or value, the essence of line and drawing in the traditional sense is still there. It was the very complexity of the surface modulations in Cézanne's painting that dictated the need for a more arbitrary line than was used by Renaissance painters!

Pictures that would come under the category of the foregoing description are illustrated in Plates X, XII, XIX, XXII (Versions I and II), XXV, XXX, XXXI. These are examples of work in which Cézanne has achieved the highest synthesis of all the elements of form; the basic linear structure is more obvious, in spite of complex surface variations, than in the paintings of Renaissance masters. There are other pictures, however, late works, in which the form becomes spotty because of overemphasis on color planes or modulations. Illustrations (Plates XXVI and XXXIV, below, and Nos. 785 to 804 in the Venturi catalogue) indicate a tendency toward overcomplexity that produces a strong patchwork effect. In these late works Cézanne is beginning to achieve a greater freedom that presages the abstract art, so forcefully adopted by American and international painters between 1945 and the present (1962). Cézanne began to make his color planes larger, and he distributed them in a more arbitrary abstract way. Definite objects and forms lose their identity to some extent as the color planes acquire a more independent structure.

With a realization of Cézanne's growing tendency to shift color planes over the surface and to create space effects without even overlapping, it is easy to see why earlier writers like Fritz Novotny should have come to the familiar conclusions about the importance of the "individual patches of color." Novotny believes that they are the "real supports of the pictorial structure in Cézanne's painting," more so even than the "composition and outline drawing."[18] Other writers have made the same emphasis,[19] but Cézanne himself has left no statements to clarify his increasing use of flat planes of color.

CÉZANNE'S DISLIKE OF FLAT AREAS. Cézanne had
a violent prejudice against flat painting of every kind. When Emile Bernard told Cézanne that Gauguin was one of his great admirers, Cézanne replied in a fury: "Well, he hasn't understood me; I have never wanted and I shall never accept the absence of modeling or of gradations; it's nonsense. Gauguin isn't a painter, he has only made Chinese im-

Entrance to Cézanne's studio on the Chemin des Lauves, now named Avenue Paul Cézanne.

ages."[20] This outburst did not merely express resentment that Gauguin should have "stolen his little sensation and paraded it before the public." Cézanne expressed contempt for all painting that was not rounded or modulated. According to Gasquet, he considered Cimabue clumsy, Fra Angelico naïve. "There's no flesh on those ideas; I am a sen-

[18] *Cézanne* [paintings and drawings selected by Fritz Novotny and Ludwig Goldscheider], Phaidon Press, Vienna; Oxford Univ. Press, New York, 1937, p. 12.

[19] Aside from Meier-Graefe, Bernard, and others who concur with Novotny, there are Tristan L. Klingsor, *Cézanne*, published by John Lane, London, and K. V. Tolnai, "Zu Cézannes geschichtlicher Stellung," *Deutsche Vierteljahrsschrift für Literaturwissenschaft und Geistgeschichte*, Jahrgang XI, Heft 1.

In contrast to the foregoing examples, attention should be directed to the work of Dr. Albert C. Barnes, *The Art of Cézanne*, Harcourt, Brace, New York, 1939, in which sound, intelligent statements about Cézanne's use of line are to be found. For example (p. 29): "Line is indeed so vitally essential to the fabric of the picture that sometimes it is introduced without any warrant in representative necessity." The excellent essay by Roger Fry, cited in note 8 to the Introduction, also reveals a clear understanding of the obviousness of Cézanne's linear content. [20] Bernard, *op. cit.*, p. 37.

sualist,"[21] he would say. It seems perfectly justifiable to assume that Cézanne's reaction to early Christian art, and to Oriental pictures, was very much like the traditional, conventional interpretation: namely, that such painting is entirely lacking in deep space. If one accepts this view, it seems justifiable to believe that Cézanne's own painting depends, in a structural way, upon the color modulations on the surface in order to achieve a feeling for space and depth. The factor of the large planes overlapping, manipulated and rotated in and out of the depth, thereby assumes less importance. The interpretation expressed graphically in the diagrams that follow is quite different; *this explanation considers these larger planes, created with outlines or contrasts, to be the essence of the spatial structure.*

Cézanne was so impressed with the modeling and sensuous color of the great Venetians that he made statements indicating his concurrence with the now old-fashioned conviction that with lines and flat color shapes alone no sensation of three-dimensional depth and movement can be created. With the same outworn, uncontemporary approach the late Abstract art of Picasso, Braque, and others is often rejected today because of its so-called lack of space and depth. But there is an ever-growing appreciation and understanding of the sensational space effects in such Abstract art. And it is only with this contemporary, revised conception of space that Cézanne can be understood in relation either to typical Impressionism or to later Abstraction.

The essential difference between Impressionist form and Cézanne's form could never be explained in words as forcefully as it is demonstrated by the comparison of paintings by Cézanne and Renoir from the same motif, the mountain called the Sainte Victoire (Plate XXIII). The glaring difference apparent there is not merely that Cézanne's painting is firm in its contours where Renoir's is soft, but that Cézanne actually *superimposes* definite lines at the contours, notably in the distant mountain. Renoir's mountain fades away in typical Impressionistic, aerial perspective; Cézanne's is stepped back with overlapping planes, so that, through these more constructive plastic means, its location in deep space is absolutely clear. And, being firmly outlined and expanded in size, it takes its place again with the foreground, and maintains, also, its relation to the picture plane. (See Plate XXIII, Diagram I.)

Renoir is a great artist in his more mature work; his contours are very firm and definite when compared with those of painters who are likely to be considered as typical Impressionists. Nevertheless, when Renoir's painting of the Sainte Victoire is compared with Cézanne's, it seems soft and realistic rather than formally composed.

It must have been the frequent appearance in Cézanne's pictures of lines boldly superimposed over patches of color that gave Dufy his point of departure for a systematic method of painting. Dufy uses color in large decorative areas; the form and space depend, almost entirely, upon superimposed lines. Picasso, in some of his masterpieces of the period from 1925 to 1927, and Braque in somewhat comparable works, have shown astonishing knowledge and control of space effects that do not depend on modulations or chiaroscuro. They, and certain other important painters, have grasped the fundamental greatness of Cézanne and yet have not followed him imitatively. They have understood that his greatness lay in his drawing, his structure, his control of space. They have asserted with daring power that the basic instruments for the creation of space are *line* and *plane*.

Ironically, it turns out that Cézanne's work has revived for present-day art a flatness and austerity that he might have deplored. Likewise, a new estimate of the extraordinary space drawing in early Christian and Byzantine art has in large part arisen as a result of the emphasis on the unusual space factors in Cézanne's drawing.

THE FUNCTION OF LINE AND MODULATING. In John Rewald's book, in a chapter entitled "Théories artistiques de Cézanne," the author quotes from Balzac's novel, *Le Chef-d'œuvre inconnu,* a passage in which, as he says, the hero, Frenhofer, expounds a theory of drawing that is surprisingly close to the meaning of the quotations I have cited from Cézanne. It is well established that Cézanne felt a deep emotional identification with Frenhofer. It is my opinion that Cézanne's contradictory opinions in some measure owe their origin to this identification.

Frenhofer explains: "I have not dryly traced out the outer contours of my figure and made every little anatomical detail stand out, because the human body doesn't end in lines. . . . Strictly speaking, drawing does not exist . . . line is the means by which man gets a clear idea about the effect of light on objects; but there is no line in nature, there everything is full: it is in modeling that one draws, that is to say that one detaches things from their surroundings, the distribution of light alone is what gives the true semblance of things! . . . Perhaps one should not draw a single feature; it might be better to approach a figure at the center, beginning first at the protuberances nearest the light, passing on to the more shaded parts. Doesn't the sun

[21] Joachim Gasquet, *Paul Cézanne,* Editions Bernheim-Jeune, Paris, 1926, p. 163.

Interior of Cézanne's studio, showing draperies, table, skull, and bottles often used in his still lifes. The small statue by Puget was a favorite of Cézanne's. Prints by Delacroix, Mantegna, and Poussin are on the wall.

proceed in this way, that devine painter of the universe?"[22]

Regardless of the many statements Cézanne has made that are similar to the theories expounded by Balzac's character, his actual procedure in painting was quite different. For example, instead of beginning at the highlights of the forms, Cézanne began with the dark at the outer contours. He modulated gradually toward the light, painting with chromatic gradations. We know this because, in a typical unfinished painting, the protruding part of the volumes is often entirely unpainted (Plate XXXVIII). Almost all the water colors tell the same story. (For further discussion of the procedure, see page 25 under "Color Modulation.") These facts, which can be discerned only by carefully analyzing his pictures, seem to be contradicted by Cézanne's words in a letter to Emile Bernard, words that recall the ideas of Frenhofer: "In an orange, an apple, a ball, a head, there is a culminating point; and this point is always —in spite of the terrible effect: light, shade, sensations of color—the nearest to our eye. The edges of objects recede toward a center placed at our horizon."[23]

I have chosen to translate quite faithfully and literally, finding no justification for changing a confused French into a more logical English. In fact, it is the confusion in the meaning, the lack of pertinence to important elements of

Cézanne's own form, and the obvious recollection of Frenhofer's ideas, that lend interest to this quotation. We may surmise, then, as a possible explanation, that it was Cézanne's wish to be, and to think, like the great hero-painter Frenhofer. If this conjecture is true, it may well be what compelled him, so often, to speak in contradiction to the methods he actually employed.

Rewald goes on to explain that "Cézanne, like Frenhofer, and like all the Impressionists besides, denied the existence of line in nature. 'Pure drawing is an abstraction.'"[24] Mr. Rewald is obviously correct in his reference to the Impressionists' denial of line. As for line in nature, I trust it was no discovery of the Impressionists to find that there is none—that line, indeed, is an abstract element. But Cézanne, far from following the Impressionists on this point, introduced line, superimposed it upon his color system, which was an outgrowth of the broken-color theory of the Impressionists. Proof that he did so should be clear enough in the comparison of the Renoir version of the mountain with Cézanne's (Plate XXIII). One of the aims of the present study is to change the general thinking about

[22] Rewald, *op. cit.*, p. 399.
[23] Bernard, *op. cit.*, p. 73.
[24] Rewald, *op. cit.*, p. 399. See also Richter's *Literary Works of Leonardo da Vinci*, Vol. I, p. 129, no. 49, in which Leonardo proscribes the use of outlines.

the *relative* importance of line and color-plane modulations. It is not only that Cézanne himself was confused about the means he had employed; the general understanding is still close to Cézanne's. It is based, broadly, on the belief that line is a purely decorative element of form, that it is impossible to create depth and space with outlined planes alone. But it would be equally an exaggeration to deny that the system of modulating in planes of color, from cool to warm, had a space- or form-building function. The systematic breaking up of color into a series of planes that tend to follow the forms in their roundness was far more structural than the juxtaposition of multicolored spots that created atmosphere and light.

Even the Impressionists depended strongly on the protruding character of warm colors and the receding character of cool ones, to give a certain substance and structure. The fact that Cézanne's little color planes were not blended, but remained separate, like steps, added significantly to the space factor in warm-to-cool modulating. The shimmering surface quality, the opulent and luminous effect of Cézanne's colored surfaces, is one of the most original achievements in the history of painting. The sensuous delight in following these surface manipulations is so intense that the underlying framework is taken for granted. In some of the pictures the lines are so loosely and freely brushed, and so perfectly integrated with the total color fabric, that their structural importance is overlooked. Certain statements of Cézanne's express this integration of color and line quite logically. It will simplify the problem when statements like the following to Emile Bernard are remembered, and others forgotten: "Drawing and color are not separate, everything in nature being colored. *During the process of painting, one draws;* the more the color harmonizes the more the drawing becomes precise. When the color has attained richness, the form has reached its plenitude." [25]

Here, in contrast to preceding quotations, Cézanne is not denying the importance of drawing. Definition at the contours develops simultaneously with the filling in of the color areas. When the color runs over the border of a plane, making the drawing indistinct, a new line is superimposed. As the color becomes more intense, or more rich and translucent, the contours may need to be altered, from layer to layer. It is a unique method of developing line and color simultaneously, quite different from earlier methods such as grisaille, for example, or underpainting with white on a dark ground. In the latter procedures, drawing and value modeling (chiaroscuro) were completed before the color was laid on in glazes and thin layers. *Cézanne's system was a decidedly new approach to the use of*

both line and color; it was the denial of neither. It was perhaps the most profound synthesis of these rudimentary plastic elements that had been seen since the days of Titian and the other Venetian colorists.

DRAWING AND ORGANIZATION. There are other statements of Cézanne's that have a significant bearing on the deeper characteristics of his work; but nowhere in any of his letters, as I have already said, can one find anything but vague suggestions that he worked out his intellectual theories to fit the interpretation that will be given here in the diagrams. In my opinion, his best statement about drawing was made in a letter to the painter Charles Camoin, in December, 1904: "...what you must strive to attain is a good method of *construction*. Drawing is merely the configuration (or outline) of what you see." [26] In this statement we can see that drawing is understood as the means of locating and arranging the elements of a motif. Drawing is the structural organization of the space-volume relations in a picture.

There are other vague but suggestive ideas in the famous cylinder-and-cone letter to Emile Bernard, dated April 15, 1904, which deserve more attention than the statement about cylinders and cones: "Lines parallel to the horizon give extension [*l'étendue*], whether it be a section of nature or, if you prefer, of the spectacle that the *Pater Omnipotens æterne Deus* spreads before our eyes. The lines perpendicular to this horizon give depth. Now for us, nature is more in depth than in surface." [27]

Verticals and horizontals play a primary role in Cézanne's art, in both the drawing and the composition, but particularly in relation to his extensive use of parallel color planes; it is possible to make diagrams showing how this idea actually works. The quotation should perhaps not be taken literally as a theory of drawing or composition. The important idea here is that Cézanne shows himself well aware of the space function of line. He makes it clear that the organization of the deep space—"nature is more in depth than in surface"—is the central problem. He continues: "Nature is more in depth than in surface, whence the necessity of introducing into our vibrations of light, represented by reds and yellows, a sufficient sum of bluish tones, in order to give a feeling of air."

Again, Cézanne suggests that he thought about the factors of space in a more abstract, a less objective, sense than the theory of color modulations usually implies. The

[25] Bernard, *op. cit.*, p. 37.
[26] Rewald, *Paul Cézanne. Correspondance*, p. 268.
[27] Bernard, *op. cit.*, p. 67.

contemporary idea about the advancing nature of warm colors, "reds and yellows," the receding character of cool colors, *"bleutés,"* is here definitely stated. There is a passage in another letter, to his most admired artist friend, Pissarro, written in 1876, which indicates that he had occasional glimpses of form that did not involve modeling. It might well be used as a verification of the opinion emphasized throughout this essay and in the accompanying diagrams, that modulations are not of paramount importance in Cézanne's structure. It would be wrong to do so, however, and we are justified only in regarding it as an insight which comes to light in the paintings but is more often confused or contradicted in the theories he expressed. This passage in the letter reads: "The sunlight here [Cézanne was then living and painting at L'Estaque] is so terrific that it seems to me objects stand out in silhouette, not only in black and white, but in blue, in red, in brown, in violet. I may be mistaken, *but it seems to me to be the antithesis of modeling.*" [28]

"WHAT HE SAID TO ME." Of all the conversations purporting to be records of Cézanne's own words, that in Joachim Gasquet's chapter, "Le Motif, ce qu'il m'a dit," comes closer to revealing Cézanne as a great composer and draftsman than any other I have read. Unfortunately it is difficult to accept this chapter as the language of Cézanne. The thought and word formations, except where quotations are incorporated, do not seem close enough to those found in the letters. Gasquet wanders off into a prose that is obviously his own; but, whether or not the basic ideas are really Cézanne's, in a general way the approach to pictorial creation is related to the diagrams and analyses in this book.

CÉZANNE. I have my motif (he joins his hands). A motif, you see, is this....

GASQUET. How's that?

CÉZANNE. Eh? Yes—(he repeats his gesture, draws his hands apart, fingers spread out, and brings them together again, slowly, slowly; then joins them, presses them together and contracts them, making them interlace) there you have it; that's what one must attain. If I pass too high or too low, all is ruined. There mustn't be a single link too loose, not a crevice through which may escape the emotion, the light, the truth. I advance, you understand, all of my canvas at one time—together. I bring together in the same spirit, the same faith, all that is scattered. All that we see disperses, vanishes;

is it not so? Nature is always the same, but nothing remains of it, nothing of what comes to our sight. Our art ought to give the shimmer of its duration with the elements, the appearance of all its changes. It ought to make us taste it eternally. What is underneath? Nothing, perhaps. Perhaps everything. You understand? Thus I join these straying hands. I take from left, from right, here, there, everywhere, tones, colors, shades. I fix them, I bring them together. They make lines. They become objects, rocks, trees, without my thinking about it. They take on volume. They acquire value. If these volumes, these values, correspond on my canvas, in my feeling, to the planes and patches of color which are there before our eyes, very good! my canvas joins hands. It does not vacillate. It does not pass too high or too low. It is true; it is full. But if I feel the least distraction, the least weakness, above all if I interpret too much one day, if today I am carried away by a theory which is contrary to that of the day before, if I think while painting, if I intervene, why then everything is gone.[29]

The joining of his ten fingers is a graphic gesture that symbolizes very well the interweaving, the interlocking, of lines and planes that make Cézanne's work so unified and compact. The statement, "I advance all of my canvas at one time," is not a boast; it is a fact, proved to us innumerable times, both in the water colors and in the unfinished oil paintings. No matter where he left off painting, the entire picture area had been considered. If there were merely a few lines, a few color planes on the bare canvas, they usually had a relation to the four sides of the picture and suggested the basic spatial rhythms. More often than not, the painting was a complete unit at every stage of its development.

There are many ideas in this conversation with Cézanne that might be used as a justification for the form and space concepts expressed in the present essay, but only through twisting and implying meanings could the whole fabric of my own interpretation be based upon Cézanne's words. The paintings themselves, and the photographs made from their motifs, offer the only dependable data. Yet I cannot resist interpreting, as a justification for the intellectual searching and probing that has gone into the diagrams which are the core of this study, a statement Cézanne made to Emile Bernard. Cézanne said, "The painter ought to consecrate himself entirely to the study of nature and try to produce *pictures which will be a teaching.*" [30]

[28] Rewald, *Correspondance,* p. 127.
[29] Gasquet, *op. cit.,* p. 130.
[30] Bernard, *op. cit.,* p. 70.

[15]

III. AN ILLUSTRATED GLOSSARY

Part One

THE PICTURE PLANE, or the area upon which the artist draws and paints, is a flat surface having only two dimensions, marked 1 and 2 in the illustration. The two-dimensional character of the picture plane will be taken as the primary law or premise of picture making in the art of Cézanne as well as in that of other masters of classical space.

Words and phrases used to describe the character of the picture plane are: two-dimensionality, flatness, architectural character, mural character, and verticality of the picture plane. Phrases that are used to denote the ultimate relation of all the forces of design and three-dimensionality to the flatness of the picture plane are: plasticity, two-dimensional balance, two-dimensional equilibrium, and architectural balance. In Cézanne's painting there are decorative qualities and other space- and volume-controlling factors that afford the ultimate two-dimensional balance and plastic unity.

THE PICTURE FORMAT is a term that will be used with reference to the shape or proportions of the picture plane (1 x 2 in the diagram, for example). A picture format may be rectangular, square, circular, triangular, and so on. *A well-organized picture must be a self-sufficient and closed unit within a specific frame or format.* The use of the word format in referring to the shape of a picture plane is not widely familiar, but it seems to be the most suggestive term that has come into use and a plea is hereby made for its adoption.

NEGATIVE SPACE is the three-dimensional depth, the volume of air or empty space, within which the solid or *positive* volumes of a picture are organized. In Diagram II the two dimensions of the picture surface, described in Diagram I, are marked 1 and 11. Dotted lines behind this picture plane mark out a plausible three-dimensional "picture box," as if seen from an imaginary position above and to the right of the motif. This "picture box," which may be compared with the stage space of the theater, is the negative deep space used up or "filled" in Cézanne's landscape, the "Jas de Bouffan" (Plate VII). Objects do not seem to protrude in front of the picture plane, and they do not recede into depth beyond controllable limits. Terms such as spatial movement, recession, overlapping of planes, are used to describe the activity that takes place within this deep space. There is no theoretical limit to the amount of depth or distance that can successfully be depicted on the picture plane. Devices of drawing that prevent the funnel effects and holes that develop from the blind acceptance of scientific perspective, the use of color so that it appears to remain flat and related to the

DIAGRAM I
THE PICTURE PLANE AND THE PICTURE FORMAT

DIAGRAM II
NEGATIVE SPACE AND THE "PICTURE BOX"

picture plane, and the avoidance of the falling away that results from a naturalistic use of color (aerial perspective)—these are some of the means used by Cézanne to control three-dimensional space. The significance, for example, of the roadside wall, marked A, which is parallel to the picture plane, is discussed in relation to the motif in nature (see Plate VII, Diagram II). When the realistic deep space of a subject in nature, as illustrated in the diagram, is re-created by the artist and made to function architecturally, plastically, in relation to the picture plane, the space becomes *pictorial space*.

It is then no longer sculpturally imitative or naturalistic space. No greater mistake could be made than to assume that the term negative space implies emptiness in the sense of being inessential. The negative space, as indicated in the diagram of Cézanne's painting, Diagram II, page 17, is reduced to a minimum, so that the sky plane and the foreground plane are comparatively close together when compared with the space in the motif photograph for this painting, Figure 2, page 52. This negative void space between sky and foreground is essential to provide room for the *positive volumes* of houses, trees, and hills. Both negative and positive space must therefore be understood as positive, independent, functioning elements in a picture, perhaps comparable to the positive and negative wires in an electrical direct-current circuit. In a formally organized work of art the size and extent of the negative depth areas are and must be as thoughtfully "drawn" as the more palpable positive shapes. In Analytical Cubism, for example (see Figure 3, p. 103), there is sometimes no distinction at all between positive and negative. The objects cannot always be distinguished from the background or surrounding space; all elements have literally become fused into a unity. The whole picture thus becomes an object itself rather than a representation of things in the outer world.

DIAGRAM III
NEGATIVE SHAPES

Terms used in referring to the negative space are: three-dimensionality, deep space, total space, "picture box," stage space, recession into space, spatial movement, and three-dimensional movement.

THE PLASTIC MEANS or PLASTIC FORM are terms used often in the present study, and are given a connotation different from that made familiar in art criticism and art history in general. The traditional connotation implies sculptural roundness as achieved through light-and-shade modeling and chiaroscuro. In this book the term *sculptural effect* is used when roundness is implied. On the contrary, *plastic unity* here implies that the three dimensions of nature have been transformed so as to unite with the picture plane. Diagram II is intended as a compendium of the plastic field for Cézanne's picture shown in Plate VII. All the diagrams in the Glossary deal with various aspects of the plastic means. The sum of all the diagrams for Plates I and X constitute the analysis of the plastic means that Cézanne has used in creating these paintings. Thus line, plane, volume, color, texture, and so on, are the plastic means used to build and organize the total space on the picture plane. Hence plastic qualities are not only three-dimensional, but two-dimensional as well.

NEGATIVE SHAPES. In the two-dimensional sense, with no regard for three-dimensional depth, the terms negative shape, negative pattern, and negative space are often used. Areas such as those marked N in Diagram III could be cut out of a flat piece of paper. The elements of design and pattern, of variety in sizes and shapes, are usually considered with respect to this purely two-dimensional aspect. The object against a negative background, the *positive* volume of an apple against the negative table top, the positive volumes of trees against the negative sky, are examples of positive and negative areas, patterns, shapes. Diagram IV of Plate X describes positive and negative shapes in this sense. Most discussions of composition are concerned only with such flat design. The more mysterious, purely illusory element of deep space, or three-dimensionality, illustrated in Diagram II, where positive volumes are located in the negative space of the "picture box," is of primary importance in the understanding of Cézanne, and most of the diagrammatic analyses and photographs of Cézanne's motifs in this book are concerned with it. The correlation of two-dimensional factors of design and flat pattern with three-dimensional elements of volume and space, the relation between color and form—these are the purely plastic factors upon which the art of Cézanne was founded. The plastic qualities in Cézanne should not be confused with sculptural solidity. Throughout this study the term sculptural effect is used when the latter quality is described. *Plastic qualities,* as here referred to, *signify the total sum of the elements involved in a formally planned relationship between color and form.*

Part Two

THE PICTURE PLANE. Diagram I shows the vertical and horizontal axes of a picture plane, the original *static* plane which is to be activated by the artist.

STATIC PLANE. Diagram II establishes plane A (with its axis bars) in a position parallel to the picture plane. Being parallel to the picture plane, it is *static*. Plane A is on a ground plane, B, the axis bars of which indicate that the ground plane is a diagonal or dynamic plane. Plane A is here parallel both to the picture plane and to the back wall, plane C.

DYNAMIC PLANE. Diagram III establishes plane A in relation to a ground plane, B, and a back wall plane, C. The diagonal top and base lines of plane A force it to *rotate* away from the wall, plane C, as indicated by the curved arrow extending from the axis bars of plane C. Plane A is therefore a *dynamic* plane in the sense intended throughout the text. Scientific perspective plays no fundamental part in this space effect.

OVERLAPPING PLANES. Diagram IV is a configuration of static planes which, through overlapping, create a definite fixation in space; they move into depth as indicated by the arrows. Thus, dynamic or *three-dimensional movements* can be created with static planes. The diagram should clarify the fact that space, as Cézanne achieved it, was not dependent on the diminishing sizes of scientific perspective. In the diagram there is no convergence, no vanishing point, and the sizes of the planes increase rather than diminish, as they recede into depth. But the location in space is clear and not subject to equivocal interpretation, as many perspectival projections might be.

DIAGRAM I

DIAGRAM II

DIAGRAM III

DIAGRAM IV

DIAGRAM V

DIAGRAM VI

DIAGRAM VII

THE FUNNEL EFFECT AND THE HOLE IN THE PICTURE. Diagram V is a configuration of overlapping planes that recede toward a vanishing point at the horizon. The exaggerated effect of deep space is the result of an uncompensated perspectival convergence and diminishing of sizes. The diagram illustrates what is meant by a funnel effect and a hole in the picture.

This illusion of space cutting into the picture plane results when no provision for a *return out of depth* is made. Cézanne never created this kind of effect, and it is intended here as an illustration of a very disturbing and tasteless kind of three-dimensional arrangement.

While it is true that many great Renaissance masterpieces were constructed with reference to a central vanishing point, it seems fairly safe to say they were never composed with that complete absence of compensation and lack of any means for a "return out of depth" which are illustrated in the diagram. Detailed analysis of Renaissance pictures usually reveals the mastery with which their space was organized, *in spite of,* rather than because of, their use of mechanical perspective. There might be innumerable methods for successfully incorporating the type of funnel effect illustrated here. Cézanne's handling of this specific problem is shown in Plate V.

PLANES OF A VOLUME. Diagram VI simply illustrates how planes A, D, and E form a solid volume when properly combined.

VOLUMES MOVING IN SPACE. Diagram VII is an illustration of sound spatial organization. In Diagrams IV and V the space was created with flat planes; here we see solid volumes clearly located in the deep space of the "picture box." The small arrows indicate the movement from one volume to another, and the large three-dimensional arrows mark out the general circular movement from foreground into deep space. The circular movement starts at the lower left and rises with the rising and receding progression of the volumes in the left center. The upper arrow encircles the distant volume and leads forward into the large arrow returning at the right. This right-hand arrow symbolizes the *return out of depth* which a self-contained spatial organization provides. Thus, volumes are seen to be moving in the negative deep space without the aid of scientific perspective or light and shade. (The diagram is based on the painting shown in Plate XXXVII.)

TWO-DIMENSIONAL MOVEMENT. Diagram VIII shows a complex, or mass, arrived at by surrounding all the planes of Diagram IV with a single outline. By eliminating the overlapping individual planes the obvious effect of three-dimensional movement is lost and a more purely two-dimensional movement following the arc of the double-pointed arrow remains. The outer contours of the mass still *suggest* the original movement seen in Diagram IV, entirely through *shifting*. Cézanne's color planes, in his latest work, tended more and more to suggest depth through shifting even while maintaining their identity with the flat picture plane.[1]

DIAGRAM VIII

TWO- AND THREE-DIMENSIONAL MOVEMENT COMBINED. Diagram IX contains two distinct types of movement. The planes which overlap from 1 to 5 establish a definite recession into space—a *three-dimensional movement*. But the large irregular plane sandwiched between 1 and 5 moves up and down from A to A without losing its parallelism to the picture plane. The movement from A to A is therefore called a *two-dimensional movement*. Many great Renaissance pictures, particularly the reclining nudes of Giorgione and Titian, are organized on the principle described here.

DIAGRAM IX

RISING AND FALLING MOVEMENTS. Diagram X exemplifies another aspect of two-dimensional movement. The three rectangular planes are perfectly parallel to the picture plane and do not overlap one another. But they are unified within the picture format, and as the eye traces their height, going up, down, and up, a rising and falling action takes place. (This type of movement is the antithesis of the isocephaly found in Byzantine and Assyrian art. Isocephaly is a form in which the heads of all the figures in a composition, whether seated or standing, are established on a common level.) The rising and falling movement effect is related to the concept of shifting and goes far beyond mere two-dimensional design and arrangement.

DIAGRAM X

LINEAR RHYTHM OR MOVEMENT. Diagram XI presents a serpentine line that may be called a two-dimensional movement, even without the directional emphasis afforded by the arrow point. Most of Cézanne's paintings are full of such linear rhythms, but it is rare to find them working in a purely two-dimensional way as the single line does in this diagram. (Movements remain two-dimensional as long as they remain parallel to the picture plane throughout their course.) It is this aspect of line, sometimes referred to as "beauty of line," that has apparently become instilled in the minds of those who are unaware of the space-building function of line. (See also Plate I, Diagram VII.)

[1] The great contemporary painter and teacher Hans Hofmann must be given full credit for emphasizing and practicing the concept of *space through shifting*.

DIAGRAM XI

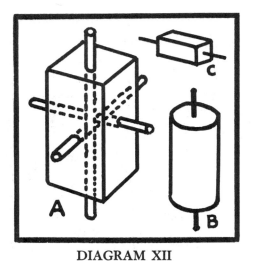

AXES OF VOLUMES. Diagram XII illustrates the long central axes of the three volumes A, B, and C. But in volume A the two short lateral axes are also indicated. It is impossible to understand the idea of tensions between volumes (see Diagram XV) without having a clear conception of volume axes.

DIAGRAM XII

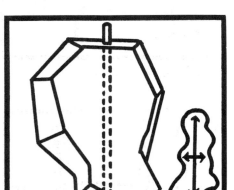

AXES OF IRREGULAR VOLUMES AND PLANES. Diagram XIII illustrates the approximate main axis of an irregular volume, A. On the right, the axes of an irregular plane are illustrated. Tensions and relationships between volumes and planes in general can only be understood when axes are understood.

DIAGRAM XIII

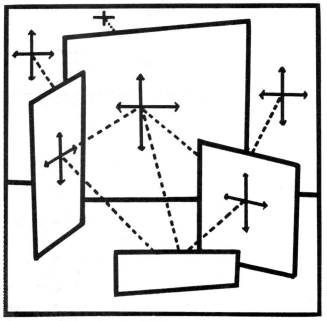

TENSION BETWEEN PLANES. Diagram XIV is a combination of static and dynamic planes organized within the frame of the picture format. The heavy dotted lines extending from plane to plane indicate the amount of space, the pull or tension, between the various surfaces. When a combination of forces in space becomes unified within the borders of the picture format, and unified in relation to the picture plane, the result is a composition that achieves the quality of *tension* or vitality. *The final tension is therefore a combination of various tensions.* Any vital work of art is an organization or composition of pictorial or plastic elements; it necessarily has tension.

DIAGRAM XIV

TENSION BETWEEN VOLUMES. Diagram XV is an elaboration of Diagram XIV in terms of solid volumes. The three-dimensional space of the "picture box" should become clearer when solid volumes, rather than mere planes, are established on a ground plane. Tensions between surface planes of volumes are symbolized with dotted lines as in the previous diagram.

In the center, a cylinder is surrounded by arrows in order to symbolize the classical concept of *volumes circulating in space around an imaginary axis.*

POSITIVE VOLUMES AND NEGATIVE SPACE. Diagram XV also illustrates the concept of *positive volumes* moving in *negative deep space.* The dotted tension lines indicate the amount of negative space that exists between the positive volumes. This negative space should be understood as a concrete and essential part of the structure. Emptiness or lack of structural necessity are certainly not implied.

DIAGRAM XV

TENSION BETWEEN AXES. Diagram XVI illustrates the increased feeling of tension that develops in a relationship between axes when they are tilted away from the self-balancing vertical or static position. As long as the unity can be maintained, the tension or magnetism will seem to increase because of the tipping or falling action of the axes. (See Plate XI, Diagram VI.)

DIAGRAM XVI

TENSION WITHIN THE OBJECT. Diagram XVII indicates how tension exists within a single object or plane. The purpose of distorting natural shapes is hereby illustrated as a means of increasing the feeling of vitality or tension.

DIAGRAM XVII

DIAGRAM XVIII

LIGHT AND DARK PATTERNS (CLOSED). Diagram XVIII is a combination of light and dark patterns all of which remain *closed within their separate compartments*. Cézanne's still lifes may often be described as closed or *compartmental* in their color shapes; but more often, and particularly in his landscapes, his color and light-dark patterns tend to be *open*.

DIAGRAM XIX

OPEN-COLOR PATTERN. Diagram XIX is an illustration of open patterns of light and dark. In painting, the system is called open color. When the patterns of light and dark (or color) are arbitrary and not confined to definite forms, it is necessary to superimpose a line drawing in order to establish volume and space. Cézanne's painting abounds in examples of free and open color with superimposed line, but his followers, notably Dufy, have made a definite method or system out of the idea. It is, of course, Cézanne's color planes that tended more and more to become open and to move freely throughout the space. These open planes became such an abstract structure that recognizable forms would have disappeared in his latest paintings except for the superimposed lines that described the larger forms of trees and mountains.

IV. HOW CÉZANNE ORGANIZED A PICTURE

LINE DRAWING. An outline of the characteristic elements of Cézanne's form, his approach to the actual painting of a picture, will serve as an introduction to the diagrams and photographs of motifs. First of all, he started to work on a bare canvas with pencil or charcoal. Regardless of how briefly he sketched in the main contours, he was *using line to establish the planes* which filled the space. Almost every water color, every unfinished oil painting, makes this procedure unmistakable. See Plates II, III, XXII, XXIV, XXXIII, XXXVIII. (Only his mature work is under consideration here.)

The next step was to retrace and verify these drawn lines with a bluish gray color, thinly applied. The line, although somewhat segmented, was line drawing in a clear sense of the word (there was no avoidance of line or starting with mere spots of color). For an illustration of this step, see Plate XXXI. A careful examination of his work makes this procedure apparent, even without reference to the report of M. Louis Le Bail, who had watched Cézanne while painting: "He drew with a brush dipped in ultramarine diluted with essence of turpentine, putting things in place with a fury, without hesitation."[1] This description need not be regarded as contradictory to Cézanne's widely understood habit of long contemplation and hesitation before applying the brush. The hesitation came at intervals. When he did put brush to canvas, he worked with intensity and vigor.

COLOR MODULATION. Once the colored outline had established the space relationships with adequate firmness, the process of distributing the small planes of color began. A careful examination of the unfinished paintings confirms the observation of Emile Bernard that he began with the dark side, at the outer contours of the volumes, using at first only cool neutral colors.[2] He distributed these cool planes, usually rather small patches, throughout the picture, without stopping to finish any single part or object in its entirety. Plates II, III, XXXVI, XXXVIII, are illustrations of paintings left at an early stage; they prove that Cézanne did, as he said, "advance all of my canvas at one time."[3] To the casual observer, these areas or patches of color occasionally appear to have been distributed in a purely abstract way, like the decorative flat color patterns of Dufy. But it would be a complete denial of the slight but definite form-building or three-dimensional function of the color changes to say this is so of the Cézanne method. The intention and purpose of the color modulations may be outlined as follows:

1. To make out of the broken-color theory of the Impressionists "something solid and durable, like the art of the museums,"[4] Cézanne invented the system of modulating a volume from its cool, dark side to its light, warm parts in chromatic nuances—that is, a series of steps or planes. The volumes attain by means of these tiny, overlapping color planes a solidity different from that attained through mere dark-to-light modeling; it is a solidity based on the protruding character of warm color and the receding tendency of cool. The modulations exploited the full range of the chromatic color scales to a degree never before seen in painting.

2. As these individual color planes overlap, sometimes as warm over cool, they are working three-dimensionally. (See Diagram III, Plate XIII, showing color modulations as definitely overlapping planes.)

3. At the same time, since each plane tends to be separate, unblended, and flat, and usually parallel to the picture plane, *the color throughout maintains an essentially two-dimensional character.*

4. At this point it is necessary to repeat what has been discussed at some length in the Introduction, namely, that my own interpretation of the relative function of the color modulations in Cézanne is at variance with that of many writers and critics. The three points covered thus far should make it clear that I am giving full and adequate importance to the structural power of the color modulations. I regard the slight form and space effects of the color planes to be *a counterpoint of movements and thrusts, definitely subservient and subsidiary to the larger structural planes,* which are usually made clear with definitely superimposed outlines, but also with sharp contrasts as the contours. Although the looseness, the chunky and broken character of Cézanne's typical surfaces and lines, was so exceptional in the history of painting, it yet remains apparent that Cézanne's structure retains a connection with the Renaissance. (Even the color modulations are mentioned under a later section, "Color," as being comparable to devices of early tempera painters and Rubens.)

[1] Rewald, *Cézanne. Sa Vie . . .* , p. 409.
[2] *Ibid.*, p. 404.
[3] Gasquet, *Cézanne*, p. 130. [4] Rewald, *op. cit.*, p. 283.

5. Another interpretation of the color changes that bears relation to the translucent surfaces found in the great Renaissance masters like Giorgione and Titian should be carefully considered. We know that these earlier masters started a picture with a systematic underpainting, usually modeling the forms in white over a dark *imprimatura*. (An egg-tempera white was used, according to Doerner; but some contemporary experts believe it was just oil and lead white.) When the underpainting or heightening with white was completed, the colors were laid on rather transparently, the crimsons and azurite blues being of a consistency that permitted glazing only. One color laid over another, in glazes and scumbles, developed a physical transparency and translucent depth which has been the envy and admiration of succeeding generations of painters. Cézanne arrived at an aesthetic effect of transparency and depth through radically different means—the color nuances or modulations already discussed. The subtle variations of color were laid side by side in planes, without blending, instead of being glazed or scumbled one over the other. Seurat used meticulous spots to arrive at a comparable effect. Seen as a system for rivaling the surface qualities of Venetian painting, the color changes are simply serving the purpose of making the surfaces rich and opulent, luminous and translucent in color.

One of the most disappointing and unsatisfying characteristics of later Abstract painting is that the large flat areas are austere and meager, offering neither the transparency of Renaissance painting nor the surface variations of Seurat or Cézanne. Braque, with an apparent wish to compensate for the barren, nonsensuous effect of large flat areas, has for a number of years been developing a system of underpainting in thick, crusty white, and then glazing over it with color in washes that sometimes seem excessively thin. This modern adaptation of an early method is an interesting revival, but it might be added that solid layers of thick paint are likely, if not certain, to crack eventually, when painted on canvas, while the excessively thin glazes will not be durable either.

THE LINE REMAINS FIRM. During the process of building up the color relations, Cézanne was constantly reëstablishing the contours. "The more the color harmonizes, the more the drawing becomes precise"[5]—not automatically, but by superimposing a firm line around those parts of a volume which might become weak through overpainting. We know that Cézanne repainted for months on end; the Vollard portrait, for example, required one hundred and fifteen sittings. Each new layer was attacked like the first fresh washes on a new painting; hence it was inevitable that the edges should occasionally become ragged and soft. But "as one paints, one draws";[6] so Cézanne would go over these contours, making them firm again with a new line. (See Plate XXII, Version II, and Plates XXVI and XXX for examples of line superimposed over open patches of color. Similar examples must have suggested to Dufy his systematic method of creating form with lines drawn over the flat color areas.)

LOST AND FOUND EDGES. Cézanne rarely drew a completely continuous line around his planes. At certain points the line would be lost, allowing the volume to fuse, to "pass" into the negative or background. These "passages" from light to dark, with contrasts of "lost and found" contours, were so much employed and developed by Cézanne that one tends to give him credit for inventing the system. Actually, it was a familiar device for many of the typical Renaissance masters. It is these characteristics of his form that, more than any other factor, have created the confusion over his dependence on line drawing in the traditional sense of the term. At those parts of the contour of the volume where the value merges, or "passes," into the value of the background, there is of course no line; the form is open at that point. It is in the water colors and unfinished oils that this most obvious of Cézanne's idiosyncrasies is carried to an extreme. Sharp contrasts and lines clarify the opposing planes and shapes, giving three-dimensionality; fused or lost edges create a merging of foreground with deep space, adding an element of two-dimensionality. We observe here one of the more obvious methods of combining three-dimensional with two-dimensional effects. André Lhote seems to give a primary significance to this factor of "passages," in Cézanne as well as in other masters, and he devotes detailed diagrams and verbal explanations to it in his book, *Traité du paysage*.[7] Plate I, Diagram VIII, and Plate XI, Diagram V, illustrate this factor. In general, the followers of Cézanne who have made it the key to their approach to form have developed the softness and lack of linear content previously referred to.

LOOSE, PARALLEL LINES. One of the most unusual phenomena to be observed in Cézanne's line is a loose parallelism or repetition of lines at a contour that could have been established with a single line. Plate XXII, Version

[5] Bernard, *Souvenirs sur Paul Cézanne*, p. 37.
[6] *Ibid.*
[7] P. 34.

II, and Plate XXX are fair examples. (See also Venturi catalogue, Nos. 718, 719, 721, 722, 1027, 1102, 1144.) There has been no little speculation over the significance of these apparently superfluous lines, and Roger Fry has stated that possibly Cézanne wished to "suggest that at this point there is a sequence of more and more foreshortened planes."[8] I feel certain that Cézanne had no such clear intention. These numerous outlines developed spontaneously, out of the nervousness and freedom of his touch. After all, we can observe the same characteristic in the pencil sketches of Leonardo and many other painters of the past. His eye never stopped to delineate one thing at a time. If his hand were performing one operation, his eye was already looking for the next step to take, working over the entire canvas at the same time. These outlines, while occasionally too prominent, are usually of a piece with the fabric, with the texture of the entire surface. They create a vibration that may properly be described as a subjective space effect since occasionally a sequence of lines actually becomes a definite series of overlapping planes. The two-dimensional function is also important, however; these firm lines stay on the picture plane, preventing the foreshortened planes from digging into space without counterbalance and return. So many of our American imitators of Cézanne, afraid of a bold line, allow the contour to soften, creating the realistic effect of deep space, but in a sculptural way, and thus destroying the architectural balance that Cézanne habitually preserved.

The important thing to remember about Cézanne's line is that, throughout the process of painting and repainting, the line was constantly being reinforced, redrawn. In his work there is no particular difference in approach between a loosely brushed and a highly developed or "realized" painting. Some of the most successful pictures show strongly superimposed lines, while others, equally successful, depend simply on clarity and firmness at the contours. In either case we say the line is firm.

PLANES. The control of planes is the essence of Cézanne's achievement. I am not so much impressed with the tiny planes that are kept distinct and unblended in the familiar chromatic passages or color modulations. It is the organization of the important underlying planes—their rotation from static to dynamic positions, the tensions, the space intervals between them, their movement into depth and their inevitable return to the picture plane—that is primarily important; it is with the plane manipulations that many of the photographic comparisons and diagrams are concerned. If Cézanne maintains a high place in the history of painting, it may well be because of his mastery over these basic structural planes and their synthesis with his rich and functional color. (See, among others, Plate I, Diagrams I and II, Plate II, Diagram II, Plate VII, Diagram II, and Plate XXXVII, Diagram I, for detailed analyses of basic planes.)

VOLUMES. With lines the artist creates planes; with planes he creates volumes.[9] If there is one point of complete agreement among artists and critics, it pertains to the effect of volume. Everyone agrees that Cézanne achieved it. But thus far there has never been an adequate discussion of the fact that Cézanne's is not merely a realistic, objective construction of volume, without compensations. The accompanying photographs of motifs reveal how much he sometimes flattened out the volumes in order to achieve integration and balance on the picture plane. The control of the negative space, the tension between the volumes, was a consideration equal in importance to the creation of solidity in the volumes themselves. Color modulations, the chromatic passages from cool to warm, so far as they help to develop the effect of solidity in the volumes, have already been discussed (pp. 25—26 above). Diagrams of volume structure appear in Plate XII, Diagram I, and Plate I, Diagram III.

COLOR. Cézanne's importance cannot rest on his color alone, for he did not establish the form and space relations solely with color. He did not draw with color, except in the literal sense that using colored outlines was drawing with color. The fact that color modulations obviated a need for strong chiaroscuro in creating the illusion of full, rounded volume cannot be considered as a substitute for drawing. *The space relations always depend upon definition at the contours.*

Cézanne took from the Impressionists the theory that light is composed of the prismatic colors. This theory brought in a higher-keyed palette and a world of new experimental possibilities. The creation of light with pure color means something quite different from the imitation of light and shade, or the chiaroscuro system of the Renaissance. Nevertheless, many of the painters associated with Impressionism seem to have remained in a blind alley, imitating naturalistic effects of light too literally. In a sense, a painter like Monet appears to be the last to make a final grand effort to rival the camera. Following the sun around the haystacks, painting only for a short

[8] *Cézanne*, p. 50. [9] See Glossary, Diagram VI (p. 20).

time each day on a canvas, taking up a different canvas when the sun changed its position, was a rather mechanical procedure. It did produce a realistic effect of light that no camera could equal. As Cézanne said, "Monet is only an eye, but, good Lord, what an eye!"[10]

Being a mere eye would not do for Cézanne. He had too much the mentality of a Giotto. His creative impulse could only find release in a disciplined, organized kind of form. Without rejecting the broken-color theory of the Impressionists, he disciplined it, as did Seurat, but in a different way. Cézanne introduced a system of color modulations (which has been discussed in a preceding section of this study), and it seems safe enough to credit him with inventing it—though we should not forget that early Italian painters also modeled volumes with changing colors. A typical early procedure was to cover the entire working surface with a green earth color and then to start coloring the light areas in a head with pinkish flesh tints, graduating, or blending with hatched strokes, toward the outer contours, allowing some of the *imprimatura* color, the complementary of the pink, to show through. It was not unusual for Rubens to change both color and value in modeling a volume from light into dark. In fourth- to tenth-century Byzantine mosaics very little light-to-dark modeling was used, but compensation for the flatness was achieved by a consistent modeling in warm-to-cool variations of the colored tesserae.[11] Nevertheless, Cézanne's method differs so much, in appearance, from anything preceding it that he may well be considered its originator.

The color modulations are but an incidental ingredient in the total color organization, which was an abstract order transcending reality. But his color, as well as his form, always comes out of nature. He expresses the character of the locale to so remarkable a degree that one is tempted to think of him as belonging to a higher order of Impressionists. To one who knows the country around Aix-en-Provence, Cézanne's color expresses the very essence of that sun-baked land. In fact, Cézanne's landscapes are, in my estimation, among the first ever produced that recreate and express nature in its true atmosphere. They truly express nature with a classical form and structure, comparably to the masterpieces of Giotto.

Yet it is not local color in the usual meaning of the phrase that distinguishes Cézanne's work, for he did not hestitate to change colors arbitrarily if the total organization required it. For example, refer to the mountain at the extreme right of the painting pictured in Plate XVI. The usual pale violet color of the mountain has been changed to an orange color that relates to the large house at left center. Between these two orange shapes a tension[12] is created that prevents the mountain from falling out, from separating from all the color areas in the picture. Although so extreme a reversal of the local color is unusual in Cézanne, it expresses his approach to the problem of color organization in general. The color, when well organized, forms a closed unit. If two areas of red in one corner of a picture are the true local color of certain objects, similar hues of red must be introduced in other parts of the picture whether other objects in the motif are red or not. There should be a complete balance and tension between the red shapes. Any other problem of color organization, Cézanne solved as an abstract necessity.

In general Cézanne intended to follow the Impressionists in the theory that warm colors advance while cool colors recede. "Nature is more in depth than in surface, whence the necessity of introducing into our vibrations of light, *represented by reds and yellows*, a sufficient sum of bluish tones, in order to give a feeling of air."[13] He understood that warm color would usually advance when thrown against a bluish background. He did not use this knowledge, as the Impressionists did, to achieve aerial perspective. He knew that distant hills and mountains must be held on the picture plane, in relation to foreground color shapes. He knew that sometimes an increase in the intensity of a bluish color in the background would suffice, and that often, in order to maintain balance, it was necessary to introduce warmer colors so that the background would hold its place with the foreground forms.

Color balance throughout the entire picture area was the final aim. The local color, or the modulations of individual units, was merely incidental. Nevertheless, Cézanne often maintained a fairly consistent light source in his paintings, and sometimes his cast shadows are a very important element in the color, form, and shape structure. The importance of his shadows is well illustrated in the painting shown in Plate VI. I recall my acquaintance with the Provençal peasant, Eugène Couton, from whom Cézanne rented a room in which to sleep occasionally and to store the canvases and equipment he was using in the paintings of the quarry near by, called Bibemus. M. Couton told me that Cézanne would have several paintings going at the same time and that "he would work on different canvases, depending on the time of day and the position of the sun." This information may be disquieting to some of Cézanne's

[10] Ambroise Vollard, *Paul Cézanne*, tr. H. L. van Doren, London, Brentano's, 1924, p. 117.

[11] For good colored illustrations see Joseph Wilpert, *Die römischen Mosaiken und Malereien der kirchlichen Bauten vom IV. bis XIII. Jahrhundert*, Freiburg im Breisgau, 1916.

[12] See Glossary, Diagram XIV (p. 22). [13] Bernard, *op. cit.*, p. 68.

admirers, who deny the existence of either light source or shadows in his work, but it would be altogether deceiving to try to divorce Cézanne, particularly certain of his habits and thought processes, from the *plein air* ideology of the Impressionists. I do not entirely agree with the strong emphasis Lionello Venturi places upon Cézanne's aesthetic bond with Impressionism;[14] but so far as working outdoors and directly from the subject is concerned, Cézanne never changed his Impressionist habits. And it is quite logical to suppose, even from the standpoint of an Analytical Cubist, that the color and shape relations of such a form as the Sainte Victoire would be one thing in the early morning and quite another motif in the afternoon.

An amusing bit of evidence concerning Cézanne's theorizing in this regard is reported by John Rewald, who was told by the sculptor Maillol that Cézanne had once said to Renoir, "In order to paint well, the angle of the shadow must be equal to the angle of the light."[15] If the report is true, I believe it should be placed in the same category with many other theoretical statements by Cézanne that tend to be contradictions of his work; because, though a definite light source can be followed in a great number of Cézanne's pictures, it is to be noted that he never hesitates to make arbitrary changes according to the exigencies of the particular composition in hand, and that many of his greatest works have only a general, diffused kind of light that is anything but imitative.

My argument is that Cézanne achieved *light* in the sense that modern painters give to the word, namely, the creation of an inner light that emanates from the color relations in the picture itself, without regard for the mere copying of realistic effects of light and shade. Cézanne, therefore, pointed the way to the freedom and release that the modern artist has regained—the release from servile imitation of light and shade.

In his great works the color is luminous over the entire surface. It never becomes three-dimensional in the destructive sense, through imitating the surface effects of local color and of local light and shade. It does not go dead, cut holes in the surface, or make objects stand out like separate, sculptured units. The color always remains two-dimensional; it lights up the picture plane. With a continuous interplay of opposing colors, of balanced color tensions, the juxtaposition of intensely light and saturated hues against dull and heavy colors, of warm against cool, of light and airy color against heavy and dark, Cézanne creates an abstract order. The quality of transparency is exploited to its limit. The color moves in and out of the space, going up and down the chromatic scales in modulations or "sensa-

tions of color" that give a transparency and depth, a richness, scarcely equaled by any other artist. It becomes an orchestration of pure color, transcending the reality of appearances and creating a new pictorial world of its own.

DISTORTION. Distortion is one of the important ingredients of form in the art of Cézanne. In the present study, a special section of diagrams is given over to peculiarities of the drawing of plates and other objects used as subject matter in studio pictures (Plates XIV and XVIII). Cézanne's drawing of such objects has given special impetus to the experiments of those modern artists who approach the space problem with a clear understanding of the two-dimensional nature of the picture plane. The diagrams in connection with the photographs of motifs will give numerous examples of the purpose of distortions and alterations of reality in the landscapes.

One of the most obvious examples of one type of distortion is illustrated by the comparison of the motif with the painting of La Maison Maria (Plate XVI). Here the axes of the building volumes have been tilted to the left, causing what is, in the motif, a lifeless little cabin, to rise up dramatically in the picture space. A dynamic feeling results from the tensions created in relation to the frame or format. A portrait (Plate XVII) also illustrates the phenomenon of axial tipping. Another portrait contains different elements of distortion, and it is examined in considerable detail in the diagram for Plate XIX. In Plate XX the phenomenon of distorted tables is analyzed.

Sometimes there are purely accidental distortions, adding nothing of interest to the picture and suggesting no ideas that might be developed by others. Often, the fact that Cézanne had not completed his picture and was still maneuvering his composition caused distortions to which no significance should be given; for example, the headless bather seated on the left in the great "Bathers" now owned by the Pennsylvania Museum (No. 719 in the Venturi catalogue). In Plate XXI, in relation to the painting, "Bathers Resting," a particularly controversial aspect of Cézanne's work is considered: the question of his clumsiness or lack of manual skill. Cézanne's detractors will revel in these examples. Some, like J.-K. Huysmans and Emile Bernard, will be convinced that the cause of them was faulty eyesight; others, using Sargent as the standard for greatness, will be certain that the poor old fellow just didn't know any better and couldn't draw anyway. But Cézanne is likely to survive all our opinions, whatever they may be.

(The question of distortion will be discussed further

[14] Venturi, *Cézanne*, pp. 26–30. [15] Rewald, *op. cit.*, p. 404.

under the headings of "Perspective," "Plates and Pitchers," and "Table Planes," pages 31–32 below.)

BRUSH STROKES; HANDLING. The "handwriting" or brush marks of an artist are often referred to as his technique. In this study the word technique will be reserved to describe a method followed or the material used, such as oil, tempera, or water-color technique. In Cézanne's work, great importance may be attached to the brushing, the handling of the pigment. In the early work, his fury and frustration, his aspiration and failure, are clearly felt in the character of the brush strokes. At first, the romantic or dramatic subjects were painted in black and white rather than in color. The paint is thick, the brush marks sweeping but clumsy. Little wonder that he found no audience for such undigested pomposity and bombast. Then, under the influence of Impressionist color, he began taming down, and produced palette-knife pictures like "La Maison du Pendu" (No. 133 in the Venturi catalogue). Color and light had now become important to him. Luminous color, he built up with layers of slightly variegated color. Later, under the direct influence of Pissarro, he began to use small brush marks and to break up his color, somewhat in the manner of typical Impressionists. (See Nos. 144, 147, 151 in the Venturi catalogue.)

The first characteristically Cézannean paintings were those executed in uniform, rectangularly shaped strokes that often fell in diagonally parallel directions throughout the picture. The brush strokes of this period reveal, automatically that a system and point of view has been discovered. For the first time Cézanne has a formula under his control; he has discovered his "little sensation," the color gradations. Small, regular strokes are ideal for rendering these unblended, steplike planes of color. One valuable function of the parallelism is to give a uniformity and cohesion to the picture as a whole. Like a set of predominant construction lines, these parallel strokes help to establish a two-dimensional equilibrium. Thus the brush strokes themselves take on a structural significance. Cézanne has now given up the bombast and romanticism of his sterile illustrations and has finally realized that his great power lies in organization, in classical form and structure. The brush strokes are perhaps too uniform, too obviously calculated, in this period, but the originality and functional meaning behind them is justification enough. (See Nos. 397, 341, 319, 311 in the Venturi catalogue; all great masterpieces.)

The later phases of his painting all bear some relation to the period just described. The direction of the strokes, however, begins to shift from one part of the picture to another.

There may be several sets of directions, all helping to express opposing movements or areas of space. (See Plates V, X, XV, XVI, XIX, and XXV for examples of large plane areas that are differentiated by changes in the direction of the strokes.) But, generally speaking, far too much importance is attributed to the space- and form-building power of the brush strokes. Cézanne almost never follows the direction of his forms as Van Gogh does, for example. It would be safer to deny that the varied directions of the brush strokes have any three-dimensional function in Cézanne, than to stress this superficial element unduly.

Through the influence of his own work in the more fluid medium of water color the handling becomes more and more free. Finally, he attains a freedom of execution that is one of the marvels of modern painting. It is not the superficial virtuosity of a Sargent; the weight of deliberation and plastic function are always felt. The surfaces vary from light washes, thinned with turpentine, to paint that piles up to a dangerous thickness from endless repainting. That Cézanne could have repainted certain pictures more than a hundred times without ever losing the freshness of a quick sketch is one of the mysteries of art. Perhaps no other artist has ever succeeded in doing quite the same thing. There should be no hesitation about admiring these surface qualities in Cézanne. The extraordinary richness of his color depends specifically on his method of applying the color. The juxtaposition of variously colored little planes produced an effect of transparency, depth, and fullness, comparable to or even richer than the effects achieved by Renaissance painters, who depended on glazes and scumbling over forms built up with white. In these Renaissance paintings the transparency was a literal, physical fact, particularly with respect to the deep crimsons and azure blues, but it should not be overlooked that age contributes to the translucency of oil paint, giving in some areas the effect of a glaze where originally there was a rather opaque film of paint. Cézanne, however, does not depend on this physical transparency; in his painting the effect is achieved by means of the color relations. The minute intervals between the tiny planes of the chromatic passages play their part in producing the shimmering surface vibrations that are unique in the art of painting. Almost every inch of the way, the eye is rewarded in traveling over these surfaces, finding sensuous pleasure in the subtle nuances. The special character and movement of the brush strokes cannot be dissociated from these organic qualities of the color.

TEXTURES. In Cézanne there is no actual concern with textures, in the modern understanding of the term. There

are no polka dots, hatching, lines, surfaces mixed with sand, imitations of wood grain (which, in Braque, are actually imitations of imitations of wood grain). But Cézanne had his part even in all this. Van Gogh developed a new decorative concern with brush strokes and pigment textures that was obviously a simplification and stylization of Cézanne's brushing; the Abstract painters carried on after Van Gogh, using textures in a new, deliberate way. The textural life in a painting by Cézanne is simply the result of his method of creating color and form. Not that he was immune to the patterns and designs on drapery and other forms (see Plate I, Diagram IX); but generally the rich, textural quality is the result of brush manipulations, as described above. The brush strokes follow out and build up the form; as the character of the form changes, the textural effects change. A flat surface will remain quite smooth, while leaves and trees and brushes will take on a variegated, broken kind of texture. These differing textural weights were balanced. It was not merely a matter if rendering the varying characteristics of form as they occurred in the motif. If a flat surface needed more weight in relation to other parts of the picture, for example, he would not hesitate to introduce heavy modulations. It is this plastic balance that makes it justifiable to consider the textural elements in Cézanne to be related to the conscious, abstract textures that developed in later Abstract painting.

SPACE ORGANIZATION. Cézanne's comment that "nature is more in depth than in surface" [16] suggests that his major concern was with the spatial elements rather than with decorative pattern. Without underestimating the great importance of decorative design, it makes a clarifying comparison to say that Gauguin, for example, was more concerned with the surface elements of pattern, shape, and texture. Another quotation from Cézanne indicates a deep, intuitive feeling about space: "There are in nature two agents that work toward harmony: they are light and air. Light colors, air envelops." [17] It is convenient to recall this statement, for there can be no doubt that it indicates intellectual awareness of the negative space—the air between the positive volumes. Almost all the mature paintings demonstrate how profound was his preoccupation with this all-embracing problem.

Perspective. Space drawing in Cézanne's painting included devices that are found more specifically in Byzantine icon painting and Abstract art than in other art forms or periods. One of the truly revolutionary elements in Cézanne's drawing involved an almost complete reversal of scientific perspective (see Plate II and diagrams relating

to the painting called "La Roche-Guyon"). His roads were always drawn so as to create a clear illusion of space; but they were manipulated, through turning, through expansion (the elimination of convergence to a "point at the horizon"),[18] so as to remain integrated with all the other planes in the picture, and with the picture plane itself.

With respect to scale, again Cézanne does not diminish the size of objects according to scientific perspective. He expands or diminishes size to satisfy the requirements of the composition as a whole and in accordance with the emotional or associative significance the forms or objects had for him. El Greco offers a fundamentally similar explanation for his landscape, the "View and Plan of Toledo." Incorporated into the design of this picture is a plan of the city of Toledo and an explanatory inscription that reads as follows: "It has been necessary to represent the hospital in the form of a model because not only did it cover up the Gate of Visagra, but its dome or cupola rose so high that it overtopped the city; and thus, once it was represented in the form of a model and moved from its original place, it seemed better to depict the principal façade than some less imposing aspect. You can determine its actual relationship to the city by studying the plan. Also, in the history of 'Our Lady Presenting the Chasuble to St. Ildefonso,' I justify enlarging the size of the figures for decorative reasons and on the grounds that they are celestial beings which for us are like lights seen from afar that appear large even though they are actually small." [19] Thus El Greco and Cézanne created a perspective that grew out of the exigencies of the particular composition rather than from mechanical rules. In one of his most significant statements André Lhote says, "He [Cézanne] gives to each object the place and the size that its expressive quality assigns to it, rather than that which results from distance [*éloignement*] and which the absurd work of the academies pitilessly fixes." [20]

Plates and Pitchers. Cézanne approached the arrangement of his still lifes in a spirit close to that of the most abstract painters. It was a problem of arranging planes and colors so that the space would be filled and balanced. The young painter Louis Le Bail had the honor of assisting Cézanne one day in setting up a still life. Excerpts from his report say that "Cézanne arranged peaches, . . . tipping, turning, equilibrating the fruits as he wanted them to be, using coins of one and two sous for the purpose. He brought to this task the greatest care and many precautions; one

[16] Bernard, *op. cit.*, p. 68. [17] *Ibid.*, p. 106. [18] *Ibid.*, p. 73.

[19] Willumsen, *La Jeunesse du peintre El Greco*, pp. 673 and 675. My translation of the passage has been arrived at with the kind assistance of Professor Arturo Torres-Rioseco.

[20] Lhote, *La Peinture, le cœur et l'esprit*, Denoël et Steele, Paris, 1933, p. 13.

guessed that it was a feast for the eye to him." [21] The tipped-up platters were not an accident of drawing, but part of a preconceived arrangement. Other more complicated and partly accidental variations did develop in the process of painting (see Plates XIV and XVIII and the accompanying diagrams).

Abstract art has found the clue to many of its intentional distortions in similar paintings of Cézanne's. The distortions were employed, here for the sake of making a thrust into space more forceful, there for the sake of holding the plane in related tension to other planes, or to the picture plane. The effect is explained in the diagram for Plate XIV as the device of *seeing from different eye levels*. The result is a new, more exciting effect of space than any mechanical perspective drawing could give. The distortion of natural shapes is thus seen as a positive "form-conditioning" factor; it cannot intelligently be appraised as mere clumsiness.[22]

Table Planes. One of the most radical space effects develops out of the drawing of certain table tops (Plate XIV) and background walls (Plates XVII and XIX). A table top or wall is often broken up into two planes, a distortion that actually became customary in later Abstract art. In Cézanne, however, these distortions develop quite naturally, whereas in later Abstract art there is a preconceived, theoretical intention behind them.

CONCLUSION. Included in this broader consideration of all the components of pictorial space is the more elementary and easily understood requirement of making the individual volumes appear solid. There has been lengthy discussion, particularly in connection with Cézanne's letters, of the relative importance of making the individual volumes solid. There seems to be a broad agreement among critics and artists, of all shades of opinion, that Cézanne did achieve some kind of solidity and three-dimensionality. Often, however, three-dimensionality is regarded as a self-contained, sculptural problem, without consideration for the complicated necessity of relating it to the two-dimensional picture plane. Complete control of pictorial space, as Cézanne achieved it in his greatest work, involves, first, the creation of space effects through the overlapping of planes. By varying the distance (the space intervals) between these planes, rhythmic tensions are developed. But *all these forces are bound within the picture format, and they find ultimate balance or equilibrium in relation to the picture plane.*

Mr. Novotny is not unaware that this is the essence of Cézanne's contribution to modern art. He says: ". . . space

in Cézanne's pictures is not illusory space in the ordinary sense. The pictorial plane contributes too much as an artistic reality to the impression produced by this treatment of space. This, however, does not mean that Cézanne's pictures can be called 'flat,' . . . the plane [of the picture] is effective even in a fully rounded off oil painting." [23] However, I must offer a serious objection to a further development of Novotny's opinion that, "strictly speaking, apart from a few isolated exceptions, no analogy to Cézanne's treatment of space can be found in earlier painting." Indeed, as I have emphasized throughout the present study, Cézanne's space may be taken as the modern rebirth of the classical ideal of pictorial space, which is three-dimensionality conceived in relation to the two-dimensionality of the picture plane.

Mr. Venturi, also, in his description of a painting of the Sainte Victoire, has expressed a perception of Cézanne's control of these dualistic elements. He says: "We feel the representation of the country in the distance, as if it were near, without ever losing awareness that it is far; and that is one of the miracles of art." [24]

André Lhote makes a detailed description of the space-control problem in his *Traité du paysage*. Lhote always implies the need for gradations from light to dark or warm to cool, with "passages," as did Cézanne; but he also makes the problem of creating depth through overlapping planes very clear. He speaks of "the planes which separate from one another, the darkest pushing the lightest forward somehow," and he says that it is "the systematic application of this phenomenon, rather than the use of classical perspective, which has made possible the suggestion of depth. . . . Each field pushing the other, the eye maneuvered in front, then behind, is forced to realize a third dimension. Genius consists in knowing how to compensate, through constant repetition of each phenomenon, for every thrust into depth, by an *equal* advance or return. Without this ruse, the eye would immediately find the horizon, the distance, without being excited by the successive oppositions, which retard its quest for space, and procure for it a subtle pleasure." (It is pertinent to recall here Cézanne's statement about "putting things in perspective," and to remember, as was pointed out, that Cézanne said nothing, either then or at any other time, which indicated that he had a clear theoretical aware-

[21] Rewald, *op. cit.*, p. 403.

[22] Glenn Wessels, objecting to the word "distortion" in describing Cézanne's drawing, has suggested the use of the term "form-conditioning." Mr. Wessels says: "I think the term 'distortion' should be used only when the form exhibits changes in the picture which are unjustified by its place in the picture relationship. Many bad painters distort, but Cézanne's paintings are seldom if ever distorted."

[23] Novotny and Goldscheider, *Cézanne*, p. 11. [24] Venturi, *op. cit.*, p. 56.

ness of the necessity of "compensating" for depth, in Lhote's sense.) "This depth, perceived through feeling, is of a different essence, if one may say it, from that physical depth which, offered to the guilty eye, seems to create a hole in the picture,[25] and takes away from it the *mural character which so many generations of painters have so virtuously respected*. . . .

"It is necessary to repeat it: the picture, regardless of the exigencies of the subject represented, *must remain faithful to its own structure, to its fundamental two dimensions*. The third dimension can only be suggested; it is from this double necessity that most of the inventions in the art of painting are born. . . .

"It is for having rediscovered this science of the compensations of volumes that Cézanne, Renoir, and Seurat were so great: they have constructed, in the midst of the modern deliquescence, the only landscapes which express depth by means of stepped-up planes, without attaining it in a stupid sense; the only landscapes in which one can experience an idealistic promenade, not by foot, but with the spirit. These constructions offer us a monumental succession of natural elements, held together somehow by the steps of an imaginary stairway, which rises from the ground and opens up into the sky, but with the last step returning wisely to the level of the first."[26]

The great men of modern painting, in particular Picasso and Braque, have put into practice in the most original, perhaps the most arbitrary, way ever seen this realization of the duality of pictorial space. But it is not a modern invention; rather it is an age-old law, which the art of Cézanne brought back to the consciousness of painters interested in plastic rather than literary meanings. With Giotto standing at the head, as the ideal master of Western painting, most of the great masters of the Renaissance who preceded Baroque extravagance display a profound realization of this "double necessity" in painting. Of course it is possible to find among the works of these masters certain exceptional or, rather,

partly unsuccessful pictures, some parts of which seem to fall out or to cut holes, while other forms might even protrude or advance in front of the wall. Likewise, one may point out disturbing elements in certain pictures by Cézanne. (See Plate IX and analysis.) Previous discussion has shown that I do not believe Cézanne was aware of this problem himself, on a conscious intellectual and theoretical level. But the paintings of his maturity put this problem to the fore, and most of the photographic comparisons herein explain how he solved it.

It is the masters of the modern renaissance, the French school, of course, who have been more theoretical and scientific in their approach. Accepting these basic principles does not presuppose a coldly intellectual art or "painting in the manner of" anyone else, in the imitative sense. I do not see how a wider adoption and understanding of these plastic means, beginning with training in the art schools, can fail to improve the quality of American painting. It could not easily work as a restraint upon freedom and monumentality of expression. To the contrary, it would prevent innumerable and pointless faults in composition, and would eliminate much of the confusion and bad taste that hampers American art today. The diagrams and photographic comparisons should make clear how important this problem of the organization of space becomes when the classical structure of Cézanne is subjected to severe analysis. Indeed, the real aim here is to demonstrate how in Cézanne the highest degree of expressiveness, of freedom and liberation, was based on certain factors of composition that every artist should know. These basic fundamentals, once learned and understood, can be relegated to an unconscious level, leaving the artist free to express his emotion about any kind of subject matter imaginable. Such training will prevent the aimless struggling that Cézanne's early, undirected efforts represent.

[25] See Glossary, Diagram V (p. 20).
[26] Lhote, *op. cit.*, pp. 30–33.

V. CÉZANNE'S MATERIALS AND METHOD

THERE IS NO indication that Cézanne gave much thought to the technical problems of painting. Fortunately, most of his surfaces have aged very well, and with the exception of early pictures, or others which have obviously been rolled or creased, there is comparatively little cracking. It is safe enough to assume, on the basis of their good condition today, that Cézanne's procedure was technically sound. The first layers of paint were reduced to an aqueous thinness by the addition of turpentine. As subsequent layers were superimposed, the film became somewhat heavier. Thinning with turpentine made it possible to paint innumerable coats without building up the *impasto* to a dangerous thickness. (Many of the early paintings were extremely thick, but we are concerned here only with the work of his maturity.) The thick surfaces that developed in the very last period have acquired an enamel-like quality that suggests permanence.

Thinning the layers of paint with turpentine kept the mixture lean; hence there should be little danger of darkening. But it is unlikely that Cézanne had in mind anything beyond the added fluidity that turpentine afforded. It has often been recognized that his handling of water colors directly affected the method of brushing in the first fully mature period of his oil painting. Turpentine also aided drying. Cézanne's habit of painting over the same picture, on consecutive days, and weeks, indicates the practical expediency of adding turpentine. I think we may always be safe in assuming that Cézanne avoided any procedure that interfered with ease of handling. Carelessness is certainly nothing to emulate, and it is likely that some of the surfaces were thinned out too much. Conservators today are unable to do any thorough cleaning of such pictures, for fear of removing the tenuous film of pigment. In 1928 I had the pleasure of seeing in Ambroise Vollard's private stock some fourteen of Cézanne's paintings, most of which had never been exhibited. They were unframed, and very likely had not been restored since the time of painting, but had been stacked up casually in the big closet off Vollard's dining room. Several of the canvases were excessively mat, hiding the translucence and depth of the color. This mat quality was apparently the result of too much turpentine, and the pictures seriously needed varnishing. I was amused at Vollard's casual reply to my suggestion that varnishing would be beneficial. He said, "Oh yes, perhaps—but very, very lightly in any case." It is unfortunate that some conservators, far from agreeing with Vollard, have gone to the opposite extreme. I recently saw one of the portraits of Madame Cézanne that had acquired a set of cobweb cracks plus an amber film—the result of overstretching and heavy varnish.

A rather disquieting bit of information is found in one of Cézanne's last letters. He is very much annoyed by the tardiness of a Paris merchant in sending him, along with certain pigments, a bottle of *siccatif de Harlem*.[1] This drier is generally considered dangerous. It is easy to guess why Cézanne found turpentine inadequate as an aid to drying, for we know that in his last years he painted more thickly. Unless a sun-thickened or heat-oxydized oil is employed as a medium, thick films dry slowly. As we have already seen, Cézanne painted day after day on the same picture, and for that reason, presumably, he found it necessary to add a drier to his paints. The "Sainte Victoire" of the Pennsylvania Museum (reproduced in Plate XXVI) has developed cracks that might well be the result of using *siccatif de Harlem*.

More to be feared than cracking and darkening is the possibility that colors will fade or go neutral. The list of colors used by Cézanne, according to Emile Bernard, is as follows. *Yellows:* Brilliant Yellow, Naples Yellow, Chrome Yellow, Yellow Ochre, Raw Sienna. *Reds:* Vermilion, Red Ochre, Burnt Sienna, Rose Madder, Carmine Lake, Burnt Lake. *Greens:* Emerald Green, Viridian (chromium hydroxide), Green Earth. *Blues:* Cobalt Blue, Ultramarine, Prussian Blue. *Peach Black* and *Silver White* (Lead White) [the latter color inferred by Bernard, but not listed]. There are several colors of doubtful permanence on this list, according to present-day standards. The lesson of Cézanne in this connection is that the contemporary painter should learn more about painting as a craft. The history of art would certainly sustain a grave loss should Cézanne's color be destroyed. Fortunately, there is no indication of fading at the present time. Even the intense Emerald Greens seem to retain their full intensity.

[1] John Rewald, *Paul Cézanne. Correspondence*, p. 274.

PLATES AND ANALYSES

VI

INTRODUCTORY ANALYSIS
OF A STILL LIFE

GENERAL PROBLEMS of form that indicate some of the "constants" or recurring principles of composition in Cézanne's art are analyzed here. Many of these same principles can be applied to the analysis of masterpieces in painting, throughout history.

PLATE I

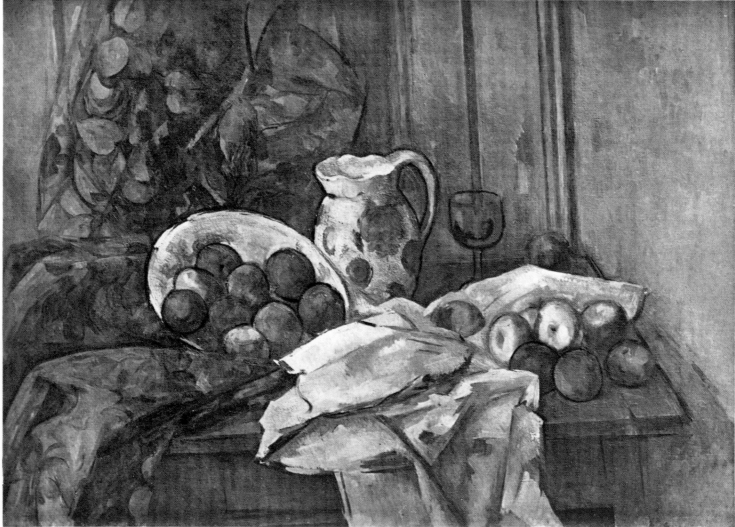

Courtesy of Dr. Oskar Reinhart, Winterthur

Still Life with Apples. CÉZANNE

DIAGRAM I is simply a tracing around the outer contours of the large areas of the picture. The essential plane and space relationships are thus established by *outlines*. Although Cézanne certainly did not begin a painting with the completely defined, closed compartments shown in this diagram, it is nevertheless these basic space relationships that he roughly established with pencil and colored outlines in the first stages of most pictures. The fundamental linear structure in Cézanne's painting and his linkage with earlier traditions of composition should be apparent in the light of this tracing.

It must surely be clear that this diagram, further elaborated with outlines around all the smaller forms and divisions in the draperies, could serve as the cartoon to be traced with an incising stencil on a Renaissance fresco or tempera surface. Or, for other types of Renaissance tempera or oil painting that were to be toned with an imprimatura, these outer contours would be drawn with dark tempera lines or black ink. Cézanne did not use any of these procedures, of course, and it was only when the painting was entirely finished that his compositional structure, based upon

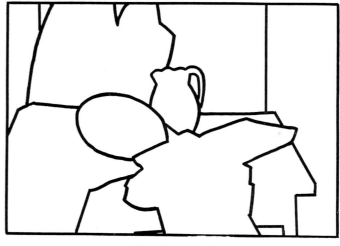

DIAGRAM I

outlines and contrasts at the contours, could be in any sense compared with that of Renaissance masters. It would be the gravest of errors to assume that he began with a fixed and continuous outline which he never altered in the course of building up the color planes. His procedure was infinitely complex, and until the last line had been put down the drawing and composition were continually in a state of flux. The openness of his approach to color, the effect of color on color as the composition crystallized, creating expansions and contractions in relation to the first sketchy outlines, demanded slight alterations as well as continual reëstablishment of the line; but "as one paints, one draws," and "the more the color harmonizes, the more the drawing becomes precise." In the very latest landscapes, such as the one illustrated in Plate XXVI, the line is segmented and tenuous, and the entire structure is very open and depends more on the small color planes. But even there the large plane divisions can be marked out with outlines as shown in Diagram I accompanying Plate XXVI.

PLATE I
(continued)

DIAGRAM II reduces the elements of the picture to flat planes. The double-pointed crossbars indicate the long and short axes of the planes. These axis bars help to indicate the position of the planes in relation to the picture plane. The short, heavy arrows point into depth in the direction indicated by the overlapping of one plane over another. Tensions[1] between planes are great or small, depending upon the amount of space, the interval, between them. As the diagram indicates, space and tension can be created with perfectly flat planes when they are made to overlap, thus establishing their position, their fixation, in space. (The location of these planes should be as apparent in the diagram as in the painting.) Other elements of tension are analyzed in Diagram IV.

At the lower right, the arrow A indicates the rising of the table top away from the horizontal line of the frame and the consequent dynamic rotation to the right of the front plane of the table. This rotation pushes the table into space away from the picture plane. This subtle impetus into the right-hand deep space is probably the origin of the dynamic quality of the painting. Diagram III analyzes the movements in a more general way.

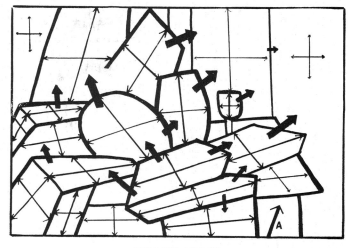

DIAGRAM II

DIAGRAM III shows how space and depth are created as the volumes move in the negative space. In this picture there is movement both to the right and to the left, as indicated by straight arrows. But the movement stays within the borders of the frame. A third movement factor, indicated by arrows revolving in circular activity, keeps the organization well closed. This circular movement is somewhat vague, and difficult to prove graphically. It is both a two-dimensional and a three-dimensional movement. Two-dimensionally, it follows rhythmically along lines in the white cloth (as shown in Diagram VII); its central coil can be felt in the plate and the curved pitcher handle. It is three-dimensional because its path revolves from foreground into background, receding into the deepest part of the so-called "picture box," the *negative* space.[2] The movement activity of the apples is also indicated by arrows.

Light and dark planes have been indicated in order to heighten the volume effect. Diagram II has shown, however, that *the basic spatial relations can be demonstrated with perfectly flat planes.*

In this painting the dynamic activity of elements moving in space is *controlled* and related to the flat picture plane, partly by eliminating too great a protrusion of the forms at the bottom and partly by expansion and enlargement of the forms in the background: the tipped-up plate of apples, the vertical pitcher, and the heavy vertical drapery against the vertical wall afford the necessary expansion.

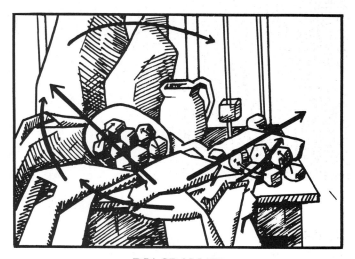

DIAGRAM III

DIAGRAM IV analyzes two elements of tension not emphasized in Diagram II. A tension path, somehow comparable to the act of opening up a fan, can be felt from axis to axis of planes and volumes. Dotted lines running through the center of axis bars, starting at the lower left, marked I and ending at V, represent this tension path. An important factor in the path referred to is the dynamically tipped pitcher. The pitcher, because of the distortion or tipping, becomes part of the general movement activity; it is no longer a mere object.

A set of tensions between the apples is indicated by dotted lines. This tension would exist both because of the color relations between the apples and because of the similarity in their sizes and shapes. The massing or grouping of the apples is important. On the left, inside the plate, is a large mass (or complex); to the right, there is a medium-sized mass; and behind the white cloth sits a lone apple, related through tension to the other groups of apples. See Diagrams XIV to XVII of the Glossary for more complete explanations of the concept of tension.

[1] See Glossary. [2] See Glossary.

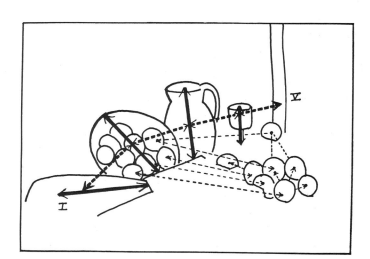

DIAGRAM IV

PLATE I
(*continued*)

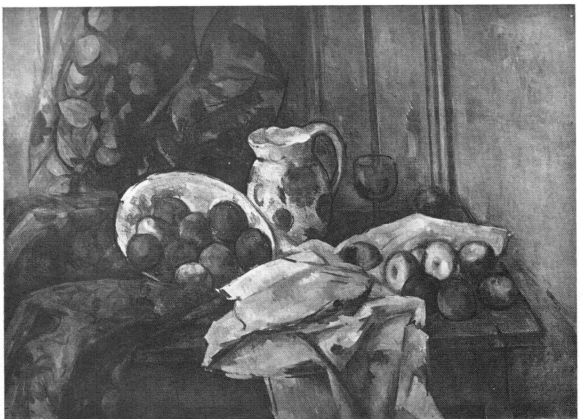

The reproduction of the still life is here repeated in order that text, diagrams, and original painting may be taken in at a glance. As a painter seeking knowledge about plastic form through books, I have always wished for the type of arrangement that will, so far as possible, be followed in the present work.

Courtesy of Dr. Oskar Reinhart, Winterthur

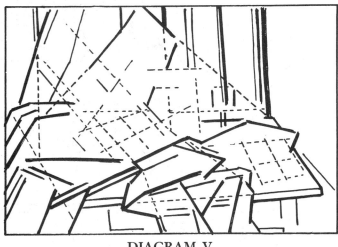

DIAGRAM V

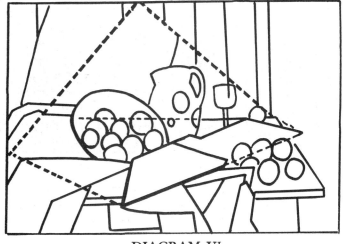

DIAGRAM VI

DIAGRAM V is a two-dimensional, linear construction based on actual as well as subjective or "carry-through" lines. The solid black segments of line are simply traced from the still life. The so-called "subjective" lines, which merely seem to "carry through" from the edge of one object to that of another, are indicated by dotted lines. This important element in the organization of a picture—the network of horizontal, vertical, and diagonal lines—is made more emphatic by leaving the shapes incomplete, in segmented lines. These construction lines, weaving back and forth throughout a picture, give structural power and *two-dimensional balance.* I do not believe that Cézanne conceived of these lines as a factor unrelated to depth and space, and it is only for purposes of analysis that they are shown as a separate element here. (But it is important to notice that *even when an attempt is made to reduce such a painting to its construction lines, a space effect is created.* Subjective planes, suggesting space, develop as soon as a line cuts across the picture plane.) The lines may be understood as *dynamic* and *static* elements, the vertical and horizontal being the *static,* and the diagonal the *dynamic,* lines. Of great importance here is the slight tipping of the vertical lines. This habit of tipping lines that are vertical in nature gives to Cézanne's painting a new dynamic quality. In fact, there are no positively static lines in the entire picture. The belief that these dynamic elements resulted from Cézanne's poor eyesight (see Emile Bernard) can by now, perhaps, be discounted! Similar phenomena can be found in the work of many of the great masters of the past. Picasso and Braque, particularly in their first Cubist period, which was a direct development from Cézanne, made extensive use of construction lines.

DIAGRAM VI is concerned with the geometric shapes in the painting. Underlying or subjective shapes are indicated with dotted lines. The largest subjective shape is a diamond, based almost entirely on subjective or carry-through lines. Within the large diamond, the upper half makes a fairly obvious triangle. It was the recognition of these nonobjective shapes in Cézanne and in the old masters that gave the Abstract painters one of their points of departure. The obvious or objective shapes in this picture are seen as circles (apples, and designs on pitcher), ellipses (plate and pitcher), and various triangular and rectangular shapes in the drapery, table, and wall. The aim is to achieve the greatest possible variety and contrast in the size and character of these shapes. (The decorative character of the large objective shapes of draperies is analyzed in Diagram IX.) The two-dimensional balance and the mural character of the picture plane are greatly enhanced by these underlying subjective shapes.

PLATE I
(continued)

DIAGRAM VII analyzes the organization of rhythmic curved lines. The dotted lines indicate how the curved lines seem to carry through, binding various elements of the picture together, creating rhythm. Go back to Diagram III to see how the circular movement of lines relates to the *movement in space,* which is of fundamental importance. Refer to Diagram V for analysis of straight construction lines.

Consideration should be given to the purely decorative character of line—line for its own sake, or "the beauty of line," as it is often called, even though it is a comparatively superficial factor. There is a play of round and curved against angular and straight lines. There are the contrasts of long and short lines. The curved and diagonal lines are dynamic; the vertical and horizontal, static. All these diagrams make obvious how important *line* is in the organization of a Cézanne painting. It is difficult to understand the critics' fable of Cézanne's "lack of linear content."

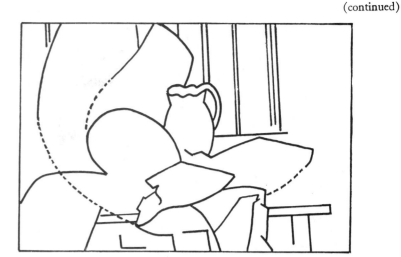

DIAGRAM VII

DIAGRAM VIII is based on the most purely individual characteristic in Cézanne's paintings, namely, gradations. The practice of starting with the darkest outer contour of a form and building up from cool darks to the warm lights, as was Cézanne's usual procedure, gave his work the spotty character which has misled so many critics and artists to believe that "Cézanne created his picture with little touches of color" and "avoided the line." Note that all preceding diagrams were line drawings, with no gradations indicated. This method of building up forms with distinctly hewn-out planes of color on the principle of *warm color* for light planes and *cool color* for receding planes is the most widely understood element in Cézanne's effort to "make out of Impressionism something solid, like the art of the museums." It is the element in his form about which he talked so much, but which, according to the approach made here, is decidedly of secondary importance.

The accompanying diagram is an attempt to show how the picture may have looked at an early stage of its development, with the difference that basic outlines are here purposely avoided. (See Plate XXXVIII for an unfinished canvas.) The separation of the planes is achieved more through contrasts at the contours than with lines. But, as the painting progressed, the lines were more definitely superimposed at the contours, as we can observe in the photograph of the painting, particularly in the white cloth and in the table. Among followers of Cézanne, Andrew Dasburg and Henry Lee McFee come to mind as painters who depend almost entirely on these contrasts of dark against light, light against dark, and carry a picture to completion with a conscious avoidance of superimposed line.

DIAGRAM VIII

The merging, the losing of edges at certain points of the contours, is clearly shown in the diagram. When part of a contour thus "passes" into the adjacent form or into the background, a fusion that has a two-dimensionalizing function occurs. With the positive volumes closely related to the background, the entire surface becomes a well-integrated two-dimensional area, and the effect of separate, sculptured units floating in unused, unrealized space is done away with. (Although definite, the importance of fusions or "passages" is comparatively slight in this painting.)

Picasso, Braque, and other artists who developed Analytical Cubism used the elements of Cézanne's form, described in this diagram, as their particular point of departure. (See Plate XXV.) Gradations of light to dark, dark to light, with additional lines here, fused edges there, and strong emphasis on oppositions of curved against straight lines are the obvious characteristics of the early manifestations of Cubism.

DIAGRAM IX reduces the light and dark shapes to definitely closed or compartmental areas. The basic light, dark, and gray shapes create an interesting, firmly organized pattern. The vibration of light against dark shapes creates a pictorial light that exudes from the picture itself. It has nothing to do with light and shade, chiaroscuro, or naturalistic light-source concepts. The light in this sense is abstract, a purely plastic, pictorial quality that derives from the formal relations in the picture itself.

Slight variations in texture are also indicated in this diagram. Cézanne was never much concerned with the imitation of textural surfaces, nor was he interested in pigment textures like those invented by Van Gogh, nor in abstract pattern textures, so common in the Abstract painters. Cézanne was always primarily concerned with the structural, voluminous character of forms. But in this painting the flower design in the heavy drapery inevitably created a heavy textural weight that had to be balanced by other textural weights. The lights and darks in the apples create such a balancing weight, and so do the modulations in the white cloth.

Some consideration should here be given to the concept of positive and negative shapes. The positive shapes are the obvious objects and draperies, the gray wall serving as a negative area. The diagram is concerned only with the decorative, two-dimensional qualities of positive and negative. Diagram III explains the three-dimensional concept of the negative deep space or "picture box," within which the positive volumes are moving. It is also interesting to notice how the white cloth, the pitcher, and the plate are all merged into one mass or "complex" of white. A more perfect organization and binding together of the different objects is thus achieved, and the two-dimensional, mural character of the picture plane is heightened.

DIAGRAM IX

VII

PROBLEMS OF PERSPECTIVE

CERTAIN PAINTINGS that demonstrate Cézanne's approach to the problems of perspective, converging roads, diminishing sizes, and so on, are here compared with photographs of their original motifs. In Plate IX a partly unsuccessful picture is analyzed for the provocative problems it presents in regard to the concept of the "picture box" and the picture plane.

PLATE II

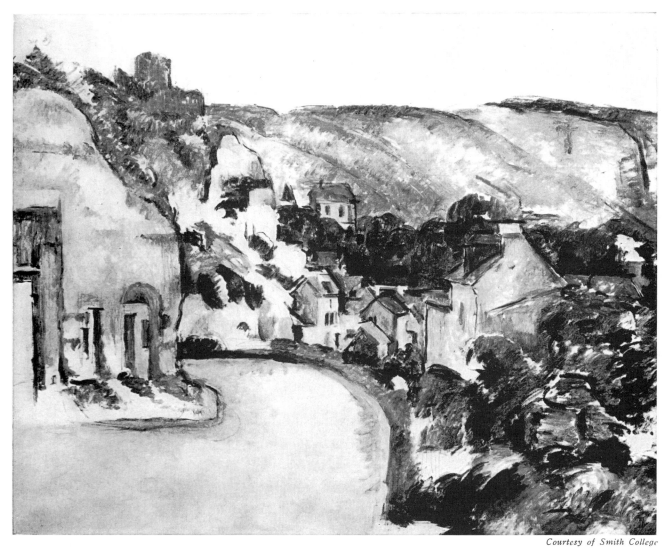

A narrow section of the right-hand edge of the painting was eliminated in the photograph from which our reproduction is made. This section is almost entirely bare canvas in the original and has no particular significance.

Landscape at La Roche-Guyon. CÉZANNE

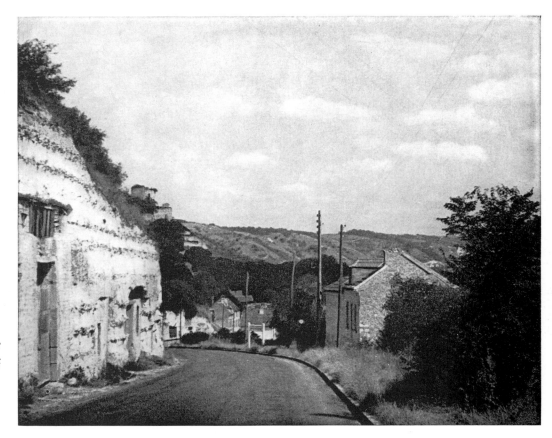

Photograph of the motif

PLATE II
(continued)

DIAGRAM I is a tracing from the photograph of the motif. Several unruly elements are emphasized here for the purpose of facilitating comparisons with Diagram II. The road expands at the bottom, E. The hillside masonry expands at the left, o. This same hillside shape starts an uncontrolled rising movement, arrow c, in relation to a dropping action of important distant hills, arrow A, which leaves a vast empty space in the upper sky area. The next diagram will attempt to show exactly how Cézanne proceeded toward solution of these problems in a superb painting, somewhat incomplete, yet expressing the essential character of the motif. It is an eloquent demonstration of the creative process of reorganizing an unruly motif into a balanced, plastic unity.

DIAGRAM II emphasizes characteristics of drawing, of plane manipulation, that are typical in Cézanne's later work. The road makes a strong turn to the left, around and behind the vertical wall at the left side of the picture (small arrow A). This movement is clearly three-dimensional. But the disturbing expansion, indicated at letter E in Diagram I, has disappeared. Compare the main contours of the road, at its horizontal and vertical contours, in both Diagram I and Diagram II. Notice that the expanding, diagonal lines of Diagram I have been changed to horizontal and vertical lines, marked x in Diagram II. Scientific perspective has been disregarded, to say the least. The entire road shape becomes a comparatively flat two-dimensional plane, as indicated by the horizontal and vertical axis bars, numbered 1. (The road, in Cézanne's painting, actually projects farther, achieving a more positive three-dimensional turn than it does in the photograph of the motif, which unfortunately cuts off a great portion of the lower and protruding area.) We have a good example of the combination of planes working three-dimensionally, but at the same time two-dimensionally so far as they relate to the picture plane, and staying closed within the frame or format.

The hillside masonry shape has been changed from a diagonal or dynamic plane, expanding out of the picture, letter o, Diagram I, to an almost flat or static plane, indicated by axis bars, numbered 2, in Diagram II. The significant fact here is that, while the dynamic position of the shape has been eliminated, a feeling of *space* and *air* behind the masonry shape, a strong *tension* between this shape and the distant hills, has been created. The tension between the masonry shape and the distant hills is symbolized by the heavy broken arrow.

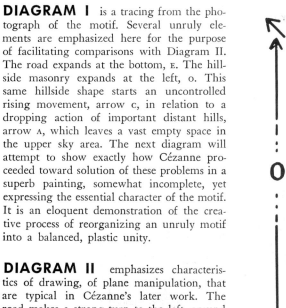

DIAGRAM I

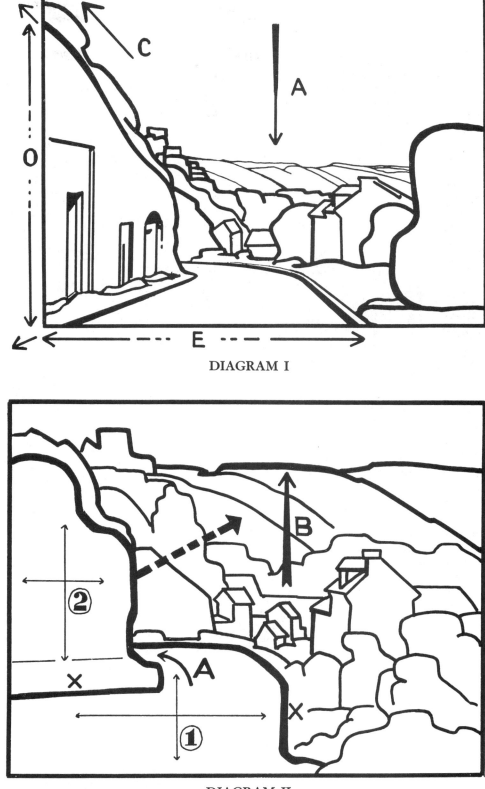

DIAGRAM II

Another important change is to be noted in the size of the distant hills. In Diagram I the arrow A indicates how the hills drop in relation to the hillside masonry, which is rising and running out at the upper left, letter c. In Diagram II the hills have been expanded in size; they rise up vertically, arrow B. The funnel-like spatial effect which is so strong in the motif has been eliminated through these various adjustments. The psychological effect of enormous hills is recorded in plastic terms. The painting, when compared with the photograph of the motif, should give a graphic illustration of the problems that must be solved when creating three-dimensional space and movement on the two-dimensional picture plane.

PLATE III

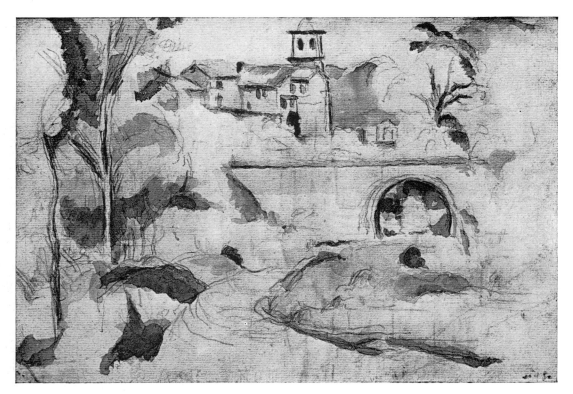

Road to Gardanne.
CÉZANNE

THE WATER COLOR reproduced here is not an important work of art, but, when compared with the photograph of the original scene on the outskirts of Gardanne, it does clearly reveal Cézanne's method of organizing space. (a) The foreground has been compressed in size and flattened by a sharper turn in the road.* The large trees on the left have been reduced enormously in scale, but of course due allowance should be made for growth since the time Cézanne's painting was made.

(b) The background buildings and railroad bridge, which in the photograph of the motif are tiny in size, have been radically enlarged in Cézanne's painting to become the most important forms in the entire picture. (c) Thus, scientific perspective is again completely ignored, if not actually reversed, in the process of organizing deep space and relat-

ing it to the flatness of the picture plane. In less technical terms, Cézanne was primarily interested in the bridge and church. He made them large because they were psychologically the most important forms in his subject; and furthermore, the tall trees on the left could only be balanced by enlarging the forms on the right.

Recently published data on Ingres reveal that even such a precisionist as he did not hesitate to alter perspective. See his sketch "The Classic View" with a photograph of the same subject in *Art News, May* 1–14, 1943, article "Ingres and the Camera," by John Rewald.

* When comparisons are not accompanied by diagrams, the various plastic problems will be lettered to suggest that the reader might mentally improvise a graphic diagram for each category listed.

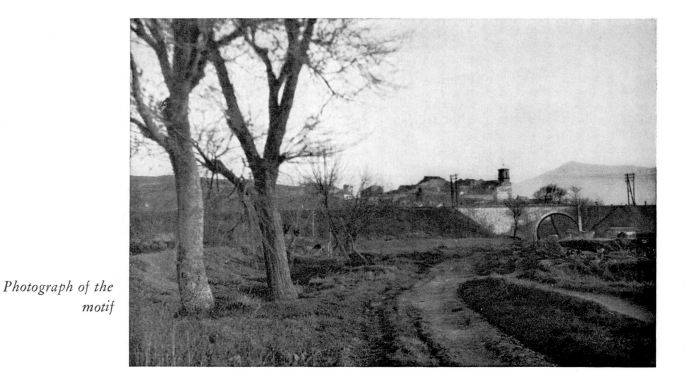

*Photograph of the
motif*

PLATE IV

Farm at Montgeroult
CÉZANNE

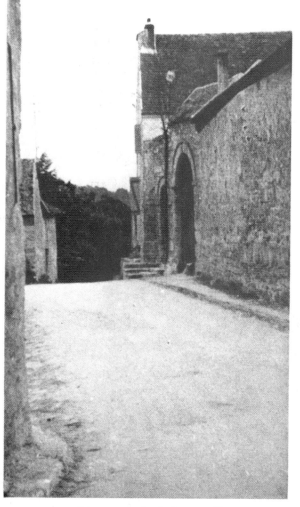

Photograph of the motif

THE PAINTING illustrated here reveals typically drastic modifications of perspective. (a) The effect of protrusion and expansion in the road has been lessened, and the distance from the base of the stone curb, at lower left, to the crest of the road, radically reduced. (b) The alteration in scale may be judged most easily by comparing the amount of space taken up by the background of heavy foliage in the painting with that in the photograph of the motif. In the motif these trees are relatively small, but Cézanne has so far enlarged them as to create a heavy mass that brings the background plane into prominence. (c) A strong effect of overlapping planes (Cézanne's characteristic color planes or modulations), moving into space from left to right, can be studied in the painting of these trees. (d) The arched doorways on the right have been drawn more nearly parallel to the picture plane, as if observed from a closer point and from the left side of the road. (e) The building on the left, going downhill, has been drawn as if seen from the right. (The inclusion of the stone-and-plaster wall on the left seems to eliminate the possibility that Cézanne could actually have been standing closer to the buildings, and therefore it is plausible to credit him with forcing these alterations deliberately.) The effect of "seeing around" the space, in a fourth-dimensional [1] sense, has thus been achieved and the planes of the buildings have simultaneously been brought into a more nearly parallel relation to the picture plane. Paradoxically, the effects of three-dimensionality ("seeing around") and two-dimensionality (particularly in the arched doorways) are thus simultaneously increased.

[1] See Plate XIV and the diagram accompanying it.

PLATE V

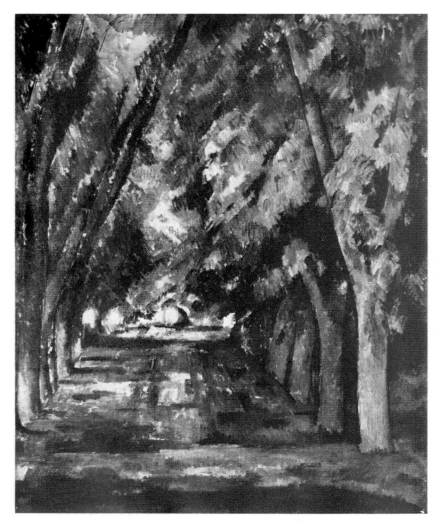

Lane through Chestnut Trees (at the Jas de Bouffan). CÉZANNE

ASIDE FROM the fact that the photograph of the motif was taken in winter when the trees had lost their leaves, the obvious difference between Cézanne's painting and the scene in nature is the typical one of a modified perspective in the drawing of the lane between the trees. (a) The strong convergence and funnel effect seen in the photograph of the motif have been eliminated. (b) The plane of the alley between the trees has been "tipped up" to a position more nearly parallel to the picture plane. (c) The distance does not fade out in aerial perspective, and foliage interlaces the two sides of the picture. (d) Cézanne has reduced the number of trees, which can be counted in the photograph of the motif, thereby modifying the funnel-like depth and recession. (e) An important pattern of foliage is prominent in the upper right-hand fourth of the picture, and this light shape is carried into the central area of deepest recession; the most recessive area of the deep space is thus brought into relation with the most prominent plane of the foreground foliage.

(f) Strong construction lines, similar to those in Plate I, Diagram V, carry through from one side of the picture to another. These construction lines, together with the modification of perspective effects, offer adequate compensation for the deep space represented. The picture "stays on the plane."

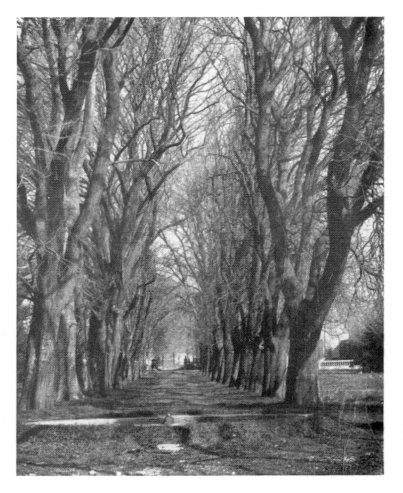

Photograph of the motif

PLATE VI

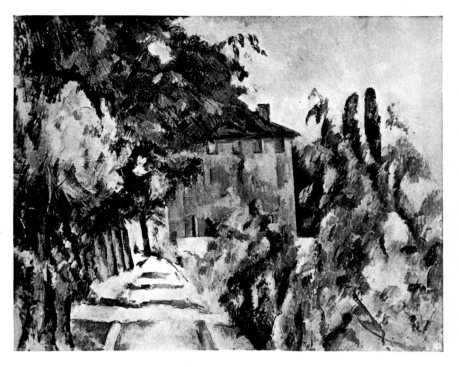

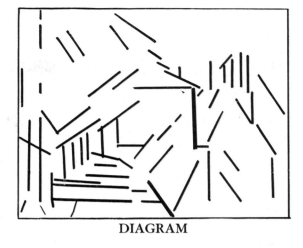

DIAGRAM

The Jas de Bouffan.
CÉZANNE

IN THIS painting of the Jas de Bouffan, Cézanne does not seem to have eliminated realistic perspective to the radical degree observed in previous paintings analyzed, particularly Plates II and III. However, when the position of the camera in relation to the subject is considered (the photograph of the motif actually does not take in as much of the surrounding nor as much foreground space as Cézanne has represented in his painting), it will be seen that perspective has been drastically modified.

The interesting problem to analyze here is the means Cézanne has chosen for achieving a satisfying equilibrium in a picture that contains both a converging road and diminishing tree trunks. (a) First of all, he has built up the forms in the right foreground (although the photograph of the motif gives no suggestion for most of these forms and one must conclude that the garden has been altered) so as to create a balancing complex of volumes to oppose the enormously heavy trees on the left.

(b) The less obvious means of achieving two-dimensional balance have been indicated in the diagram, where a powerful complex of two-dimensional construction lines, running vertically, diagonally, and horizontally, makes an intricate and firmly knit pattern (see also Plate I, Diagram V, and Plate XI, Diagram II, for the same problem). This linear pattern affords two-dimensional balance by counteracting the overpowering recession into space observable in the photograph of the motif. (c) Particularly important in lending stability are the horizontal lines across the road. The trees and road at the left are prevented from expanding out of the corner of the picture by means of these horizontal directions. It is interesting to note that these horizontals (actually they are important color shapes that were suggested by shadows cast by early morning sunlight) are used by Cézanne for a purely abstract, nonrepresentational purpose.

(d) The enormous tree trunk that expands out of the picture on the left side of the photograph of the motif has been held back in Cézanne's picture. (e) A rhythmic quality has been achieved through the tipping of the axis of the house. This leftward tipping is repeated in many of the trees at the left of the road. (Incidentally, the same tipping axis exists in the photograph of the motif, but there it is obviously a photographic distortion. See Plate VII, Figure 3, for an accurate photograph of the house.)

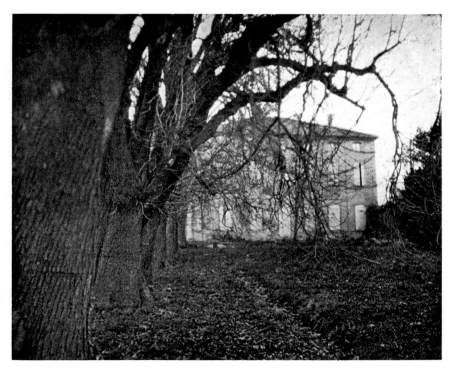

Photograph of the motif.

PLATE VII

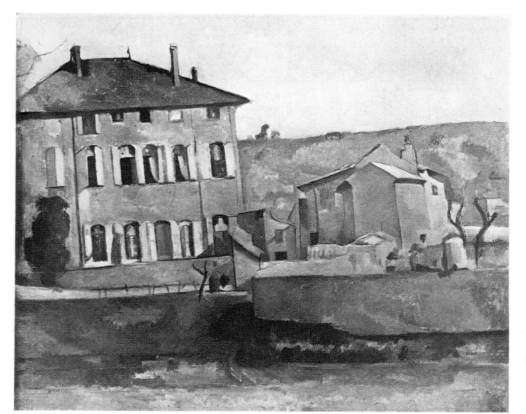

Figure 1.
The Jas de Bouffan.
CÉZANNE

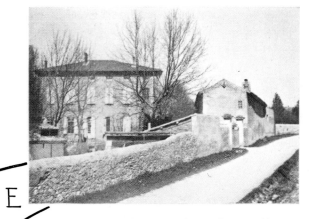

Figure 3. *Photograph of the motif*

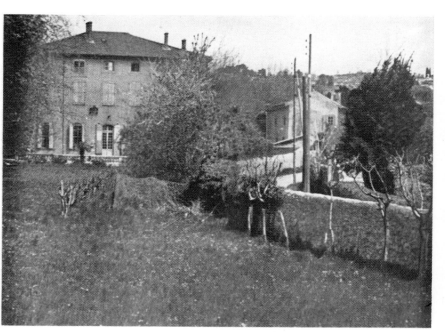

Figure 2. *Photograph of the motif*

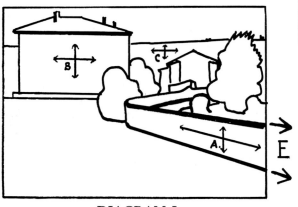

DIAGRAM I

DIAGRAM I is a tracing from the photograph, Figure 2, which was taken from about the same eye level that Cézanne used for his painting. The arrows expanding beyond the frame at letter E indicate the strong perspectival protrusion of the wall that would necessarily occur toward the right in any photograph or scientifically correct drawing, made either from a higher or a lower eye level than that seen in the photograph, Figure 2. The second photograph of the motif, Figure 3, which was made from the other side of the road, shows the actual distance between the wall (marked A in the diagrams) and the buildings. The curve in the road and wall is not even indicated in Figure 3 except by the drawn lines extending beyond the lower left-hand corner, marked E. The radical space compression which Cézanne has effected in his painting, Figure 1, can easily be judged by comparing it with the photograph, Figure 3.

PLATE VII
(*continued*)

DIAGRAM II illustrates some of the forces at work in one of Cézanne's most extraordinarily dynamic compositions. The photographs of the motif, showing the buildings to be those of the Jas de Bouffan, the Cézanne family's country estate, explain the origin of the formal relations, but they give no indication of the dramatic and emotional force that Cézanne's painting expresses. This painting has always suggested to me the setting for a melodramatic scene in a Dostoievski novel, and when I first went to Aix I was particularly anxious to discover the actual motif. I thought possibly it would be found in some barren workers' section near the outskirts of town. The photographs shown here make the disappointing and prosaic truth clear enough.

The most obvious distortion is the dynamic tipping of the house on the left. The dramatic quality of the picture derives principally from this strong leftward movement of the axis of the house, but the window shapes, giving a somewhat haunted or deserted aspect to the scene, also contribute to the dramatic effect. The leftward-leaning axis of the house may be understood as a distortion that increases the tension of the house in relation to the four sides of the frame as well as in relation to the planes marked A and C.

Cézanne's most important transformation of the motif becomes apparent when one compares the plane of the stone wall, marked with axis bars and letter A in Diagram II, with the same wall, similarly marked, in Diagram I. In Diagram I it is obvious that there is no organization, no satisfying correlation between planes A, B, and C. Plane A is the unruly element, as is emphasized by the arrows expanding beyond the frame at E, in Diagram I. Turning the wall, A, back so that it became parallel to the picture plane, as we see it in Diagram II, not only eliminated the forward rotation and expansion of the wall, but also brought plane A into relation with the two other basic planes, B and C. A satisfying tension now exists between planes A, B, and C, as is indicated by heavy broken lines from the back of plane A to plane B, and from the back of plane B to plane C.

The movement into space, so closely related to the spatial tension between planes A, B, and C, is indicated as beginning at the lower left with the curved arrow marked I. The spectator's eye follows this movement into depth and is turned upward by the parallel plane of the house. The eye is easily drawn upward by the strong vertical lines of windows, drainpipes, and chimneys; but the leftward tipping of the axis of the house must be recognized as the principal magnetic force, pulling the eye into space toward the upper left and up to the house roof. The diagonal plane of the roof, marked with axis bars and letter H, carries the movement past the corner of the picture into the sky at the top center of the picture. The roof's strong diagonal contour on the left prevents the movement from leading out of the upper left-hand corner, and fortifies the turning of the movement toward the right. The pull between the back of the house and the distant hill, plane C, helps to bring the eye over to the right, into the deepest recess of the space. The heavy curved arrows, charting the circular spatial movement, continue downward over the roofs of the complex of buildings and the trees on the right. One may say that the movement returns to the picture plane to the point at which the eye was first led into space, at arrow I.

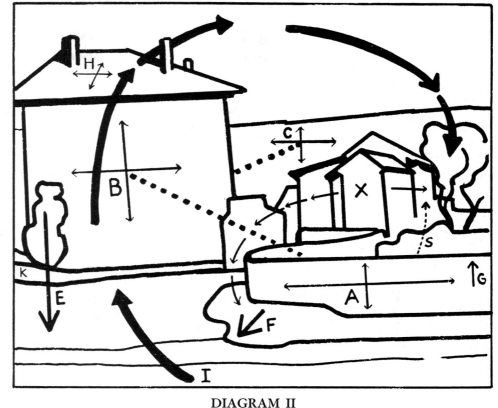

DIAGRAM II

Some of the minor forces contributing toward the balance between the house on the left and the complex of volumes on the right are indicated by various smaller arrows. For example, the vertical arrow E at the far left, pointing downward, indicates the dropping weight created by the leftward tilt of the axis of the house. An important tension exists between the dark tree, pierced by arrow E, and the grass shape at F in front of the wall, plane A. Of course, the tree is obviously rising in relation to the grass shape at F. With the left side of the house lower than the right side, there is consequently a slight rotation of the plane of the house; it comes out at the left, and at the right turns back into depth. But notice the subtle upward turn in he path just to the left of arrow E, at K. By turning this path upward, our master of space drawing has created a feeling of space behind the house, even on the left, and has prevented too strong a protrusion at the left side of the house. Place a finger over the lines to the left of letter E, and a disturbing effect of too heavy and dropping weight in the house, which Cézanne has avoided, will at once become evident.

In relation to the downward-and-forward-coming tendency of the house at arrow E, observe the rising arrow at the extreme right side of the wall, letter G. Not merely has the wall been made virtually parallel to the picture plane, as is indicated by the axis bars at A, but the upper line of the wall rises above the horizontal toward its highest point at G. A ruler placed along this upper contour will show that it is not parallel with the bottom line of the frame. The purpose of raising this contour is to make the space between plane A and plane C shallow and closed, so as to keep the rich volume and space activity between these two planes under control. Turn back to the drawing of this same wall in Diagram I and notice again how radically it has been altered in Cézanne's painting, where it has been pushed back even beyond parallelism with the picture plane. Closely related to the inward emphasis at arrow G is a strong forward counterthrust in the dark grass shape at the diagonal arrow, F. This movement "compensates" for the left-hand convergence in the wall, as the latter goes back into space toward the turn. The wall finally makes this turn to the right, as it does in the

PLATE VII
(*concluded*)

photograph of the motif, Figure 2, but in Cézanne's painting the turn is extremely sharp, like that of a folded ribbon. The space between the front plane of the wall and the buildings behind has thus been made extremely shallow, as is indicated by the dotted, curved, tension arrow, marked s. The remarkable and typical phenomenon to observe here is that while the space between the plane of the wall, A, and the plane of the hill, c, has been closed up, made shallower, nevertheless there is a rich activity of rotating and expanding planes working to create deep space illusions within this controlled depth area. Indeed, the relation between solid volumes and void space, in the right-hand part of this picture, is perhaps more provocative than in all but a few other paintings by Cézanne.

The front plane of the smallest house is marked x. The side walls of this house, as well as those of the rear sections of outhouses, expand to both left and right of plane x, giving Cézanne's volume drawing in these buildings the extreme, distorted expansion that can be found, to a comparable extent, only in Byzantine icon painting and in modern Abstract art. Arrows show how the planes overlap and move back to the left, and likewise to the right. The arrows moving to the left have been continued in a curve, to indicate a clearly felt movement or countermovement working rhythmically within the main spatial movement previously described and illustrated with the heavy curved arrows.

The effect of the expanding walls is twofold. First, since both the left- and right-hand walls can be seen, the illusion of three-dimensionality, of "seeing around" the object, is increased enormously, so that the effect of what is sometimes called the "fourth dimension"[2] is attained. (To me, however, the two terms often used in this connotation, "universal perspective" and "fourth dimension," seem pretentious and unnecessary.) The second function of the expanding walls is to create a return from the deep space to the original two-dimensionality of the picture plane. In no painting by Cézanne is this dualistic phenomenon more clearly evident. It can be studied extensively in Byzantine icon painting; in the abstract art of Picasso and Braque it is one of the favorite and most familiar devices, particularly in the drawing of tables. The extraordinary illusion of deep space achieved through this complicated arrangement of rotating planes seen from different points of view and all working within the arbitrarily compressed and shallow space between planes A and c is one of the marvels of Cézanne's art.

Refer to Glossary, Part One, Diagram II, where the same painting is analyzed as it relates to the "picture box."

The question remains, How many of the elements of space drawing just described were found by Cézanne in his motif? A casual comparison of the photograph of the motif with the painting might lead to the conclusion that Cézanne invented the more complex form factors which have just been analyzed. The conclusion would be incorrect. Both the photographs of the motif, particularly Figure 3, prove that the expanding walls existed in the motif. Certain plaster marks, indicated by the arrow near the apex of the roof, show that the small building, marked x in Diagram II, has been enlarged in recent years so that there is no longer a break in the roof line of the small buildings on the right. At the time I took the photograph, Figure 3, I made a very careful examination and ascertained beyond doubt that such an addition had been made. The trees in the photograph, Figure 2, obscure a good part of the right-hand wall, but another photographic version that can be studied (in Fritz Novotny's book, *Cézanne und das Ende der wissenschaftlichen Perspektive,* Abb. 27) shows conclusively that Cézanne actually found the expanding walls in his subject. Observe that the expansion is not extreme in our Figure 3 because the camera was much closer to this right-hand house than it was in Figure 2, where Cézanne undoubtedly stood.

The foregoing observations are certainly not intended to prove that Cézanne painted only what he saw. The aim is simply to be honest and objective, whether Cézanne's greatness is enhanced or not. Disregarding the motif, the painting is a remarkable achievement in drawing and composition, containing some of the most readable lessons for modern art, and space organization in general, that can be found in any picture of any era.

To the person who is only able to react to the illustrative or story-telling drama of the painting this long and detailed analysis may seem a cold denial of feeling. The intention has been to show that the real drama in the painting derives from the plastic forces, without questioning the great importance of emotional and psychological associations with subject and locale. Cézanne consistently expresses the spirit of the subject, but the mysterious, Dostoievskian quality, mentioned previously, depends far more on plastic, organizational devices than on iconographic or literary means. Incidentally, there has been no mention of color modulations in the examination of this picture. All the structural problems analyzed depend on the use of line and plane, the planes being more nearly flat than in most pictures by Cézanne.

[2] See diagram for Plate XIV.

PLATE VIII

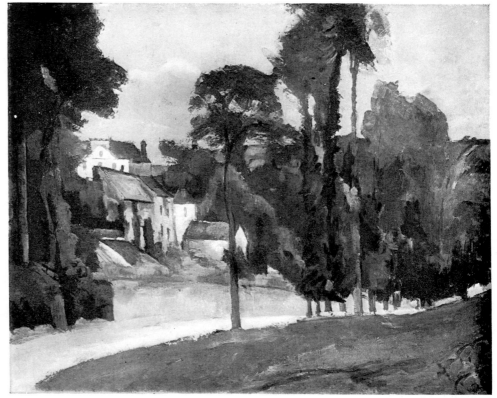

View of the Hermitage at Pontoise. CÉZANNE

Courtesy of Durand-Ruel

THE TWO PAINTINGS shown here, done from the same motif by Cézanne and Pissarro, demonstrate emphatically the difference between the space organization of a great master and that of a lesser artist. (Another version of the same subject by Pissarro presents a different composition, which lacks the disturbing space effects seen here but is a less dynamic picture and would scarcely warrant being compared with Cézanne's version.) It should be noted that Pissarro's execution and handling of the medium is far more skillful than Cézanne's. (a) In composition, however, the Pissarro is somewhat like those camera views of motifs shown earlier in this book which allow the foreground plane to protrude and expand. (b) A strong movement from left to right seems to run out beyond the frame, expanding on the left and diminishing out at the right.

(c) In Cézanne's painting the foreground area has been made very small and its roundish volume has been flattened. As a result, the trees rise up in full majesty and importance. (d) Even though the road turns out at the corner on the lower left, as it does in Pissarro's picture, important trees on the left rise to the top of the picture and turn inward at the top, thus "closing up" the picture within its frame.

(e) The effect of deep space is no less clear in Cézanne's painting than in Pissarro's; in fact, I would call Cézanne's picture more spatial. The difference is that Pissarro has recorded conventional and realistic space, without balance and compensations, while Cézanne has created space that is truly pictorial and plastic. It is three-dimensional space that holds its place on the picture plane. The solidity of Cézanne's organization, when compared with the skillful Pissarro, is even more impressive when it is realized that this painting belongs to Cézanne's rather early, pre-Impressionist or Pissarro period. It should be mentioned, however, that several of Cézanne's early pictures, done under the influence of Pissarro, do show a photographic kind of perspective. I refer to Nos. 144 and 145 in the Venturi catalogue, pictures comparatively banal in composition.

Comparisons may also be made between Van Gogh's paintings and subjects in *Art News,* April 1–14, 1942, in an article by John Rewald, "Van Gogh vs. Nature: Did Vincent or the Camera Lie?" Van Gogh's paintings rarely if ever attain anything comparable to the classic space composition that is the foundation of Cézanne's art. Van Gogh's space is sometimes chaotic; it is based on a simple-minded acceptance of the exaggerations that develop in a naïve use of mechanical perspective. Van Gogh's Expressionism is achieved at the cost of the classical values of sound space organization. Thus the photographs of Van Gogh's motifs present a problem quite the opposite of that so consistently found in the analysis of Cézanne's.

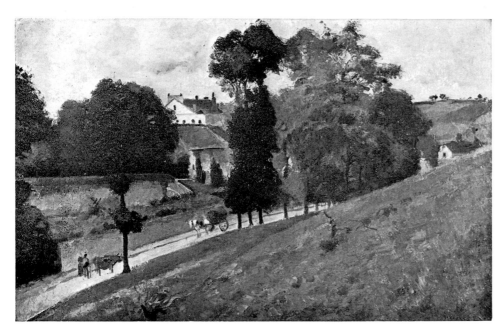

View of the Hermitage at Pontoise. PISSARRO

PLATE IX

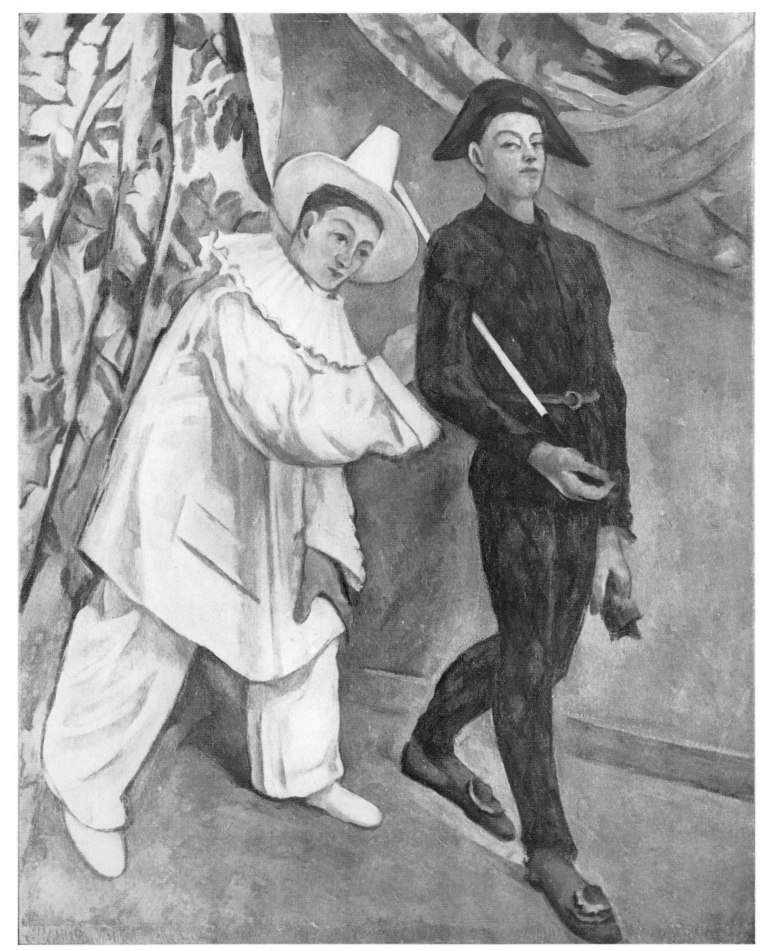

Figure 1. *Mardi Gras*. CÉZANNE

PLATE IX
(continued)

THUS FAR, emphasis has been placed upon Cézanne's ability to organize the total volume of the three-dimensional space (the "picture box") without overstepping the limits imposed by the fundamental nature of the picture plane, which is a two-dimensional surface. In the paintings previously analyzed, as well as in those which follow, the central problem of composition in Cézanne is found to be his mastery of this dualistic and eternally conflicting paradox. We have already seen how consistently and, when necessary, how radically Cézanne was willing to modify or even reverse perspective in order to preserve a relation between foreground and background, and a relation of both to the picture plane so that the final effect is that of a self-contained artistic unit rather than a photographic imitation of realistic space, unbounded by picture frame or picture surface. Cézanne's revolutionary, or perhaps one should say regenerative, role was to bring back to painting the full realization of this double role of two- and three-dimensionality. Caution against assuming that Cézanne had more than an intuitive grasp of this problem has already been suggested. The painting called the "Mardi Gras" is a particularly significant example to study with this consideration in mind.

The "Mardi Gras" is a monumental work and cannot be brushed aside as an unsuccessful early effort; yet it reveals a severe struggle with the space organization, and if there were large numbers of pictures that presented equally awkward solutions of space composition, the basic premises of the work in hand would be more difficult to illustrate with the works of Cézanne.

The diagram presents, in terms of stage space, an approximation of the total volume of three-dimensional space represented. The stage or "picture box," observed from a position to the left and higher up, is open at the top, and the broken lines are an improvised continuation of the draperies to a curtain rod above, with the back wall indicated by the letter B and plane axes. The front plane of the "picture box" is more heavily outlined than the side and top planes. The heavy base line in the diagram is indicated as *original base* because there is reason to believe that Cézanne's picture format originally had this lower limit (examine the crease running across the bottom of the picture through the harlequin's foot, which should be visible in the reproduction, Plate IX). In the diagram the harlequin gives the illusion of stepping out of the frame, in front of the picture plane itself. Even after Cézanne had presumably unfolded his canvas at the bottom, indicated at *corrected base,* enlarging the surface enough to make room for the harlequin's foot, the forward movement of the harlequin is still a disturbing factor. *This protrusion and forward movement of the harlequin is what upsets the balance of the total spatial organization in relation to the picture plane.* Cézanne's struggle with this area is clearly evident in the tortured painting and outlining around the lower limbs and feet. In comparison with the simplicity and strength of the clown in white, who holds his place in deep space and on the picture plane, we may safely conjecture that Cézanne was unsure of the problem to be solved and kept struggling with the harlequin, continually emphasizing the contours, adding cast shadows and forcing a greater and greater protrusion, as is suggested by the heavy arrows at the bottom of the diagram pointing downward and running out of the picture and destroying the usual "closed" effect. Finally realizing that more floor space must be provided for the foot, he unfolded and restretched the underpart of his canvas and then finished the picture. But the strong tension pulling between the overly long feet, plus the other elements of overemphasis noted in this region, leaves the picture in an unsatisfactory state.

Another factor contributing to this protrusion on the right is the rotation of the background wall plane, marked with letter A and the symbol of the plane's axes. The two small planes drawn at the right, marked with axes and lettered a and b, should quickly explain

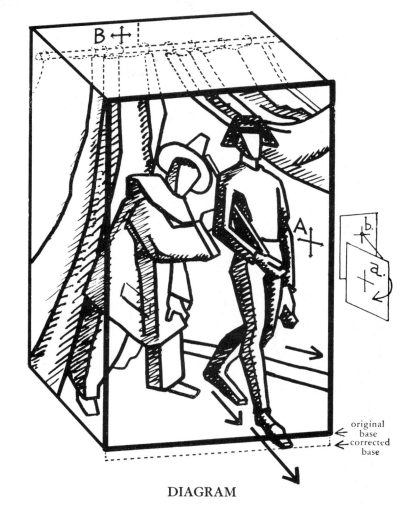

DIAGRAM

the rotation of the dynamic plane of the wall, A, and its movement away from a static position. The imagined back wall of the "picture box" is made to serve, here, for the theoretical static plane, and is marked with axis bars and letter B. (The picture plane itself is always the original static plane of a picture.)

The foregoing analysis may seem an unjustifiable laboring of an unimportant point, particularly since Cézanne made at the base a correction that went far toward solving the problem. But the fact that the correction was made is itself significant and gives strong grounds for concluding that Cézanne did not arrive at his masterly space compositions by happy accident and that he was often forced to struggle *consciously* with the paradox of controlling the deep space in order to arrive, ultimately, at a balance with respect to the picture plane. Attention should also be paid to other pictures by Cézanne that show signs of serious struggle with this problem or even indicate a failure to solve it, for no more serious mistake could be made than to believe that Cézanne was always a perfect master of composition.

The paintings that will be mentioned bear numbers from the Venturi catalogue, and, as usual in the present book, the very early work will be discounted as having too slight a bearing on the question of Cézanne's composition. In No. 175 the lower part of the picture is a diagonal and protruding roof plane too large in scale and having little relation to the interior forms of the town. If all or most of this roof were cut off, a much better composition would remain.

In No. 177 a section of a house protrudes at the lower right and juts out in front of the picture plane, thus disturbing the spatial unity of the composition.

In No. 243 the man at the lower left seems to be standing below the frame and in front of the picture plane. But it would be wrong to ex-

PLATE IX
(continued)

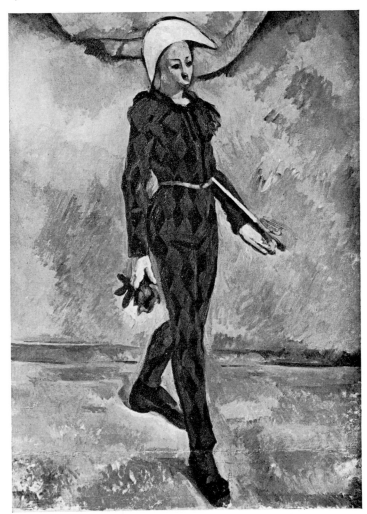

Figure 2. *Harlequin*. CÉZANNE

interweaving the deep space with the picture plane, that even the vertical tree is held in place.

In the "Nude," No. 551, the pears and cloth at the upper left are obviously a fragment of still life unrelated to the nude figure. The picture should not be regarded as a finished composition.

One of the most valuable comparisons can be made between Nos. 553, 554, and 555. The same struggle as that analyzed in Plate IX can be seen in these three paintings entitled "Harlequin." No. 555 appears to be the least successful painting and is probably the first version attempted. The front foot extends below the frame, giving the figure the effect of being forward of the picture plane. No. 554 is more nearly complete, while No. 553, the "Harlequin" reproduced here (Figure 2), is a thoroughly satisfying composition. A crease in the canvas, running across the bottom through the harlequin's ankle, and another through the toe, indicate that Cézanne may have added these lower sections to allow room for the entire foot—just as shown previously in "Mardi Gras" (Figure 1). Whether the painting as reproduced here was an afterthought or the first version makes little difference to us. As it now stands it is a fully satisfying spatial organization.

Mention should perhaps be made of the card-player series, which, on the basis of the foregoing discussion, might be misinterpreted as compositions that allow forms to run out. But in No. 556, one of Cézanne's finest creations, the form is thoroughly synthesized, the deep space being related to the picture plane and finally "closed" within the picture format. Likewise, most of Cézanne's portraits are highly satisfying space organizations, even though the frame sometimes cuts off the figure unexpectedly. No. 561, however, might be mentioned as a portrait that is surrounded by too large a volume of negative space, and No. 697 as one that is not satisfactorily related to the background forms. But a thorough analysis of these complicated pictures would take up more space than the present book affords.

In No. 726, the standing bather in the foreground is out of the picture. In the majority of Cézanne's paintings of bathers all the figures are firmly planted within the format and on the ground plane.

The compositions just mentioned stand out, then, as exceptions to the precepts of space organization that are basic for the views held in the present study. Perhaps most remarkable about this list of paintings is its small total. The only justification for giving up space to these pictures at all is the wish to approach the problem of Cézanne's composition without avoiding controversial and problematical issues.

Since an attempt to explain certain creases in the canvas has already been made, perhaps No. 804 should also be brought into the discussion; the factor of deep space and its relation to the picture plane plays no part in our explanation for the creases in this canvas of the Sainte Victoire. The creases indicate Cézanne's vacillations concerning the relation of the mountain and its surroundings to the *frame* or *picture format*. My own interpretation is that the smallest rectangle was Cézanne's final decision. (Vollard, if he is responsible, was justified in stretching out the whole canvas, if only for documentary interest.) The area within this smallest rectangle is obviously the most compact arrangement, and it has been developed and repainted far more than the area to the right.

pect too much of the pictures thus far cited since they are still too early to represent the mature Cézanne.

In No. 429, the "View of L'Estaque" from the Metropolitan Museum of New York City, the buildings in the lower foreground tend to slide forward, out of the picture frame. It is particularly revealing to compare No. 429 with No. 493, a later version of the same view of L'Estaque, now in the Chicago Art Institute. In No. 493 the foreground buildings have been lifted up and do not have the tendency to slide out noted in No. 429.

In Nos. 454 and 455, views of the Sainte Victoire from Bellevue, the vertical tree on the left had always been a disturbing element to me until I saw No. 455 in the Phillips Memorial Gallery in Washington, D. C. Although the tree runs out at both bottom and top, in these paintings, there are forceful horizontal extensions of the branches as well as powerful horizontal directions across the valley that offer significant compensation. But on seeing No. 455 in color, all my earlier doubts disappeared. The color provides so perfect a surface fabric,

VIII

THE PROBLEM OF SCALE AND THE CONTROL OF VOLUME AND SPACE

IN THIS SECTION, paintings are compared with their actual motifs in order to determine how far Cézanne reversed the natural order of size and scale. Foreground sizes tend to be diminished and flattened, while background areas are made larger and more important.

PLATE X

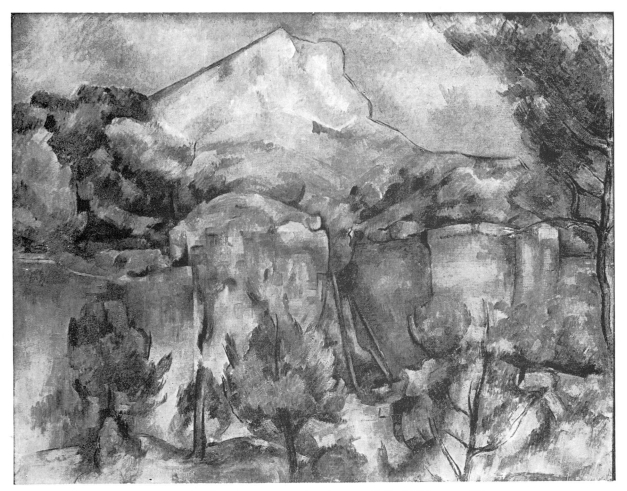

The Sainte Victoire, Seen from the Quarry Called Bibemus. CÉZANNE

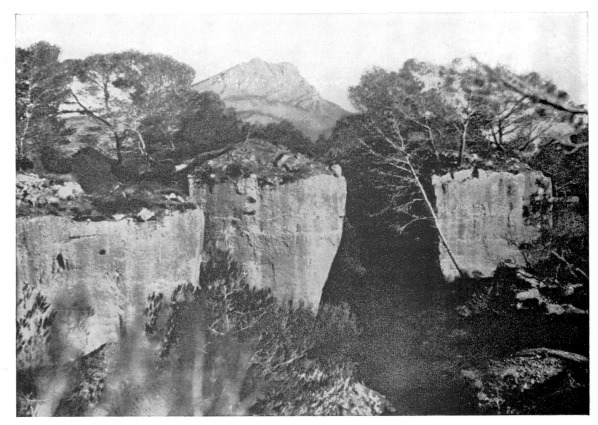

This view of the motif is a composite of two photographs. Small trees now obscure most of the mountain from this point, and it was necessary to cut them away (in the photograph) and insert a view of the mountain taken from a position slightly to the right. The combination is presented in the interest of clarity only and is in no way intended to fortify the arguments in the analyses.

Photograph of the motif

PLATE X
(*continued*)

DIAGRAM I demonstrates the marked change that has been made in the scale of the mountain. The shaded area, marked A, represents the relative size of the distant mountain as seen in the photograph of the motif. The cross superimposed over A, which represents the two imaginary axis lines of Cézanne's enlarged mountain, emphasizes the rising power, the verticality, of the enormous plane of the mountain. Cézanne has more than doubled the size of the Sainte Victoire. The illusion of magnificent height which Cézanne has achieved through these measurable plastic means is akin to the exaggerated sense of its height that one has on actually seeing it—as I had when I first discovered the motif. But the photograph of the motif utterly fails to suggest the grandeur, the massiveness, of this luminous white mountain. The usual aerial perspective and diminished size are to be seen even in this strong photograph, while in the painting the mountain rises up vertically, maintains its relation to the picture plane, and succeeds in holding its balance with the volumes of the foreground.

Cézanne's painting, as compared with the motif, illustrates graphically what should be understood and taught more widely as the basic mechanics of drawing and composition, the fundamental plastic means of expression. A methodical set of problems is here presented: 1. How can a mountain be made to look big? By drawing it large in relation to the scale of the foreground shapes, and avoiding the diminishing of sizes that is the result of applying

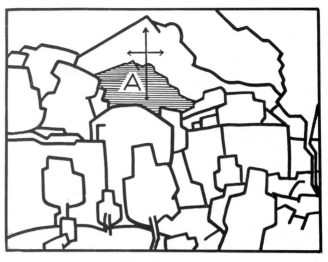

DIAGRAM I

the rules of scientific perspective. 2. How can the forms in the far distance be made to maintain the importance they have in the mind and feeling of the spectator? By avoiding aerial perspective and fuzziness of contour (Impressionism), and by drawing the forms in the distance with the force and clarity used in foreground forms. (El Greco speaks virtually the same language in a document explaining his imaginary landscape of Toledo; see page 31, above.) 3. How, by other means, can the background or distant forms be prevented from falling away? By *tilting up* the back planes vertically, instead of allowing them to fall back on a diagonal plane. (Here we recall the changing eye levels in Byzantine icons, in which buildings in the deep space are often tilted forward to reveal the top, or roof, plane.) 4. How can a canvas be kept alive and rich throughout, so that there will be no dead spots, no illusion of "holes"; so that the two-dimensionality of the picture plane is not distorted by an attempt to imitate sculpture? By flattening out those forms which are too boisterous; by avoiding the disturbing effects of light and shade so conveniently illustrated here in the photograph of the motif; further, by creating an interlocking and intersecting of planes, so that one volume "passes" into another, creating at some of the contours the fusion that we observe in this intricate painting. The general fusion of the mountain with the small bushes on top of the cliffs is particularly significant.

Cézanne illustrates here his lack of interest in textures as such. In fact, most people, seeing the black-and-white reproduction of this painting, unaccompanied by the photograph of the motif, believe that the central cliff shapes are reflections on water! The interesting pebble-and-rock motif on top of the cliffs, in the photograph of the motif, has been eliminated, and the cliffs are painted in vertical brush strokes that give the false illusion of reflections. Cézanne was exclusively concerned with building form, with explaining the structure and the small planes in every object. His method of hatching brush strokes, of creating innumerable intervals of color with tiny planes, produced the luxuriant surface quality we see in this painting. This quality can logically be interpreted in terms of textural concept because the different textural weights are so well balanced throughout the picture.

The sky, the mountain, the trees, the cliffs—each of these areas has its own quality and weight; at the same time, the differentiation is much less than that observable in the motif. This lack of strong differentiation in the surfaces contributes to the unified effect, so that the entire picture is pulled together into one plastic structure, a continuous and uninterrupted surface fabric.

DIAGRAM II is an illustration of the principle of organization so often met with in Cézanne's work: planes and volumes moving around an imaginary central axis. The axis is indicated with dotted lines. The heavy arrows represent the circular path, which can be apprehended subjectively, moving from foreground into distance and returning again. It is the power of this circular movement that gives the painting its ultimate "closed" effect. Actually, this canvas has many elements of open form, for example, the trees at the bottom, and the large tree at the right which runs out at the side; personally, I find these latter elements sufficiently resolved and not at all disturbing. In view of this openness, the binding power of the circular movement can be still further understood and appreciated. The small arrows indicate the endless movements and countermovements from one overlapping plane to another. The essential planes have been indicated, in the diagram, without departing too much from the appearance of the picture. It is easy to study the painting by this method, easy to understand why

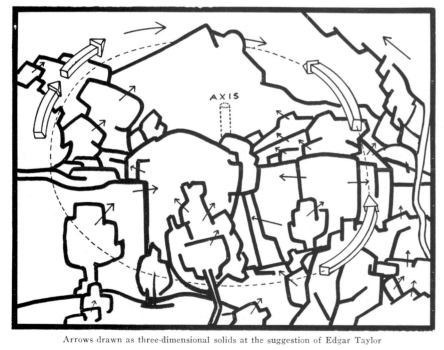

Arrows drawn as three-dimensional solids at the suggestion of Edgar Taylor

DIAGRAM II

it remains closed within its frame, the picture format. More important, the movement into depth and out of depth, the continuous rhythmic flow from one part to another, all take place within the limitations imposed by the two-dimensional picture plane. In all the individual forms there is an astonishing resemblance to the motif, particularly in the mountain and the rocks, which have not been altered by time and growth. Cézanne's picture, however, becomes a new reality achieved by purely plastic means, by color and form alone.

PLATE X
(*continued*)

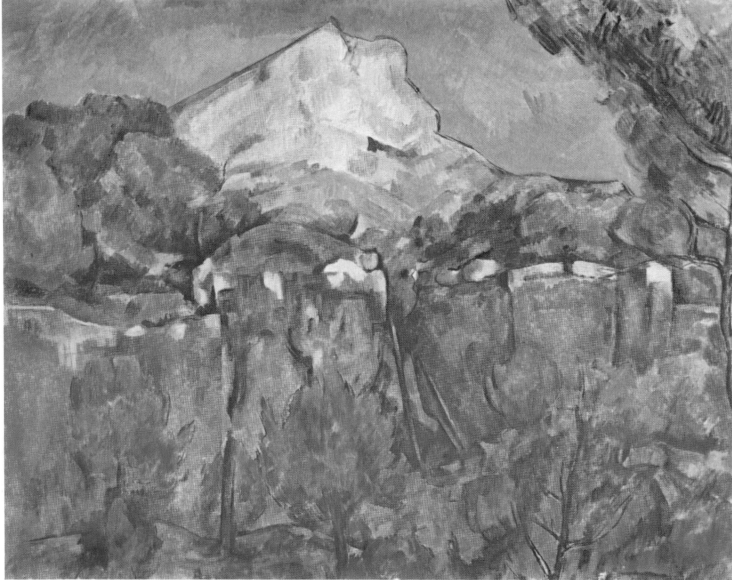

Kodachrome by Shaeffer, Baltimore

The Sainte Victoire, Seen from the Quarry Called Bibemus. CÉZANNE

DIAGRAM III
THE ORANGE AND GREEN SHAPES

DIAGRAM III. The orange mass of cliffs and the green tree shapes are here reduced to two-dimensional patterns. The green trees are indicated as a dark area of horizontal directions, while the orange mass is represented by the lighter area of vertical strokes. Within the green area certain trees or parts of trees are outlined in order to emphasize (1) the great contrasts in their sizes, (2) the variety in their shapes, and (3) their geometric or otherwise positive, decorative character. (4) The fascinating variety in the space intervals between the different trees and groups of trees should also become more clear in the black-and-white diagram.

The diagram should explain (5) the concept of the distribution, the interweaving and interlocking of green shapes into one network embracing all parts of the pictorial surface. (6) The complete interlocking of the orange with the green shapes should also be clear. The small color planes that dominate the surface structure throughout should be understood as the secret of Cézanne's method. It is a powerful two-dimensional structure that seems to be clearly symbolized in Diagram III by vertical and horizontal lines.

PLATE X
(continued)

DIAGRAM IV. The climactic mass of the Sainte Victoire is here shown in combination with the small white shapes to which it is related. Without these small areas of repeated neutral white the mountain might remain isolated from the rest of the color scheme. There is no interweaving action, based on contiguous passages or strands, between these white shapes and the mountain; the relationship takes place simply through distribution and repetition. The relationship between the white shapes and the mountain is described as a tension or magnetism that affords unity. (See paragraph 4 below.)

DIAGRAM IV
THE WHITE SHAPES

THE COLOR reproduction offers additional information for our study of the preceding Plate X and diagrams, as well as our sole opportunity for correlating discussions about color, offered in early chapters, with a specific illustration. The magnificence of Cézanne's color is fully realized in this painting, and the reproduction should give at least an approximation of the original relationships.

To one who has never seen the strange colors and forms of the ancient quarry region called Bibemus, not many miles from the town of Aix, this work might be taken as evidence that many of Cézanne's paintings were highly imaginative, abstract, inventions. As a work of art, complete and self-sufficient, it should indeed be regarded as a creation of that kind, for the plastic means of color and form have here been combined to create an abstract order that transcends the reality of appearances and of local color. Visual sensation is derived from the impact of volume relationships and the symphonic organization of color. The reality is here, in the picture itself.

And yet, for those who have seen the quarry of Bibemus, not the least remarkable fact about Cézanne's painting is its faithful recording of the actual local color. A clue to the color and form of all Cézanne's quarry pictures can be found in this reproduction, and Plates XII, XXXI, XXXII, and XXXIII should be "read" with this guide. I wonder if ever before in the history of painting there has been a comparable expression of the color and form, the atmosphere and light, of nature thus combined with abstract meaning and emphasis. Cézanne's uniqueness and perhaps his historical greatness is found in his power to synthesize abstraction and reality.

A systematic analysis of the color organization should place emphasis on the simple complementary color scheme, which is a theme founded in the warm and cool contrast of orange against green and blue. These are the elemental colors of Provence, and most of Cézanne's Provençal landscapes are dependent on them. If for a moment we disregard the tiny nuances and color intervals, we shall see that the structure of the painting is founded on the relationship and distribution of large masses of color.

1) The orange of the cliffs and earth is the most intense and dominant color, and it covers a rectangular area involving more than half the entire surface of the canvas. (This area is represented in Diagram III by vertical stripes.)

2) The green trees are not quite so completely saturated with color, but they form the most complex shapes and movements of the picture (see, in Diagram III, the darker area of horizontal stripes); (a) some are small, others are large, and they run a gamut of triangular, conical, round, and angular geometric shapes. (b) The space intervals between the trees are surprisingly varied and the result is a powerful effect of tension between all the green tree shapes. (c) In spite of their complexity as shapes and the wide range of color changes, the trees are held together in one vast area of related green (see, in Diagram III, the simplified dark area). The unity of the green derives partly from the basic similarity in the *hue* of the individual trees, (d) but also from the grouping of some of the trees into masses or complexes, as at the

upper left. (e) The most subtle, and perhaps the most significant, unifying principle is found in the narrow strands or passages of green that connect the various individual trees and also connect the trees of the upper regions with those of the foreground. This all-embracing network of color movements, reaching out like the arms of Siva, not only achieves an interweaving and interlocking of the scattered shapes of green, but also provides for the final locking together of the green shapes with the underlying orange mass. The interlocking of upper and lower green areas is found at the right-hand edge of the picture and through the center (see Diagram III). (f) An especially fascinating aspect of the color problem may be studied in the apparent difference in the green of the upper part from that of the lower part. Actual changes in the green hue do occur, of course, but the phenomenon involved here is that in the lower half of the picture the green is thrown against orange, while in the upper regions the same type of green hue *appears different* simply because it is seen against the opposite colors of blue sky and neutral mountain. (g) It should also be noted that the leafy texture of trees is achieved through loose hatching of the brush marks that build up the small color planes. Texture as a decorative element is entirely absent, however, and the surfaces merely change with the character of the form. Cézanne's form, as usual, has the looseness and freedom of open form; and yet, because of the firm outlines and the somewhat structural nature of the color modulations, it attains the compactness and solidity of closed form.

3) The blue sky provides the widest contrast of cool color against the complementary orange cliffs. It is the most isolated color in the organization, but its importance as a cool contrast and foil for the orange cliffs saves it from taking on the character of realistic local color. (a) Although the blue color of the sky is not repeated in large and obvious amounts, significant repetitions in the dark parts of the green trees, and even in the orange cliffs, provide the necessary interlocking with other parts of the picture. It was this distribution of the bluish hues that Cézanne had in mind when he said, "Nature is more in depth than in surface, whence the necessity of introducing into our vibrations of light, represented by reds and yellows, a sufficient sum of bluish tones, in order to give a feeling of air." (b) The blue provides atmosphere and a feeling of infinite space without falling away in aerial perspective.

4) The climax of the color orchestration is reached in the towering bulk of the Sainte Victoire. This magnificent and lordly form is of a

PLATE X
(*continued*)

whitish, neutral color, and being neutral, (a) it acts as a foil for the other saturated color shapes. As color, its innumerable color intervals add up to neutral, but as form it is the culminating positive shape in the design. (b) The mountain color is not interlocked, by continuous arms or strands, with other parts of the picture, as the green tree shapes are; the interweaving takes place simply through repetition and distribution—as, clearly, in the whitish areas in the orange cliffs and the darker neutral rocks at the lower right (see Diagram IV). (c) We have previously referred to this process of repetition as a *tension* between colors; in relation to the white areas in this painting the use of the term tension seems particularly cogent. The eye is drawn as if by magnetism from the mountain to the smaller spots of white on the orange cliffs. (d) The mountain is also related to other parts of the picture through the distribution of its darker, purplish color planes. These dark and neutral purple colors move in and out throughout the whole fabric of the picture. In fact, the planes near the outer contours of all the forms are built out of this kind of color. Again we may say that a tension exists, between the various dark, neutral colors.

5) As for the dark purplish colors used for the most emphatic contours and form definitions, it is important to notice that these dark areas do not cut into the pictorial surface or give the effect of holes in the picture. Examine the large dynamic plane, the left side of the right-hand cliff volume. In the photograph of the motif this dynamic plane is entirely black, in full shadow. In Cézanne's painting this dynamic left-hand plane is also turned away from the light, and we may assume that the painting was done during the afternoon hours when the sun was at approximately the same position as that recorded by the camera. But Cézanne has wisely avoided the destructive effect of this solid black area; instead of painting it in a solid, cool color, he has brought it forward with the addition of some of the local orange color, and hence it does not make the black cavity that appears in the photograph of the motif. Cézanne's picture thus remains luminous over the entire surface, but the light is not the imitation of the light and shade of sunlight. The light is generated in the picture itself, through the color relationships.

Color Modulations. (1) In the trees at the upper left we can follow out a systematic application of the principle of building up volumes with color planes that are modulated from cool to warm. (a) The light, protruding planes are of a yellowish hue, while variations that go into cool pink are seen in the middle values. The local green color is found in some of the darker planes, while purplish, reddish, and bluish colors are used for the very darkest planes near the outer contours and deep recesses. (b) Thus, individual and unblended planes of color are combined in such a way that the effect of rounded volumes of trees is fully realized. It is a solidity based on the advancing character of warm color and the receding tendency of cool. Cézanne's color modulations are hereby seen to produce a slight, three-dimensional volume-building effect. But gradations of light to dark still play an important part, and the tendency of these tiny planes to overlap also contributes to the three-dimensional quality. (For a detailed analysis of the overlapping of color planes see Plate XIII, Diagram III.) (c) But the concept described elsewhere should be repeated here: namely, that Cézanne's color is not three-dimensional in the sense of destroying the flatness of the picture plane. Cézanne is able to avoid the sculptured effect brought about by the relentless light and dark gradations of chiaroscuro modeling. Gradations from warm to cool color replace the black and white in significant measure. Two-dimensionality is also aided by the absence of blending. Each individual color patch remains on the surface as a distinct plane, *parallel to the picture plane*. (d) The trees take on a rounded volume-space effect by the means explained, throughout

most of the painting. The mountain is also solidly built up with overlapping planes, from cool to warm. The mountain is a neutral white shape when seen as a unit, but the intervals within this neutral area cover a wide chromatic range from orange and pink into blue. What Cézanne referred to as his aim to make out of the broken-color theory of Impressionism "something solid and durable, like the art of the museums,"[1] has thus far been described as a methodical system applied in the painting of the trees and mountain.

2) Turning to the color-plane structure of the orange cliffs, we find a different situation. In some parts, it is true, the warm-cool system aids the volume effect, as in the right-hand cliff mass. In this cubic volume the front plane is lighted with warm orange, while the dynamic plane of its left side is turned away from the light and is generally cooler. Such a change in two massive planes can hardly be considered as belonging to the color-modeling system, but with this and possibly a few other minor exceptions the warm-cool gradations are not used in a way that builds up the volume structure of the cliffs at all. (a) What we find, pulsating over the surfaces of the flat, parallel planes of the cliffs, is a full gamut of chromatic nuances, ranging from warm yellow to reddish orange, and finally into a contrasting blue which in some places matches the sky. (b) But do these color modulations, ranging from orange to blue, create a rounded volume effect? Obviously, not at all. The front planes of the cliffs remain parallel to the picture plane in spite of these manipulations of color. The facts just stated seem specifically to refute the critical conception that Cézanne built up his form and space with color, that "the individual patches of color . . . are the real supports of the pictorial structure in Cézanne's painting," more so even than the "composition and outline drawing."[2] (c) For here the color planes on the cliff surfaces are serving a purpose that is mainly decorative. Rhythmic color movements, sometimes working in opposition to the three-dimensional form, serve to *elaborate* and *ornament* the flat areas of the cliffs. (d) These wide intervals within the orange mass supply sensational variety and opulence to the total color effect. (e) The quality of translucency, of looking through many layers of color, is a factor implying a subjective, rather than an objective and measurable, element of depth. Seurat and the Impressionists attain this subjective quality of depth simply through the juxtaposition of various colored spots. It would be wiser to dismiss Cézanne's color system as one achieving no more depth quality than that existing in Impressionism than to commit the error of overestimating its structural importance. (f) While considering the translucency which is achieved in the orange cliffs through the juxtaposition of color intervals, mention should be made of the relation of Cézanne's color to the glazing technique of the Renaissance masters, as described on page 26. (g) Likewise, the technique of mosaic decoration is also comparable to Cézanne's method of placing tiny planes or blocks of color side by side.

(h) Whatever quality of solidity the modulations in the cliffs do afford is due entirely to the fact that as one plane is superimposed over another *a definite overlapping occurs*. This overlapping is almost entirely unrelated to the warm and cool aspects of the color (described in relation to the trees and mountain); for in the cliffs the cool colors may be in the forward planes and the warmest orange may be found in deeper layers. The changes in color were suggested by the actual local color variations seen in the original motif and not by the wish to make the tiny planes move backward and forward in space. The slight, three-dimensional, forward-backward manipulations within the large plane masses are thus due to overlapping and not to changes from warm to cool. (Refer again to Plate XIII, Diagram III.) The photograph of the motif shows on the cliff surfaces the kind of indentations and variations

[1] Rewald, *Cézanne. Sa vie . . .*, p. 283.
[2] Novotny and Goldscheider, *Cézanne*, p 12.

PLATE X
(*continued*)

that Cézanne has freely suggested by overlapping one plane over another. (1) It is interesting to recall that Cubism, which grew out of Cézanne's modulations and "passages," was not at all concerned with warm and cool color. Analytical Cubism is almost without color, and its contrapuntal movements in and out of depth are based on the light-to-dark gradations and overlapping-plane aspects of Cézanne's form. In the arbitrariness and apparent abstractness of the surface gradations on the cliffs, and in their failure to suggest form on the basis of their warm-to-cool gradations, Cézanne's cliffs are directly related to the Cubist system. (Diagram II on page 61, above, is intended as a simplification of the true basis for the form and space relationships in Cézanne's painting. It is strictly a line drawing.)

SUMMARY. The colors and forms in the "Sainte Victoire Seen from Bibemus" are so unfamiliar that one might logically assume that Cézanne's painting was highly imaginative and abstract. The photograph of the motif, however, proves that it is very closely related to the subject. I would also affirm that the color was derived from the local color found in the subject. A detailed analysis of the color organization indicates that the fundamental structure is a warm-and-cool combination of orange, blue, and green colors summed up into large and comparatively flat areas. The color modulations are merely incidental; they occur within this larger order of color relations and remain entirely subsidiary to it. A large rectangular orange shape is interlocked with a highly complex pattern of green tree shapes. The blue sky is the only color that might, at first glance, appear to be a local color, unrelated to the rest of the design; actually, it is repeated in many places, even in the orange cliffs, and therefore becomes interwoven with the fabric of the whole surface. Above all, the blue provides a feeling of air and space and acts as a contrast and foil to the dominating and saturated orange cliffs. The mountain is the neutral area in the scheme, but it is composed of rich intervals of pink and blue. As a form, it constitutes the climax for the whole painting. The whitish color of the mountain is repeated, notably in the orange cliffs, and the total effect is that of a magnetic relation and tension between all the neutral white areas. The dark purplish colors are also widely distributed, and are used for the outlines and outer planes of almost all the forms.

The color planes or modulations act as a luxuriant counterpoint of movements and variations, subsidiary to the basic color and space composition, and build up surfaces of great translucency and opulence. A definite three-dimensional attribute of the color planes can be observed in the painting of the trees and mountain. But the variations of warm and cool color in the cliffs have almost nothing to do with the plane-volume structure of the cliffs, and one may judge by this example that the volume-building function of Cézanne's color modulations has been greatly exaggerated and misinterpreted.

The creation of light is the final result of the color orchestration in this painting, but it is not an imitative light based on sunlight and shadow. The luminous, atmospheric qualities are generated within the picture itself by means of the color relationships.

The detailed analysis of the color problem in this painting relates to all Cézanne's late work, and considers both the warm-to-cool and other form-building effects of Cézanne's color planes or color modulation system. The final conclusion is, however, that Cézanne's great secret, the function of his "petites sensations," was to hold all the form to the surface of the picture. It was a two-dimensional structure that began to work with the first few patches of color. It still dominated even after the prolonged work that went into the completion of this painting, one of his most highly "realized" works. It was a mosaic of clear planes that created an abstract structure stronger than the forms of nature.

PLATE XI

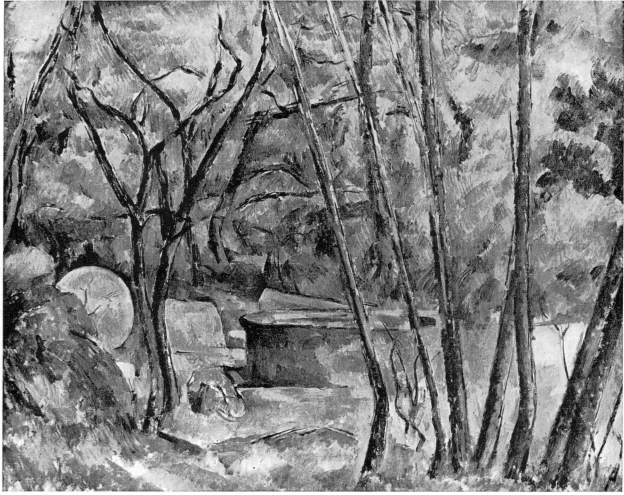

Figure 1. *Well and Grinding Wheel in the Forest of the Château Noir.* CÉZANNE

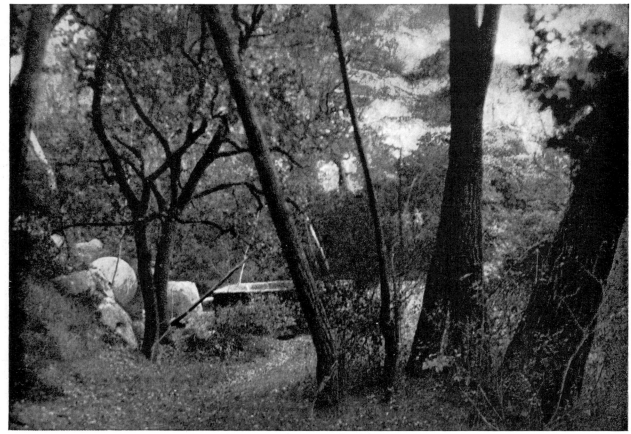

Figure 2. *Photograph of the motif*

PLATE XI
(*continued*)

DIAGRAM I is a graphic demonstration of Cézanne's reorganization of the motif, Figure 2, into the painting, Figure 1. The total area of the group of trees on the right in Cézanne's picture, marked A, is seen to be much smaller than the original area in the motif, which would extend into the dotted shape, marked c. Going quite contrary to laws of scientific perspective, Cézanne makes the more distant forms larger, and reduces the scale of the foreground trees. This change in scale allows the interior forms of the well and grinding wheel to come forward in importance, giving to the painting a balance, with respect to the picture plane, that is lacking in the photograph of the motif. (Some consideration should be given to the fact that time has played its part in altering the scale of things in this motif, but in view of the similar evidence that most of the other photographs present, many of them being changeless architectural subjects, there is little justification for doubting the transformation made by Cézanne.)

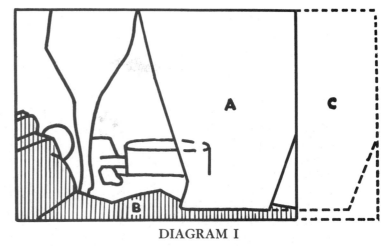

DIAGRAM I

The photograph of the motif, Figure 2, shows a path leading to the well. Cézanne eliminates this path and flattens the foreground area into one simple, frontal plane of bluish gray—indicated in the diagram with vertical stripes and marked B. It is a comparatively slight but definite factor contributing to the two-dimensional balance so well established by reducing the area of the foreground trees. It also keeps the foreground closed within the frame and thus well related to the picture format.

DIAGRAM II is an analysis of the two-dimensional construction lines. These conform mainly with the actual movements of the trees, but directions of lines are also felt as they "carry through" along borders of volumes and planes. (Some artists use the term "subjective lines" to explain this factor.) It is obvious, upon referring to the photograph of the motif, that Cézanne's arrangement is no mere copy. These linear directions create a balanced pattern of diagonal, vertical, and horizontal lines. The diagram indicates that activity is held within the picture area by a circular movement, which is examined as a three-dimensional factor in the following study.

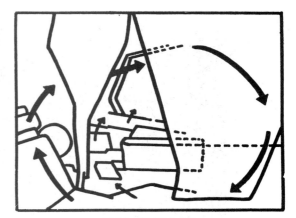

DIAGRAM II

DIAGRAM III Arrows indicate how the planes and volumes move in three-dimensional space. Elements of balance outlined in Diagrams I and II are closely related to the movement analyzed here and help to explain why the movement is so well controlled. There are inward thrusts and recessions, but the movement returns, continuing along a circular path around the pivotal well. A general feeling of air and space pervades the picture. Cézanne's fame is rightly based on his ability to organize space and create compositions that attain classical synthesis.

DIAGRAM III

DIAGRAM IV is a study of the decorative attributes of line and shape found in the painting. The trees show extraordinary variety in long and short, straight and curved, sections of line. Comparison with the photograph of the motif reveals how closely these variations were based on the contemplation of nature.

The geometric shapes of the *circular* grinding wheel, the *elliptical* rim of the well, the *triangular* rock immediately behind the well, the *rhomboidal* shape of the central rock, are all derived quite definitely from the motif. The decorative geometric shapes, the trees, and the foreground plane have been shaded to suggest how these elements work as the positive shapes. The intervening white areas can be interpreted as the negative shapes in the picture. But these areas of the diagram are, in Cézanne's painting, so rich in small plane movements and modulations that it is an extremely arbitrary simplification to represent them here as perfectly flat shapes. The shaded foreground area contains both negative and positive elements. The only justification for considering these elements of positive and negative surface design is that they reveal part of the basic structure of the picture. This structure depends on a strong line-and-plane organization; the color modulations that contribute the shimmering atmospheric quality are a subsidiary counterpoint of movements. The danger in laying too much stress on the decorative aspects of line and shape is well illustrated in the nonspatial decorations of the so-called "nonobjective" art of painters like Rudolph C. Bauer. A more fully rounded plastic approach, the opposition of positive volumes to the negative deep space, and the spatial tension between planes, is described or implied in Diagrams I, III, and VII.

DIAGRAM IV

PLATE XI
(*continued*)

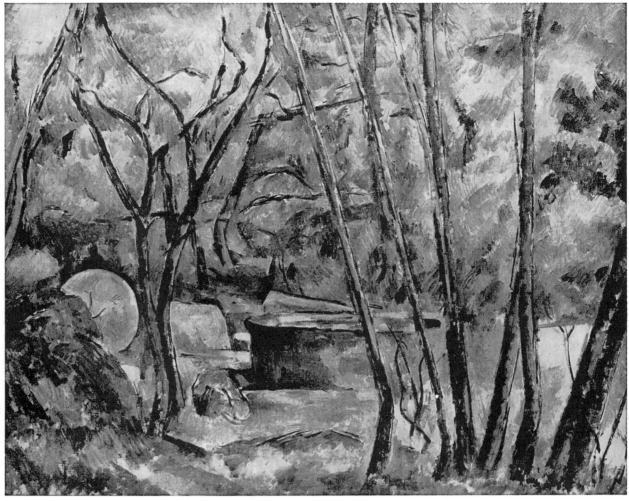

Figure 1. *Well and Grinding Wheel in the Forest of the Château Noir*. CÉZANNE

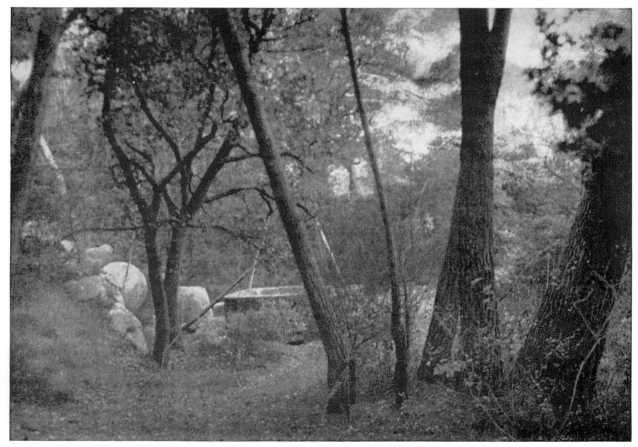

Figure 2. *Photograph of the motif*

PLATE XI
(*continued*)

DIAGRAM V deals with one of the most obvious personal characteristics of Cézanne's style. The diagram directs attention to the organization of dark-to-light grada-tions, which, in this picture, are based definitely on the same right-hand light source as that seen in the motif. Cézanne's water colors and unfinished paintings show clearly how he proceeded from a light but definite outline drawing to a gradual building up of the volumes with innumerable little planes, often loosely referred to as "touches of color." These planes were built of graduated variations of color that moved systemati-cally from the cooler, darker, outer planes to the warmer colors of the planes nearest the light source. Modeling—or "modulating," as Cézanne preferred to call it—from cool to warm became a definite system for creating a certain degree of volume with color. By now it is part of the equipment of many academic painters. Cézanne devel-oped the method in the most positive and original way that has been seen, but even Rubens used color changes in the modeling of flesh. Giotto and other Italian tempera painters achieved similar results by painting pinkish warm flesh tones over a *terre verte* imprimatura that was allowed to show through as the forms were modeled from light into dark. (Cézanne's color modulations are differently analyzed in the discussion of Plate XIII, Diagram III.)

This *breaking up of the surfaces* led to the first phases of Cubism. Picasso and Braque made their departure from reality by animating the picture plane with arbi-trary passages of light to dark, dark to light. Mr. Alfred H. Barr, in his *Cubism and Abstract Art,* traces this development with excellent reproductions and brilliant text. An-other quick glance at the diagram will show a strong all-over effect of two-dimensional balance and densely filled space.

DIAGRAM VI emphasizes one of the most interesting elements of design in the painting. The two-dimensional space intervals between the trees are the most important factor of variety in a combination of trees that are of almost the same thickness through-out. Not only is the spacing between the trees varied across the top, but the spaces between the same trees change radically at the bottom of the picture. These space intervals create tension and balance in relation to the frame.

The path of dotted lines, marked A, indicates the pull or tension that can be felt between the axes of the trees as they expand, like a fan, toward the top. Cézanne's control of this dynamic factor may be studied by reference to Diagram I and the photograph of the motif. In the photograph the distance across these trees is uncon-trollably large, and it would have destroyed the balance and tension in the painting if it had been copied literally from the subject.

DIAGRAM VII reduces the two complex masses of trees to flat planes, marked A and B. The theoretical axes of these planes, indicated by the double-pointed vertical and horizontal arrows, have been drawn in order to make the relation, the tension between the two masses of trees, more graphic. Other, smaller planes have been marked to indicate that all the planes in the picture are similarly related one to another. The broken line between A and B illustrates exactly what the distance in depth is between the two areas. The distance between the planes, the variety in their relative positions, the clarity of their position in the deep space—these are the factors of creative organiza-tion that Cézanne has brought to his painting. The right degree of tension or pull between A and B was achieved by reducing the size of B, as illustrated in Diagram I. The total space has thus been organized into a perfect unit.

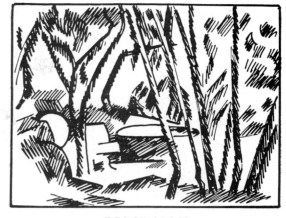

DIAGRAM V

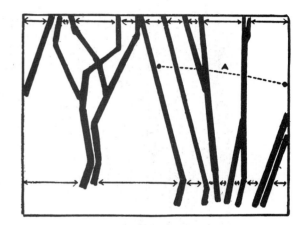

DIAGRAM VI

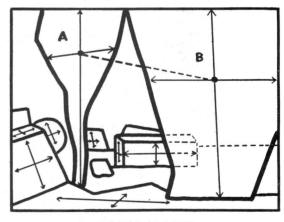

DIAGRAM VII

PLATE XII

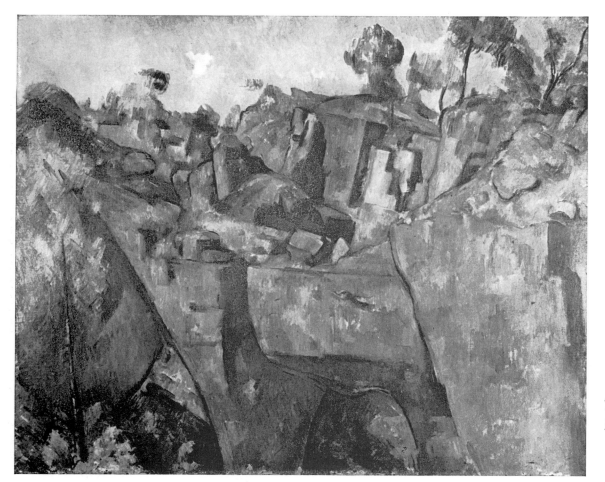

The Quarry Called Bibemus. Cézanne

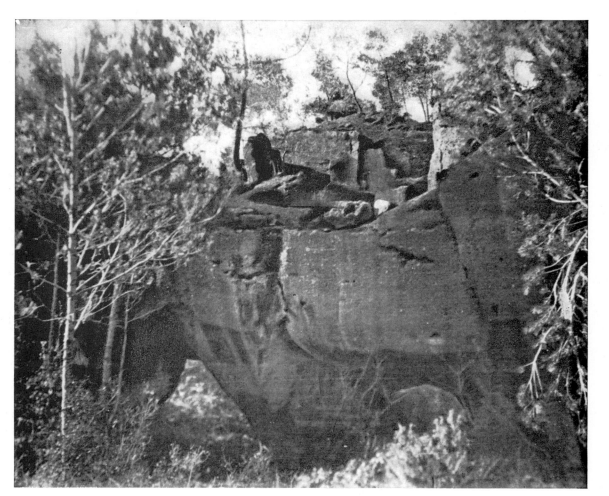

Photograph of the motif

PLATE XII
(*continued*)

DIAGRAM I, in light and dark planes, is intended as a simplification of the cubical volume structure of the quarry cliffs. All trees and shrubs, except the tall tree at the extreme left, have been eliminated in order to make the orange quarry shapes more understandable. In black-and-white reproductions, particularly of some of these quarry pictures, it is extremely difficult to know exactly what the form and space relationships are. Where in color the contrast between a bright green tree and the orange rock against which it is silhouetted makes the space perfectly clear without a line around the tree, in halftone there is sometimes no differentiation at all between such forms.

Cézanne's alteration and adjustment of the scale of foreground and background masses should be easy to follow by comparing Diagram I (at right) with the photograph of the motif. The complex foreground mass, indicated as one mass or plane with axis bars and letter A, has been compressed in size, while the geometric mass behind it, marked with axis bars and letter B, has been lifted up and increased in size. A sufficient number of photographic comparisons is shown in the present study to prove that, whether or not Cézanne had intellectual theories and preconceived ideas about it, his more or less invariable practice was to flatten out and diminish the

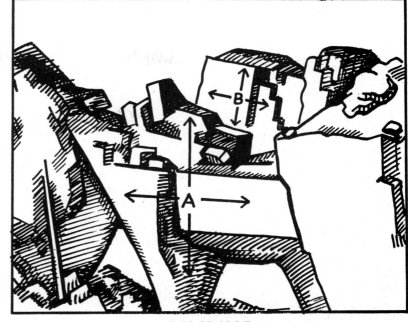

DIAGRAM I

size of foreground forms that were too protuberant. (Notice how, in the photograph of the motif, the large horizontal sections of the quarry rock at A seem to bulge out and push forward.) With the holding back of foreground forms, we have usually observed a concomitant increase in the size and psychological importance of background shapes. The result, as in this painting, usually gives satisfying illusions of deep space and movement, but there is also the counterpart, the balance in relation to the two-dimensional character of the picture plane. In less technical language, the volume in the background with its interesting step motif—a result of the cutting of stones from the quarry—has simply been given a size and importance commensurate with the interest it had for Cézanne.

Another important change may be observed by comparing the axial position of mass A in relation to mass B. Mass B has been tilted far to the right, creating a stronger spatial pull or tension in relation to other volumes than a vertical or static volume would afford. Further analysis of this dynamic quality follows in the next diagram.

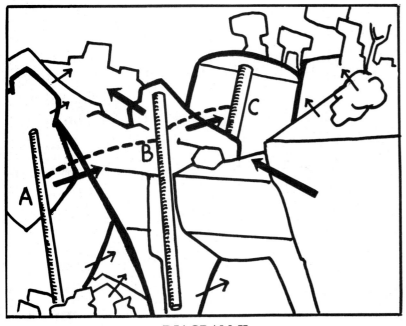

DIAGRAM II

DIAGRAM II presents the complex forms of the painting in simple, flat shapes. When one shape or plane overlaps another, a spatial relation between the two is established. Throughout the diagram there are small arrows indicating how such overlapping creates a definite movement or thrust into depth. There are thrusts and counterthrusts; there is movement everywhere except out of the picture format. There is movement into space, but there is also countermovement out of the depth; thus the spatial elements attain the necessary balance in relation to the picture plane.

A definite "tension path" is analyzed, starting with the vertical axis of the tall tree on the extreme left, marked A (the shaded cylinders symbolize the axes). A heavy broken line indicates how this tension can be felt from axis A to axis B (the latter being the imaginary axis of the heavy vertical section of quarry rock). From axis B the broken line extends to axis C, which is the dynamically tilted axis previously discussed in Diagram I. The strong tension, or pull, which can be felt between these axes as they open out, fanlike, is increased by a strong movement into space, which also goes from axis A to axis C, as indicated by arrows pointing toward the upper right. Then there is an important countermovement to the left, which goes much deeper into space. Arrows pointing to the upper left mark the path of this movement. It would be plausible to analyze the continuity of movement and countermovement as a circular activity, in this as well as in other paintings that have been so analyzed. One might then visualize the vertical rock, into which the top point of the axis bar B is now inserted, as the "central point around which the planes rotate" back and forth in the deep space.

The interlocking and interpenetration of planes and volumes presents one of the most complex and perfectly integrated examples of this compositional problem in Cézanne's work.

PLATE XIII

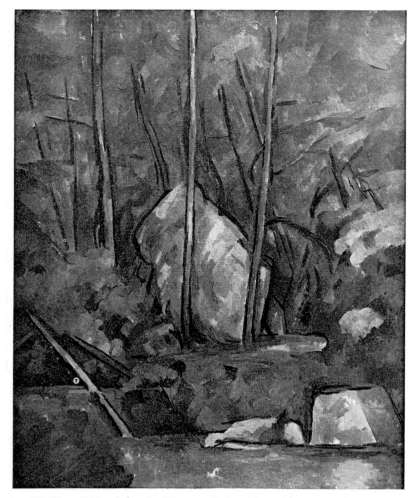

Well and Rock in the Forest of the Château Noir. CÉZANNE

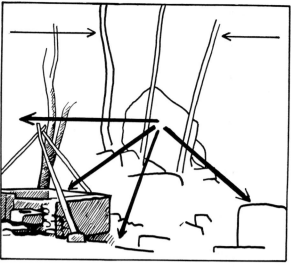

DIAGRAM I

DIAGRAM I is a tracing from the photograph of the motif (below), showing the spatial locations exactly as they are except for emphasis on the form of the well on the left. The heavy arrows, radiating from the central rock, suggest the tendency of the well and right-hand rock to expand and protrude away from the central rock. The planes and details of the well are further emphasized by means of light and dark modeling. At the top, arrows pointing inward and away from the frame indicate how these upper trees seem to be compressed in relation to the expanding forms in the lower central part of the photograph. The only purpose of this diagram is to draw attention to elements in the motif that Cézanne has altered or suppressed in his painting.

But while significant changes have been made, as will be demonstrated, the primary revelation is that Cézanne shows that he was remarkably faithful to the subject. In this connection, reference should be made to a photograph of the same place taken by John Rewald and reproduced in Fritz Novotny's book, *Cézanne und das Ende der wissenschaftlichen Perspektive,* Abb. 32. At a casual glance, Mr. Rewald's photograph, cut to a format identical with that of Cézanne's painting, seems also to present the same relations found in the painting. Further examination will reveal, however, that a large space not found in Cézanne's picture has been included at the top, and the left side of the well has been cut away. In my own photograph I have purposely cut the format down so as to include only what Cézanne has incorporated in his composition. Even so, too much has been cut away from the rock on the far right.

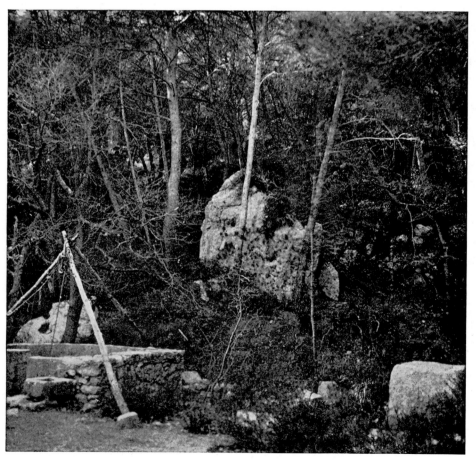

Photograph of the motif

PLATE XIII
(*continued*)

DIAGRAM II is based on the form and space relations in Cézanne's painting. First of all, the picture format has been changed from the square shape of the photograph of the motif to a vertical rectangle. The same trees that took up so narrow a space in the motif now expand, as indicated by the two heavy arrows marked E, so as to keep the upper part of the picture balanced with the heavy lower part. The important forms of the lower part of the picture have been compressed and forced to exist in a much shallower and narrower space. The well has lost much of its importance in relation to the large central rock. (Refer to Diagram I, in which the well is so important and protuberant.) The central rock is what interested Cézanne in this motif; he has greatly increased its size while reducing that of the foreground well. The space between the well and this central rock has been made shallower, thus helping to preserve the two-dimensionality of the picture plane. In order to focus attention on this central rock, the well has been flattened out, its detail and texture eliminated. The vertical and horizontal axis bars, at A, indicate the flatness of this lower left-hand area of the painting, which protrudes and attracts too much attention away from the central rock in Diagram I.

Another important device, affording unification and cohesion between the main central rock and the well and rock shapes of the foreground, is indicated by the heavy, diagonal, broken lines (subjective lines) marked F. This subjective *triangle* or *pyramid,* into which the lower part of the picture fits so compactly, was achieved, first, through the reduction in the size of the well and right-hand rock, and second, through allowing the two diagonal lines of the pyramid to "carry through" from the apex of the central rock downward to the frame at either side. Within the triangle, important elements of parallelism exist: the front pole of the tripod over the well is quite parallel to the upper right contour of the central rock. Perhaps the most obvious alteration in the picture has occurred in the right-hand contour of the well structure, indicated by an arrow marked B. This line is almost parallel to the upper contour of the central rock. This parallelism of linear directions is one of the elements involved in the network of two-dimensional construction lines. In this diagram the strong pattern of vertical, horizontal, and diagonal lines should be considered for the two-dimensional surface balance that it lends to the painting. Within this skeletal structure, the smaller shapes must fit, and when elements like the tree directly behind the well, shown in Diagram I, fail to work with the larger rhythms of this structure, Cézanne eliminates them. The interesting rock just behind the same tree has also been left out, not so much because it fails to relate rhythmically as a line-and-shape element as because it would suggest too much weight and depth in a part of the painting that has already been understood as an area needing suppression and flattening.

DIAGRAM II

DIAGRAM III

DIAGRAM III presents several aspects of the movement in space. For the first time in these diagrams some of the tiny color planes or modulations, built up in sequences, have been reduced to definite, flat, overlapping planes. Diagram II showed that the most important alterations from the motif were necessitated by the need of achieving a balance of the form and space in relation to the picture plane. But while this control was being effected, rhythmic movements in and out of space were also developing. The heavy arrow, marked A, indicates the main direction or beginning of a complex set of thrusts into space. The color planes work more or less as indicated by the small arrows. It is in the central rock, however, that the overlapping of planes and the solid-form effect they build up is most definite and easy to follow. The significant thing about these small planes, as illustrated in the diagram, is that *each plane remains comparatively flat and parallel to the picture plane* in spite of the three-dimensional effect that a sequence of the same planes creates through overlapping. This phenomenon of the persistent flatness of individual color planes strikes at the core of Cézanne's unique method of organizing color in relation to form. There are indications, throughout the diagram, of the continual play of thrusts and counterthrusts, the shifting and balance of three-dimensional and two-dimensional forces. The diagram should illustrate how the change in the right side of the well structure, eliminating the sharp right angle (Diagram II, arrow B), has opened up a free, unobstructed path for the passage of the main movement into space, beginning at arrow A. The parallel diagonal directions of the tripod pole and the upper contour of the central rock tend to mark out this passageway and give an extra impetus to this spatial movement.

The heavy arrows beginning at A, moving in a circular path around the trees, suggest the main movement into depth and its return to the picture plane. Here again the planes throughout the picture seem to "rotate around the axis" of the central tree. Without the changes Cézanne made in the direction of closing up the "picture box," making it shallower, the orbit of this circular movement would have been too extensive to remain under control.

Cézanne displays his usual scorn for the play of textures as a decorative enrichment. The motif offers excellent textural patterns, particularly in the lichen on the central rock, but Cézanne has not used them. The stone pattern growing out of the primitive stone construction of the well has been obliterated completely, for the purpose (previously discussed with respect to space and form relations) of *holding the protruding well form back and permitting the central rock to dominate.*

IX

DISTORTION THROUGH THE SHIFTING OF EYE LEVELS

HERE, paintings are examined that illustrate shifting points of view, changing eye levels, split planes, or tension between "subjective" planes.

PLATE XIV

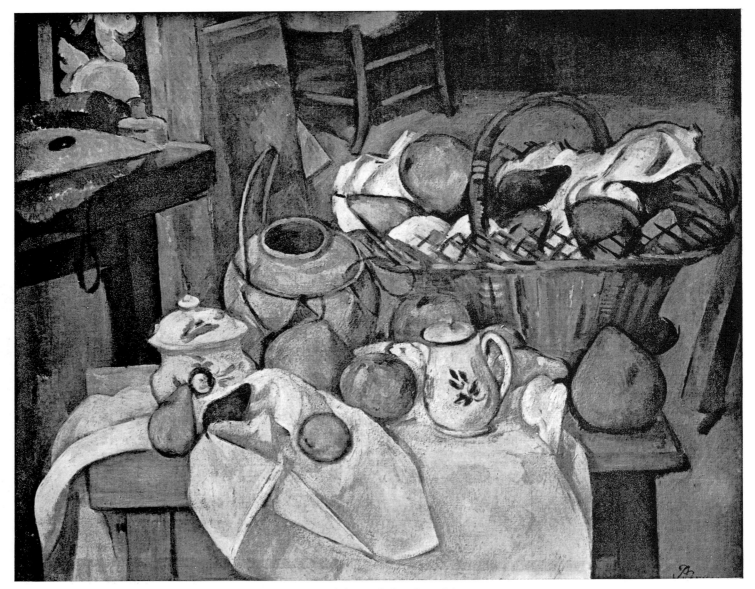

Still Life with Fruit Basket. CÉZANNE

THE DIAGRAM reveals sources for many of the devices of Abstract painting, principally the incorporation of several eye levels in one picture. The first eye level, marked I, takes in, roughly, the front plane of the fruit basket, the sugar bowl, and the small pitcher (the last two objects are seen at slightly higher eye levels). The second eye level, much higher, marked II, looks down at the opening of the ginger jar and the top of the basket, as well as other objects, including the table top.

The result of these distortions is a greater sense of three-dimensionality, but at the same time, paradoxically, these top planes of the ginger jar and basket, being tipped forward, also relate clearly to the flat plane of the picture. The endless tensions between planes seen at different levels but related also to the picture plane are the basis of the mystery and power of this still life. An emotional, nonrealistic illusion of space created by the changing of eye levels has been the point of departure for Abstract art as well as for a revived interest in Byzantine icon painting. This device, mentioned elsewhere, is sometimes called "universal perspective." Other paintings revealing the phenomenon of changing eye levels may be studied in the Venturi catalogue, Nos. 497, 574 (cup and saucer differing from adjacent coffee pot), 598, 738.

Another distortion shifts the artist's viewpoint from the left side to the right side of his motif, increasing the illusion of space, of "seeing around" the object. The change may be traced from the vertical arrow at Ia, which indicates the straight front or slightly left-hand view from which the table and most of the objects in the picture are seen. But the handle of the basket is turned, as if seen from a position far to the right, IIb. Picasso's familiar device of incorporating front and side views in a single portrait head is perhaps traced here to one of its sources.

An extraordinary distortion may be observed in the splitting of the table top. The dotted line from A to B indicates the tension that develops because the table plane fails to unite under the cloth. The arrow at c emphasizes the tension, the pushing back into space, that results from this splitting of the table plane. Abstract artists have resorted to the breaking up of planes and objects in a highly intellectual and conscious spirit, sometimes dividing the picture plane into a dark and a light area, sometimes even sharply dividing an object, as in the familiar table pitchers of Braque. Many examples of split table planes exist in Cézanne's still lifes, notably the one in the Chicago Art Insti-

PLATE XIV
(*continued*)

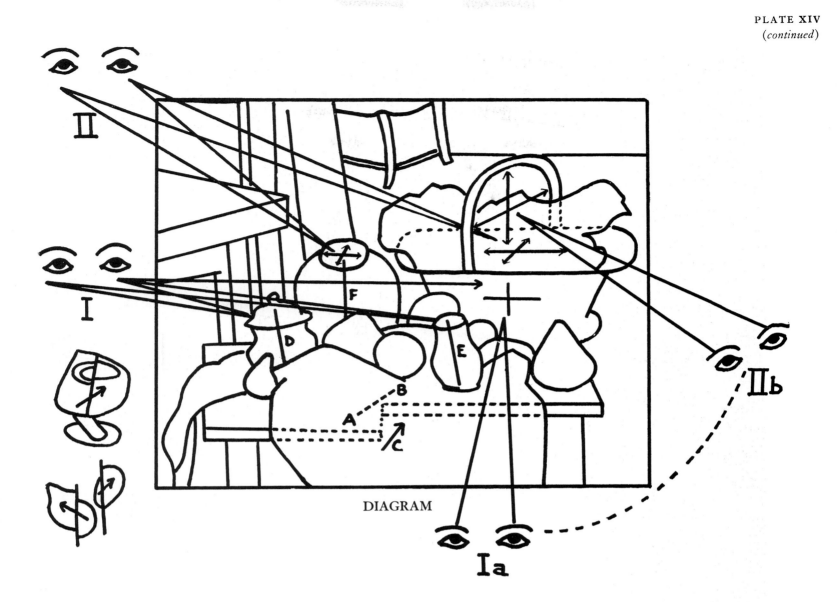

DIAGRAM

tute, No. 600 in the Venturi catalogue (see also Nos. 496, 601, 606, 733, 745, 746, and 748). It should be pointed out, however, that the two sides of the table in Plate XIV tend to converge in a more or less normal kind of perspective. In fact, so far as I have observed, there are no table tops in Cézanne's still lifes that actually expand in direct reversal of mechanical perspective; his lines tend, instead, to be parallel. Note Nos. 619 and 707 in the Venturi catalogue, which to the casual eye appear to expand, but actually do not.

Attention is called to the objects drawn at the lower left of the diagram. These are objects traced from a painting by Braque and they illustrate exactly how the idea of the split plane in Cézanne's table has been carried over into Abstract art. Arrows indicate how spatial tension is increased by the arbitrary displacement of the planes of these objects.

The last distortion explained in the diagram recalls Cézanne's habit of tipping the vertical axes of nature to the right or left. The sugar bowl and pitcher, marked D and E, are falling definitely to the left, while the ginger jar, F, remains vertical. The play and tension between axes continues throughout the entire painting, with the strongest axial variations occurring in the pears.

The conflict and dualism of static and dynamic axes, the plane tensions resulting from the shifting of eye levels, the action of three-dimensional space forced to maintain its relation to the picture plane— these are the elements of the inner life of Cézanne's art.

I have previously explained that I do not believe Cézanne arrived at these effects through a conscious intellectual and theoretical approach. Such extraordinary space illusions developed spontaneously, in the process of painting, and there is no ground for believing that Cézanne would have been able to explain them as they have been analyzed here in the diagram. Cézanne worked by feeling and intuition; the accidental distortions arose from the inner necessities of the particular problem at hand.

The painting, in spite of the fact that it affords so splendid a demonstration, is not, in my personal estimation, a thoroughly "realized" work. The relation between background and foreground leaves something to be desired. The rhythmic movements in the foreground still life are not successfully followed out in the upper left-hand area of the background, and this break in continuity causes what may be explained as an unresolved conflict between realistic and purely pictorial space. All the objects arranged on the large table are united into a perfectly consistent unit, but the break occurs in the relation between this foreground mass (or complex) and the elements of the background. The picture as a whole should have the perfect cohesion that is found in the large foreground mass alone.

PLATE XV

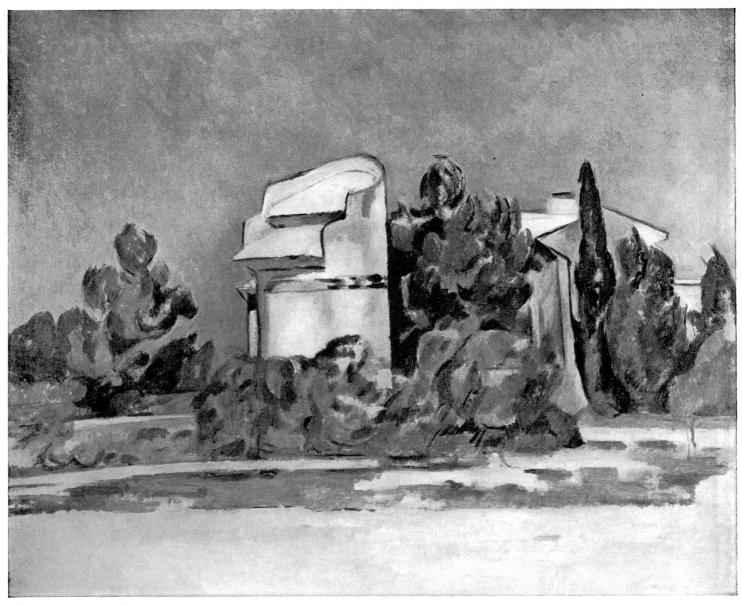

The Pigeon Tower at Montbriand. CÉZANNE

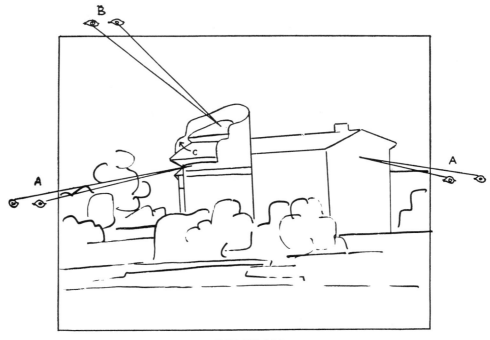

DIAGRAM

PLATE XV
(*continued*)

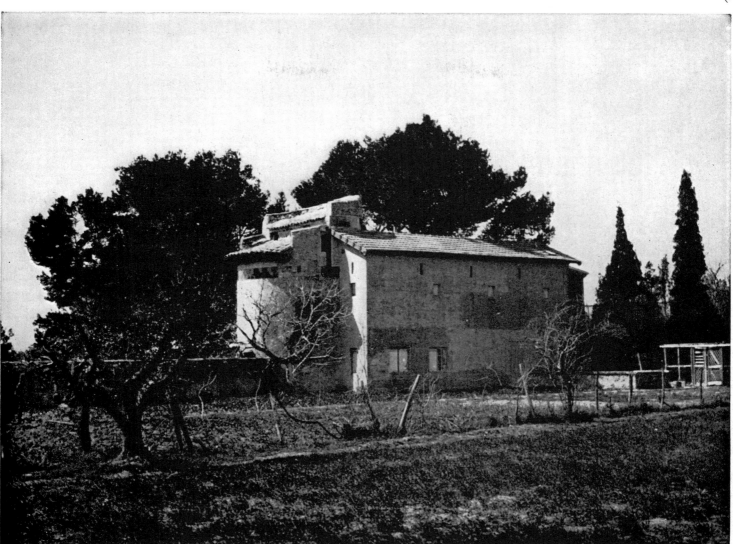

Photograph of the motif

THE DIAGRAM demonstrates, as in the previous still life, that the forms have been drawn as if seen from two different eye levels. (a) The normal eye level, marked A on both sides of the diagram, is obviously the level from which Cézanne actually saw his painting. (b) The photograph of the motif shows construction of the pigeon tower and the eye level from which Cézanne must have seen it. (The new building attached to the right of the tower should be disregarded.)

(c) The top of the tower is drawn as if seen from a much higher level, B. How far Cézanne has clarified and strengthened the three-dimensional construction of the tower is easy to judge by comparing it with the photograph of the actual place. (d) In the diagram, the small curved arrow at C, on the roof of the tower, indicates the extreme expansion that takes place. The entire superstructure pushes out to the left as well as upward, and incidentally becomes a more interesting decorative shape. This expansion and three-dimensional clarification creates a greater illusion of form and space, (e) but at the same time these upper planes come into better relation with the flat picture plane. It is the typical dualism of three-dimensional space attaining poise on the two-dimensional surface.

(f) It should also be noted that the axis of the tower is pitched to the left. This axial tipping, together with the expansion of planes previously described, creates unusual qualities of dynamic tension in a painting that was made from a simple and commonplace subject, apparently unsuggestive of exciting treatment.

X

THE PROBLEM OF DISTORTION
THROUGH TIPPING AXES

PAINTINGS that express dynamic tension by means of falling or tipping volume

axes are next considered.

PLATE XVI

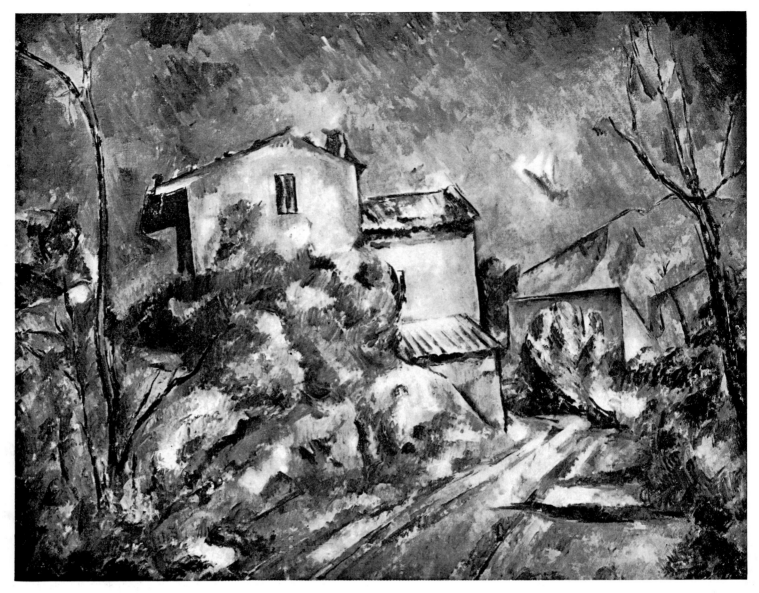

*The Maison Maria in
the Forest of the
Château Noir.* Cézanne

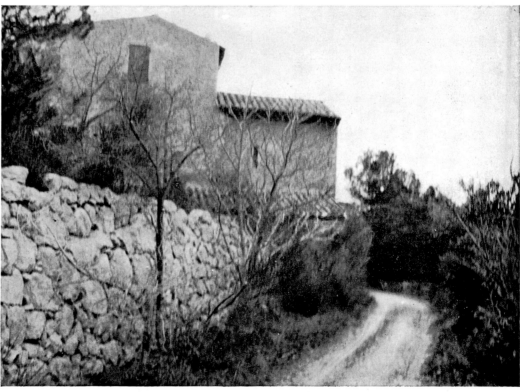

*Photograph of the
motif*

PLATE XVI

(continued)

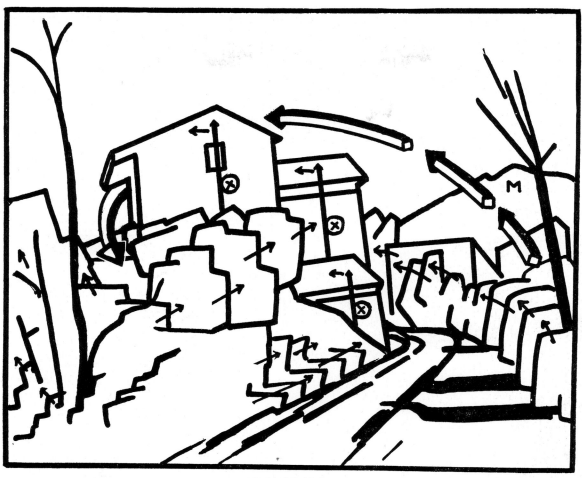

DIAGRAM

IN THE DIAGRAM the basic form and space relations are illustrated with flat planes. As the planes overlap, spatial locations become fixated and definite movements into depth occur. The small arrows chart the movement of some of the individual planes; the flight of large arrows expresses the general feeling of movement and space surrounding the house called La Maison Maria. The strongest set of planes moves from the lower left upward to the right, in the diagonal direction taken by the road, but this movement is stopped by a countermovement of trees and bushes that starts from the lower right. The latter movement is curved, and it makes a turn around the house very much in the manner of the road, although higher up of course.

The unusually dynamic force of this painting derives principally from the extreme tipping of the buildings. Axis poles, marked x, at the center of each of the three volume units of the Maison Maria, have a small arrow near the top, pointing to the left. This strong leftward pull of the house creates a dynamic tension with the four sides of the picture and also plays its part in the spatial movement previously described, by giving a strong impetus to the leftward circulation of air and space around the house. This imaginary movement or circulation of air is described with the heavy curved arrows that start at the right and move upward and to the left. The diagonal strokes in the sky also play a part, though only in a two-dimensional way, as rhythmic directions continuing this upward movement to the left. The same brush strokes oppose the important movement to the right—the movement of the road and the foliage volumes adjacent to the Maison Maria. (See the flat planes in the diagram with movement to the right indicated by small arrows.)

The tall trees on either side help to hold the dynamic activity within the format and give a satisfying "closed" effect to the picture. Likewise, the horizontal shadows across the road, relating to the bottom line of the picture format, contribute a static element for the lower part of the picture and counteract the dangerously strong perspectival and diagonal movement of the road. Thus again we find Cézanne using cast shadows to fulfill a very important abstract function.

It is obvious enough that the dynamic quality is not suggested by the photograph of the motif. Cézanne has imbued a banal subject with drama based on plastic manipulations. The lifted, suspended feeling in the Maison Maria, for example, derives principally from the leftward axial tipping of its three masses.

I have not made an analysis of the protrusion seen in the left-hand stone wall of the photograph of the motif, because there is some doubt that such a wall existed when Cézanne painted his picture. Regardless of what was there at the time of painting, Cézanne has flattened out the foreground in his usual manner. It is remarkable that the foreground does not protrude, considering the strong perspectival expansion and convergence he has permitted in the drawing of the road. But the perspective drawing in the road is counteracted by the fact that there are no large protuberant volumes in the foreground. The heavy forms, including the Maison Maria, develop in the deeper layers of space; they rise up vertically and give to the painting the necessary two-dimensional equilibrium and poise.

Two sections of the Château Noir, as well as the mountain shape marked M in the diagram, are not visible in the photograph of the motif because of the growth of trees at the right side of the road. Having made a study of these locations in the subject, I am aware of the great expansion that Cézanne has given to the size of these forms—an expansion that prevents this deepest recess of space from falling away entirely. One of the most arbitrary color manipulations I have observed in Cézanne's work occurs in the painting of this mountain marked M. Instead of the usual pinkish and bluish color, Cézanne has painted it in a brownish orange related to the color of all the building shapes. The warm color and enlarged size of the mountain make possible between this plane and those of the main buildings a tension that is essential for the balance of the picture as a whole. In fact, in the original painting the mountain advances so much, because of its color, that it gives the illusion of being a roof over the two sections of the Château Noir, and does so to a greater degree than is noticeable in the black-and-white reproduction.

PLATE XVII

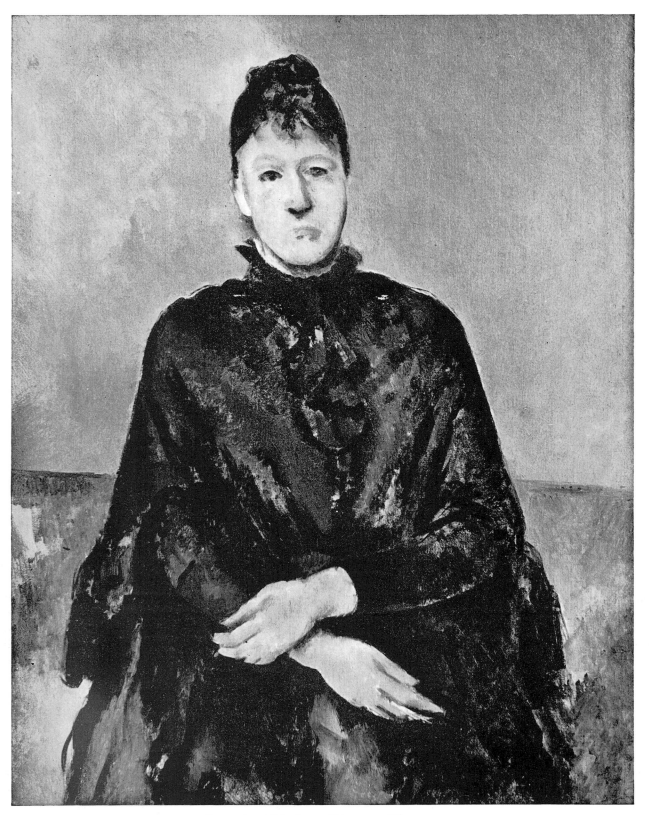

Portrait of Madame Cézanne. CÉZANNE

CÉZANNE's portraits seem to be most remarked upon, in critical writings, for their nonhuman, "dead-pan" faces. It may be justifiable to entertain such opinions of many of the portraits, which, like this one, are presumed to be of Madame Cézanne; but of others, such as the "Old Woman with a Rosary," it is absurd. Indeed, many of the portraits of peasants must be regarded as deeply moving human portrayals. And in the numerous self-portraits it is not stretching the point to say that they are highly revealing psychological studies, directly comparable to the portraits painted by Rembrandt.

There are qualities of dynamic tension in this portrait of Madame Cézanne, however, that cannot be explained on human or literary grounds. Consequently, it seems advisable to study it with an eye to

PLATE XVII
(continued)

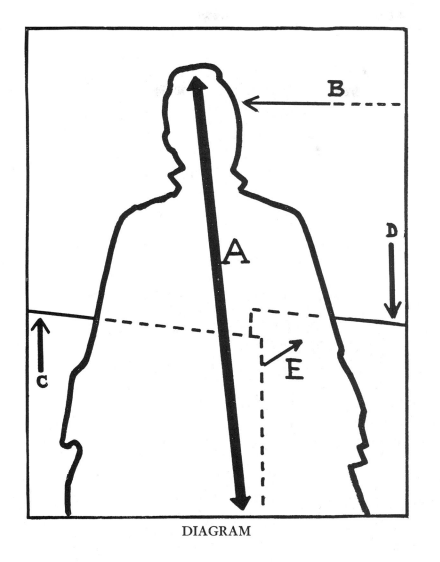

DIAGRAM

the axial tipping that contributed so much to the dramatic quality of the landscape previously analyzed, "La Maison Maria," for in this portrait there is a majestic and monumental quality having little if anything to do with the human character of the sitter.

The main volume axis of the figure is falling to the left (see, in the Diagram, the heavy bar marked A). The leftward tipping creates a strong tension and pull away from the right side of the frame or picture format (arrow marked B). (The concept of drawing and composition that regards the outside borders or frame of the picture to be the first four lines of the design can be applied very cogently to this diagram.)

One of the most original and unusual phenomena in Cézanne's drawing and composition is also illustrated in this diagram, in the diagonal division in the background wall. The diagonal direction of this division in the background gives a rising impetus at the extreme left (vertical arrow marked C), and thus opposes the leftward tipping of the axis of the figure. On the extreme right this same diagonal gives a dropping or falling action (arrow D), which also tends to balance the strong leftward tipping of the figure, axis A. Thus far we have regarded this diagonal division as a purely two-dimensional element. But when a ruler is placed exactly along the left-hand section of this division, it becomes apparent that the right-hand section of the wall division is definitely off the line and higher up. It may seem to be stretching its significance to say that a slight but definite tension or space effect can be felt between these two sections of the background, as if there were actually two separate planes pulling apart, as indicated by the broken lines and arrow at E. The same phenomenon, sometimes named "subjective planes," was analyzed in connection with the split table top in the still life, Plate XIV. If the phenomenon had occurred only a few times in Cézanne's drawing, one might be justified in dismissing the problem on the grounds of its being accidental. But if only because Abstract painters like Picasso and Braque (see diagram for Plate XIV) have made an extensive application of the principle, sometimes splitting an entire canvas into two sections of different colors, it would be necessary to examine the problem and arrive at some understanding of its significance. It is a particularly important factor in late Abstract art, where the main effort seems to be the creation of exciting tensions and space effects with the least possible disturbance of the flat picture plane.

I doubt that Cézanne was aware of a theoretical problem here. It is enough for us to know that it is one of the elements in his art that have been most intelligently exploited. Factors of so-called crudeness or incorrectness in Cézanne's drawing may thus be understood on a rational basis. Innumerable evidences of it occur in Cézanne's art. Some particularly obvious examples of split walls may be seen in the Venturi catalogue, Nos. 373, 570, 571, 572, 594, 600 (a particularly radical displacement of the two sides of a table top), 675, 685, 702, and 704, and Plate XIX in this book.

XI

DISTORTION IN DRAWING

First, problems of significant distortion are examined in still life and portrait.
Distortion is then considered as it relates to the clumsiness of
Cézanne's early work.

PLATE XVIII

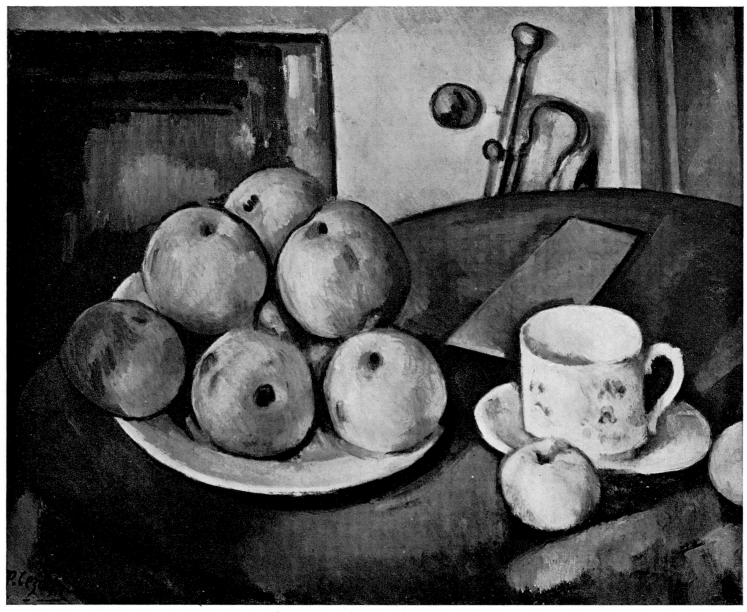

Cup and Saucer with Plate of Apples. CÉZANNE

THIS APPARENTLY humble still life contains factors of distorted[1] drawing that have a far-reaching importance in relation to all Cézanne's work, as well as to the numerous branches of Abstract and Expressionistic art that were influenced by Cézanne's painting. In general, one may say that distortion of natural shapes lends "expressiveness" in the sense made familiar by the German school of Expressionists. Cézanne's many portraits like that shown in Plate XIX have the most obvious bearing on this aspect of distortion. So far as decorative qualities are concerned, distortion may add to the intensity and elaborateness of shapes simply through variations and contrasts of size and proportion. (See Plate XI, Diagram IV, which is concerned with purely decorative problems.) In the present diagram, however, the emphasis will be placed upon the increased feeling of movement, space, tension, that results from the distortion of normal objects.

In the cup and saucer at the right, arrows indicate movements of a definitely spatial kind. The left side of the saucer rises and pushes into depth at arrow 1. The right side of the saucer drops downward, creating a "return," arrow 2, from the "thrust" at arrow 1. The cup follows the same rhythm of thrust and return, but only the rising, leftward impetus into space is indicated by arrow 3. In order to study similar distortions of single objects suggesting thrusts into space, or "thrust and return," a study of bottles and other objects in the following illustrations of the Venturi catalogue is recommended: Nos. 194, 207, 210, 344, 497 (plate), 574 (cup and saucer), 592 (fruit dish), 600 (bottle), 606 (bottle), 625 (water bottle), 732, 738 (jar), 739 (bottle), 1155 (dish), 1541 (two bottles), 1606 (plate).

Other significant factors, apparently contradicting what has been observed so far, must be understood in relation to the same cup and saucer. At the top, the suggested plane of the opening of the cup is indicated by plane axes at 4. The somewhat rectangular character of this plane is at variance with mechanical perspective drawing, and the effect produced is of a plane tilted up and thus being more nearly parallel to the picture plane itself. The front plane of the cup also becomes flatter because of the straightness of the bottom contour—plane axes indicated at 5. The saucer itself is even more flattened and related to the picture plane because of its straightened bottom contour, at arrow 6, as well as by the rectangular character of its entire shape. Thus we observe again an example of three-dimensionality and two-dimensionality working simultaneously in a single object. Both elements exist here to a greater degree than a mechanically correct drawing could ever afford. (See the road plane in Plate II.)

[1] See footnote 22, page 32, above.

PLATE XVIII
(*continued*)

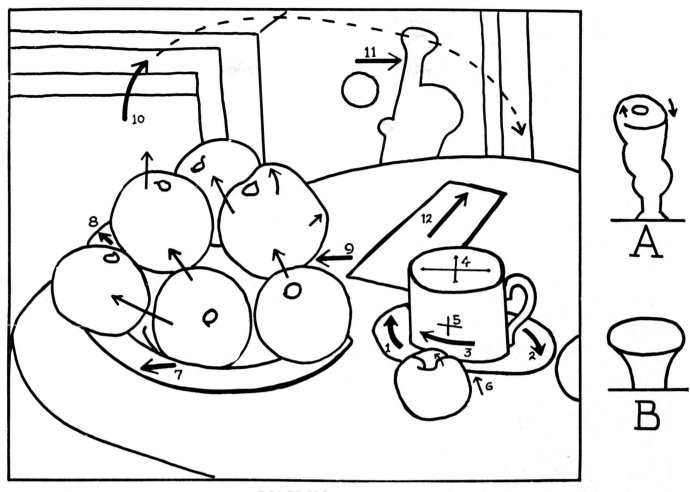

DIAGRAM

The most extreme combinations of two- and three-dimensionality are illustrated to the right of the diagram. Illustration A is a tracing from a wine glass in a painting by Picasso. Arrows at the top indicate the same kind of "thrust and return" as that analyzed in Cézanne's cup and saucer. But the top of the glass is seen from above while the bottom is drawn from a horizontal eye level. A combination of two- and three-dimensionality thus exists in the same object.

Historically the same phenomenon can be traced back to Egyptian murals and to Roman and Byzantine art. Illustration B is the general model for all three. I feel certain that Cézanne was not particularly interested in his historical predecessors in this kind of drawing; but that he practiced it and very likely was responsible for suggesting it to Picasso and the others is evident. Paintings with objects that exemplify this phenomenon in varying degrees may be studied in the Venturi catalogue, Nos. 187, 189, 194, 208 (two cups), 220, 337, 340, 494, 495, 496, 497, 598 (pot), 650, 732 (fruit dish), 738 (jar), and 1138, and Plate XIV in this book.

The complex of apples and plate on the left expresses a general expansion to the left and upward. Arrows point out the movements of the apples as they thrust into space. The plate offers an example of extreme distortion, which must be emphasized for its relation to the movement of the apples. At arrows numbered 7 and 8 the plate expands outward. But the reason such extreme expansion is felt is that the contour of the plate is eliminated at the right. An arrow, number 9, indicates the inward thrust that results from the absence of the rounded right side of the plate. A very strong feeling of tension results from the distortions just analyzed. There is no intention of magnifying the importance of such factors of distortion, because I am convinced that Cézanne arrived at them spontaneously and without preconceived plan.

But a failure to understand them and analyze them leaves the deepest mysteries of Cézanne's art unexplained. Besides, it brushes aside the seminal nature of Cézanne's drawing in its relation to later Abstract art. Other examples of expanded sides or parts of plates and dishes which increase the illusion of space and express tension may be studied in the Venturi catalogue, Nos. 194, 210, 344, 374 (portrait), 497 (plate), 592, 732, 738. Many of these pictures have already been referred to as examples containing expanded top planes of objects or plates that are at the same time flatter, more nearly parallel to the picture plane.

To serve toward completion of the analysis of the composition as a whole, a curved arrow at 10 rises up with the planes of the fireplace, and a dotted line suggests how the eye is carried over to the right by the fire tongs. The falling tongs create an axial pull to the right, as indicated by arrow 11, and the dotted arrow suggests the completion of the composition by means of the verticals and dark rectangles on the upper right. The card filling the negative area in the middle of the table pushes into depth toward the right, as indicated by arrow 12, thus completing the connection between foreground table and background wall, at the right. The spatial movement of the composition is circular, swinging from foreground into background, across the top, and then back to foreground again in a continuous rhythm, very much like that described in the Glossary, Diagram VII.

Refer to Plate I and its accompanying diagrams for examples of how the analysis of the present still life might be further developed. Consider particularly the important problem of positive and negative shapes: the positive volumes of cup, saucer, and apples, against the negative table; and so on. For analysis of negative deep space see Glossary, Part One, Diagram II, and Diagram XV for volume tension.

PLATE XIX

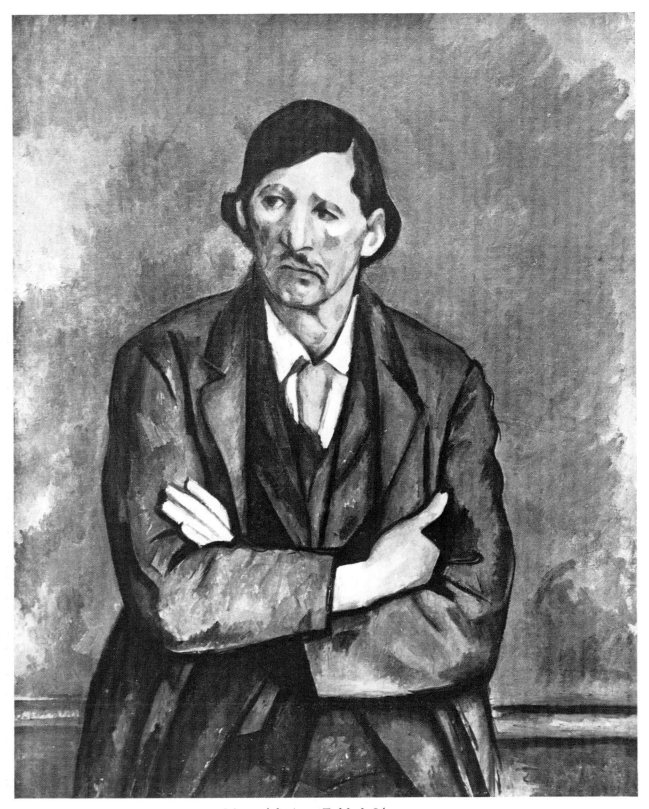

Man with Arms Folded. CÉZANNE

THE DISTORTIONS in this portrait may be compared with those found in El Greco. The plastic means are similar to El Greco's, and the resulting expressive qualities are certainly comparable. The most obvious distortion is in the features, which are out of normal line with the vertical axis of the head. The general effect is of a rising impetus on the left, arrow A, and a dropping or returning movement at the right, arrow B. At the left the upper malar bone pushes to the left and upward, while on the right the ear and heavy hair drop downward. Linear rhythms can be felt in the rising eyebrow at the left and the curved, dropping brow on the right. The mouth is also distorted and it curves down at the right, affording unusual tension as it adds to the general

downward pull on the right, in opposition to the rising movement of the eye and cheekbone on the left side.

In terms of space, the front plane of the head, the dotted rhomboid shape in the diagram, rotates dynamically away from the static background wall, as indicated by the curved arrow pushing away from the wall axes, at C. Smaller arrows in the head indicate the strong thrusting into the leftward deep space.

Another spatial phenomenon is analyzed here as a shift in eye levels. The subject's right eye and eyebrow are arched, as if seen from below—symbol of eyes at I. But his left eye is drawn as if seen from above—symbol of eyes at II. Accidental or not, this device increases the illusion of

PLATE XIX
(continued)

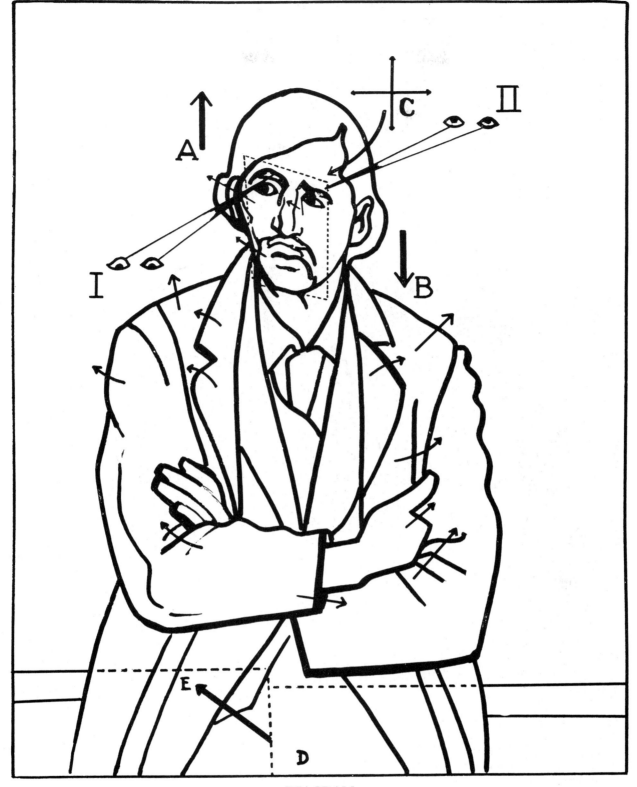

DIAGRAM

space, of "seeing around" the head. Picasso and Braque carried the idea to its radical conclusion, and they have made a complex system of drawing which incorporates two or three different views of the head in one image, front view with two sides, for example.

At the bottom of the picture the device of splitting the wall into two subjective planes can be observed. The lines of the wainscoting have been carried across with broken lines, and the slight feeling of space and tension which result from their failure to meet is indicated by the arrow pushing from plane D to plane E. (See Plate XVII for the same phenomenon, and Plate XIV [lower left of diagram] for examples of Braque's drawing.) Split walls may be studied in the Venturi catalogue, Nos. 373, 570, 571, 572, 594, 600 (tables), etc.

Small arrows throughout the figure give indications of the overlapping planes that create space and depth.

The devices of distorted drawing explained in the diagram are the basis, in plastic terms, for the tension and dynamic character of this portrait. They are qualities that would not be present in a purely realistic, imitatively drawn portrait. But at the same time, considering the picture on human terms, it is correct to say that the expressiveness, the grave and contemplative character of the peasant model, are mainly a result of the plastic manipulations described. In any case, Cézanne has produced a profoundly moving human document in this portrait. Here is no lifeless mask, but a revelation of human character that brings Rembrandt to mind.

PLATE XX

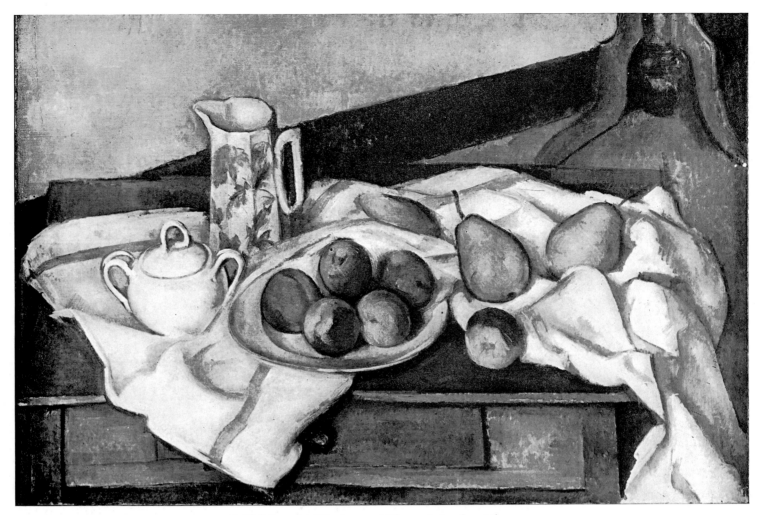

Still Life with Pitcher and Plate of Apples. CÉZANNE

THE PROBLEM to be explored with the help of the diagram is that of Cézanne's bent table tops. Our premise is that the wavering contours, so prevalent in the drawing of still-life tables, cannot be satisfactorily explained as the accidental result of an unsteady hand.

1) With respect to the purely decorative and two-dimensional considerations, the wavering outlines, emphasized by arrows in the diagram, add an interest and variety that mathematically straight contours would not afford. One could say that a positive quality of tension was thus added to the line (note arrows pushing up and down near the base of the picture).

2) Again, so far as two-dimensional qualities are concerned, it is important to avoid the monotony that would result from the repetition of horizontal table lines running parallel to the base of the picture frame, and Cézanne almost invariably does avoid it.

3) Perhaps more important than the first two aspects of the problem is the element of space and tension that the bent tables give to Cézanne's compositions. Often these variations are so extreme as to create an actual split in the table top. (See Plate XIV and its accompanying diagram for a description of the phenomenon of split tables and the resulting spatial tension comparable to the pull between two separate or overlapped planes.) In the still life shown here the variation in the upper contour of the table from the left side to the right side of the tall pitcher is great enough to create a spatial tension, as if between two planes on a lower and a higher level. The heavy arrow to the right of the pitcher emphasizes the rising contour on the right.

4) At the upper left-hand corner of the table another split is indicated by the broken line and the arrow that thrusts to the upper left. This slight thrust is particularly significant in the composition; together with the thrusting spout of the pitcher, marked with an arrow, it works to counterbalance the almost overwhelming movement of the floor and wall rotating into space toward the upper right.

(Mention should be made of the fact that the sides of the table seem to expand toward the top, in reverse perspective. In spite of the illusion of expansion, a device familiar in Byzantine and Abstract art, Cézanne's table actually converges slightly toward the back, as a careful measurement will prove.)

5) The front plane of the table is bent inward (as indicated by arrows), thus creating a rhythmic repetition of the arc of the white cloth.

Other pictures containing radical or significant bendings in contours and planes of tables should be brought into the discussion, lest the

PLATE XX
(*continued*)

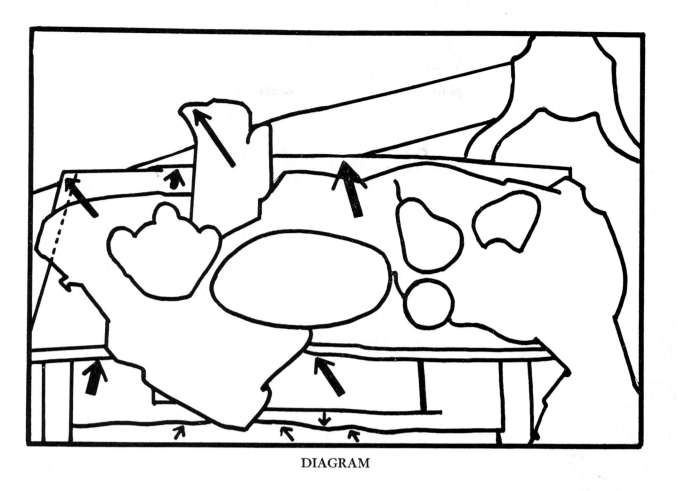

DIAGRAM

phenomenon be taken as a rare or accidental feature in Cézanne's drawing. In the Venturi catalogue, No. 356 has a bent table that creates a thrust into the right-hand space. No. 593 has a bent table thrusting leftward in opposition to the diagonal band of the wall on the right. Nos. 733, 734, 740, 758, 1135, 1142, 1145, 1150, 1154, 1155, 1541, 1567 indicate how extensively Cézanne made use of the variety-giving device of bending the contours of tables. In the landscapes and in the floors and walls of many portraits the same phenomenon can be observed, working both spatially and decoratively.

Now, if there were no absolutely straight lines in Cézanne's paintings, the argument of carelessness or an unsteady hand might deserve serious consideration. But the interesting and highly significant fact is that *there are a great number of lines that are quite straight—even appearing to have been drawn with a ruler.* The only possible conclusion is that Cézanne's lines were irregular because he wished them to be so and that he used them for contrast with straight lines. It will be instructive to list a series of paintings in which straight lines are an important element in the design. The sharp tension that results when wavering lines occur in the same composition in which ruled straight lines are used is a very important factor in many of Cézanne's paintings. In the Venturi catalogue, picture No. 502, the comparatively straight horizontals of the table are repeated at the top of the picture. The opposition of these straight lines to the round shapes of the fruit makes a significant geometric design. In No. 516 the vertical stretcher

bar appears to have been drawn with a straightedge. In No. 556 most of the slightly tilted verticals appear to have been ruled (see Section VIII above). Some of the lines in Nos. 557, 558, 559, and 560 also appear to have been ruled. The slanted verticals in Nos. 561, 574, and 576 are very straight. In No. 580 the trunk of the tree on the right is very straight; toward the center the verticals are "subjective construction" lines that lend great stability in contrast to the vivid curved and dynamic elements of the rest of the picture. In No. 595 there are vertical, diagonal, and horizontal lines that appear to have been drawn with a straightedge, and in No. 625, one of Cézanne's most superb still lifes, meticulously finished and yet containing one of the most distorted water carafes, there are straight vertical and horizontal lines in the wall. In No. 650 (Plate XV in the present book) the verticals are very sharp and straight. In No. 679, the famous "Boy with Skull," there are various straight sections of line. In Nos. 704, 706, and our Plate I very sharp straight lines contrast with curves and wavering lines. In many of the landscapes that follow the foregoing numbers in the Venturi catalogue, as well as in a still larger number of other subjects, noticeably straight lines occur.

The evidence seems to point overwhelmingly toward the fact that Cézanne used a straightedge guide when he really wanted a perfect and unwavering line. The unusual bendings and waverings in the contours of tables and floors must therefore be interpreted as intentional and deliberate ingredients of his total design and space concept.

PLATE XXI

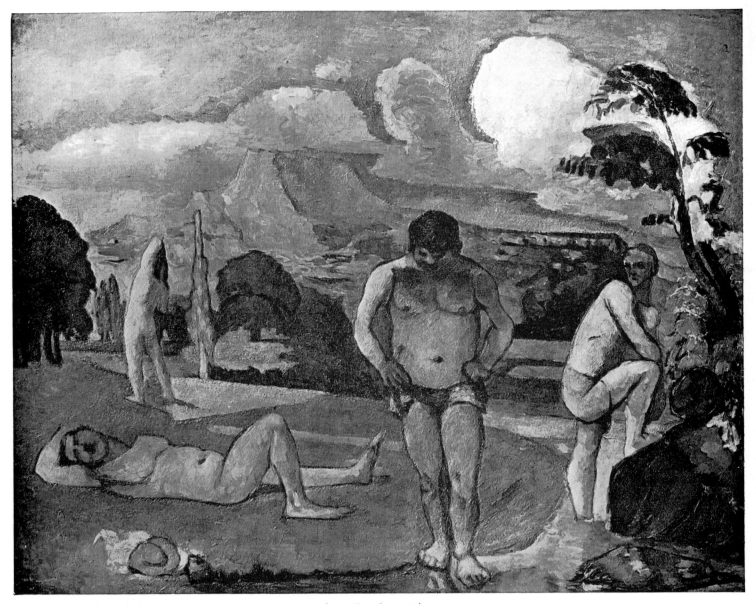

Bathers Resting. Cézanne

THE TYPE of distortion found in "Bathers Resting" has little relation to the problems that have been examined in the two paintings last discussed. Since, however, a large part of Cézanne's early work falls under the category of distortion, it seems important that such a painting as this one be explained in order to show exactly how it differs from his later work. The problem here, as in a large part of Cézanne's early work, is not one of meaningful distortion, but merely of clumsiness and lack of dexterity and manual skill. But even this picture is far in advance of the early black-and-white romantic period, and it has attained a comparatively high synthesis of color and form.

The composition is a good one. It is well closed; the corners have been turned successfully. The shapes are highly simplified and formalized; there is great variety in the shapes. The trees cover a gamut of different sizes and shapes. The deep space is well controlled. The planes rotate, as though circulating around some central axis, from the front, round the sides, into the deep space, and back again, in continuous free movement. The clouds are a particularly important factor in the plane movement, as they overlap, moving from behind the upper

right-hand tree toward the left, into space, and across the top of the sky. The prominence and clarity of these clouds is essential for bringing the deep space of the distance back to the front again, into relation with the elements in the foreground plane.

I am amused to find how many good qualities can be discerned in "Bathers Resting," since I chose it specifically to illustrate negative aspects of distortion. But the distortions here did not grow spontaneously out of the exigencies of the composition; they are crudities that resulted from Cézanne's torturing struggles with the drawing and modeling in the human figures, their faces, hands, and feet. The distortions are merely the butchering of naturalistic appearances and serve no plastic purpose. They are unpleasant and distracting. There are none of the compensating factors of interesting brushwork that developed in his later painting. How can such work be explained?

At this stage of his development Cézanne had not yet learned how to integrate form and color. Nor had he acquired the mannerisms of his first, so-called "constructive" period. This constructive period is characterized by the uniformity, the parallelism of the brush strokes

PLATE XXI
(continued)

(see Venturi catalogue, Nos. 341, 397, etc.). When the paint is applied in this manner, any gaucheries in the drawing of details, such as faces and hands, are less evident. Even without realization of its architectural purpose, the pattern of strokes itself usually suffices to divert attention away from the purely realistic appearance of things. But in this painting Cézanne has had a severe struggle in trying to apply the paint in relation to the form. These faces are not the bold simplifications we find in the later bathers. He had not yet resigned himself to reducing the heads of bathers to simple abstract shapes, for example. He attempted by smearing and smudging to draw realistic eyes, noses, mouths. He does arrive at a crude semblance of realism, but somewhat at the expense of the total effect. The faces are definitely overmodeled in relation to the landscape shapes, which are comparatively flat and simple. The dark modeling on the chest of the central figure gives a concave effect for which there is certainly no justification. Cézanne had not yet mastered his new system of painting. It took him a long time to arrive at it, for there was no teacher who could help him. To recall his words to Emile Bernard: "Today a painter must discover everything for himself, for there are no longer any but very bad schools, where one becomes warped, where one learns nothing."[2] Until a protracted effort had finally yielded a few autonomous examples, Cézanne himself had no clear vision of what he wanted to do. Very early he abandoned the easier path laid out by Manet. Renoir was too soft and lacking in architectural structure. Pissarro served as a beginning, but his influence did not carry for long. There was nothing for Cézanne but to struggle along until he had created his own vision of a new kind of form and color.

The issue becomes even more complicated when we remember the skillful kind of art-school drawing that Cézanne was able to turn out at a very early age (see Venturi catalogue, Nos. 1162, 1170). How, if he had the skill to make such finished drawings, could he be so heavy-handed in the "Bathers Resting"?

The simple truth is that the kind of form seen in these drawings cannot be rendered in terms of color. It reminds me of the invariable experience I have with new students in the life class who come with a background of conventional art-academy training in life drawing, the very kind we see in Cézanne's drawings (Venturi catalogue, Nos. 1162 and 1170). When the students are told to organize the entire space, the human figure and its surroundings, to relate it to the format, to the picture plane, the first results are usually a total loss of the slick finish in the figure drawing and a general clumsiness that belies the previous training. Any talented student can learn quickly how to copy an isolated object! Cézanne could do that as a young man. But when he imposed upon himself the task of composing the entire space and using color in a new, organic and creative way, he fell into the same clumsiness as students do. Thinking in terms of making the color related and balanced throughout the picture makes it extremely diffi-

cult to stop to draw out small objects and details. In Vollard's book on Cézanne there is an amusing passage that illustrates the difficulty of maintaining the total color relationship throughout the process of painting. It reads: "In my portrait there are two little spots of canvas on the hand which are not covered. I called Cézanne's attention to them. 'If the copy I'm making at the Louvre turns out well,' he replied, 'perhaps I will be able tomorrow to find the exact tone to cover up those spots. Don't you see, Monsieur Vollard, that if I put something there by guesswork, I might have to paint the whole canvas over, starting from that point?'"[3]

Keeping the whole picture in mind during the process of painting, and, as he described it to Gasquet, "advancing all of his canvas at one time—together,"[4] made it quite difficult to execute small parts of the human figure with accuracy. A new synthesis of color and form, the application of Impressionist color to classical form, was no easy task for a young artist not overburdened with flashy craftsmanship and skill. ("Bathers Resting" is a perfect example of this effort, and the composition bears a close relation to Renaissance painting.)

Later on, as his period of parallel brush strokes developed, a genuine skillfulness in execution can be seen. This new method of painting in regular and parallel brush strokes was an abstract system. It was an ideal method for Cézanne. It gave a uniformity to the surface, allowing color to be free from blending and the imitating of details. (See pages 30–31 above for a discussion of brush strokes and handling.)

In the final periods of his maturity—and it is with these late works that the present study has concerned itself except for the painting here considered—Cézanne's breezy execution of overlapping color planes and superimposed lines compensates for occasional crudities that recur in pictures like the late bathers.

Many years later, Cézanne made a new version of the "Bathers Resting" in the medium of lithograph (see Venturi catalogue, No. 1157). The difference between early work and late can be studied in these two versions. Distortions are present in the late version also, but they are completely integrated with the total organization. A moving, rhythmic quality pervades the total space, and the human figures are synthesized with mountains, trees, and clouds.

In memorable words to Emile Bernard, Cézanne said: "One thing is certain, we should not be content with strict reality, with trompe-l'œil. The transposition that a painter makes, with a personal vision, gives to the representation of nature a new interest; he unfolds, as a painter, that which has not yet been said; he translates it into absolute terms of painting. That is to say, something other than reality. This, indeed, is no longer shallow imitation."[5]

[2] Bernard, Souvenirs sur Paul Cézanne, p. 68.
[3] Vollard, Paul Cézanne, tr. Van Doren, p. 117.
[4] Gasquet, Cézanne, p. 130. (See p. 15 above.)
[5] Bernard, op. cit., p.114.

XII

AERIAL PERSPECTIVE

IN THIS section, paintings are compared with their motifs in order to illustrate
Cézanne's rejection of one of the important elements of Impressionism, namely,
the diminishing and fading away of distant hills and mountains.

PLATE XXII

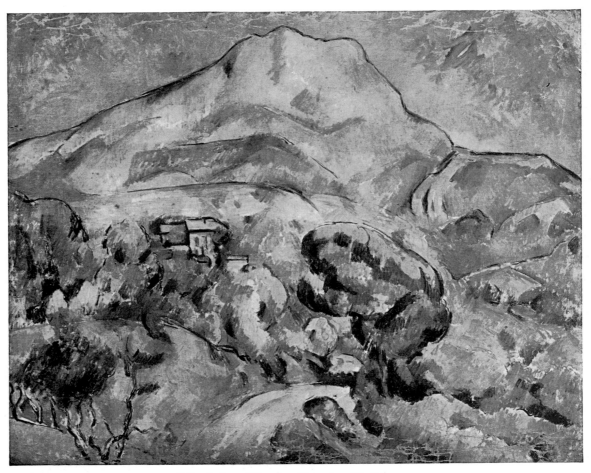

The Sainte Victoire [Version I]. CÉZANNE

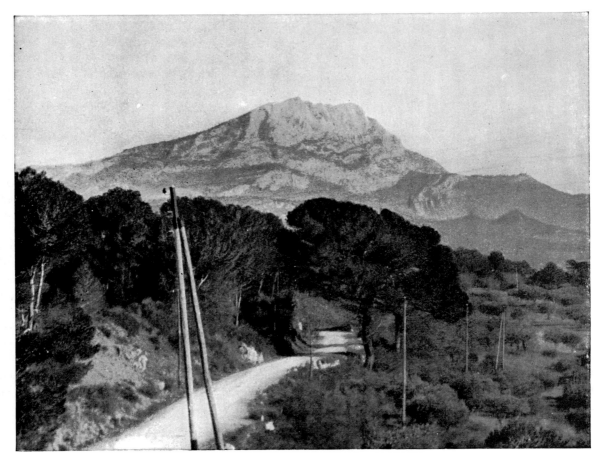

Photograph of the motif

PLATE XXII

(*continued*)

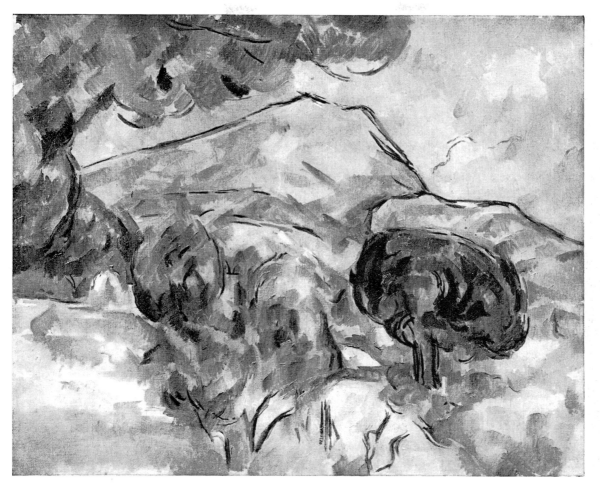

The Sainte Victoire [Version II]. CÉZANNE

THE PHOTOGRAPH of the motif shows the mountain called the Sainte Victoire in a somewhat hazy atmosphere that is appropriate for the comparisons to be made here with Cézanne's two paintings. Admittedly, a clearer photograph could have been achieved with the help of filters and proper photographic technique, but the fading of the distance is a typical naturalistic effect, highly prized and extensively developed by the Impressionists, and generally called "aerial perspective." (a) In both the paintings shown here Cézanne has avoided the fading away of aerial perspective. (b) Space and recession are achieved through the overlapping of planes; (c) the use of arbitrary line as a plastic implement was never more obvious in Western painting.

(d) In Version I, not only is the mountain made as clear and prominent as the foreground forms; the outlines of its outer contours are even more forceful and deliberate. It is obvious that Cézanne wished to avoid the fading away that characterizes the mountain in the photograph of the motif. (e) Even more important is the fact that in Cézanne's painting the mountain is enlarged, expanded in size. Perspective is again reversed to the end that the background or distance should not fall away and thus destroy the mural quality of the picture plane. The monumental effect, the grandeur of Cézanne's mountain, clearly drawn in deep space but decoratively remaining on the picture plane, is a good example of the difference between Cézanne's form and that of the Impressionists. (See Plate XXIII.)

In Version II, Cézanne makes a quite different interpretation of the mountain, although it is seen from almost the same position (about thirty feet to the left). This painting is obviously a much later work than Version I, and it is far more rhythmic and synthesized in form. (f) Looking at the front planes at the bottom of the picture, we notice that Cézanne has flattened out the olive trees, which in Version I protrude somewhat at the lower left. They have been fused with the "passages" and color planes of the earth and road. (g) All the trees are more formalized than in Version I. Notice how the main tree at right center, with its trunk here placed to the left of the foliage volume, pushes downward in rounded planes, creating a strong pull or tension in relation to the rounded forms of the trees bordering the frame at the upper left, in the sky. (h) In Version I the trunk of this same tree is pushed to the right, with the heavy foliage volumes building up and to the left. (i) These two contrasting interpretations of the same tree motif afford factual evidence of a conscious approach to organization and design on Cézanne's part. The rightness of each interpretation in its own specific composition seems obvious. Here is proof again that plastic organization demands distortion and alteration of factual appearances. It shows also that every new work of art has its own new laws, even though the same subject is used.

The mountain in Version II is austere and formal, being, on the whole, a severe simplification of the motif in nature rather than a deviation from it. (j) It is rendered in terms of subtle, overlapping, parallel planes of color. (k) But superimposed lines are particularly obvious and they mark out its four main divisions or planes, within which the smaller modulations are developed.

PLATE XXIII

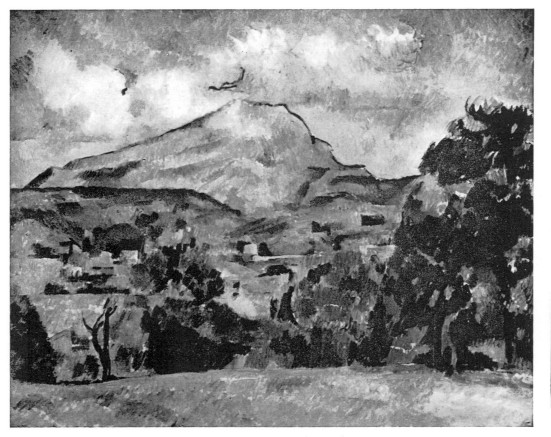

The Sainte Victoire. CÉZANNE

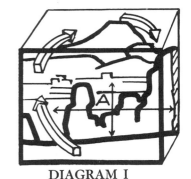

DIAGRAM I

CÉZANNE'S TOTAL SPACE SHOWN IN
A "PICTURE BOX." (SEE ALSO
GLOSSARY, PART ONE,
DIAGRAM II.)

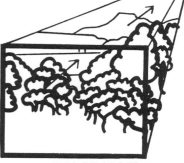

DIAGRAM II

RENOIR'S TOTAL SPACE. (SEE
GLOSSARY, PART TWO,
DIAGRAM V.)

Two Paintings of the Same Subject by Cézanne and Renoir. It seems particularly appropriate, following Plate XXII, to compare another version of the Sainte Victoire by Cézanne (above) with a painting by Renoir (below) done from the same location. (a) Renoir's painting displays a conventional approach to space and a purely Impressionistic use of aerial perspective in the distant mountain. (b) The foreground trees protrude in a naturalistically spatial way, particularly at the right, (c) and a deep, funnel-like hole seems to develop in the distant plateau at the base of the hills. (d) The mountain is faded out in a mist, giving the illusion of great distance in a stereoscopic type of realism. (See Diagram II.) (e) There is no provision for a return to the foreground. Depth and space are not "compensated." (See Glossary, Part Two, Diagram V.)

The opposite effects can be studied in Cézanne's version of the motif. (See Diagram I.) (f) The foreground trees are held together in one plane, marked with axis bars and letter A, which runs across the picture like a curtain. Great variations in the size and shape of the individual trees make

this foreground mass highly interesting, decoratively. The distant hills are reduced to another simple plane, parallel to the curtain of trees. The mountain is the last parallel plane, and instead of being faded out it is boldly outlined. (g) Its position in the distant deep space is actually clearer than in Renoir's painting because of the firm drawing of planes that overlap from the foreground back to the distant mountain. (h) But because of its clarity and parallel relation to the picture plane a strong tension can be felt between the plane of the mountain and the flat plane of the foreground mass of trees. The space is organized as indicated by the arrows in Diagram I. The "return" from deep space is suggested by the upper arrow which leads forward into the foreground trees.

Renoir is of course a great artist, particularly in his masterful figure compositions, but in this comparison Cézanne's mastery of space drawing is strikingly superior.

The Sainte Victoire. RENOIR

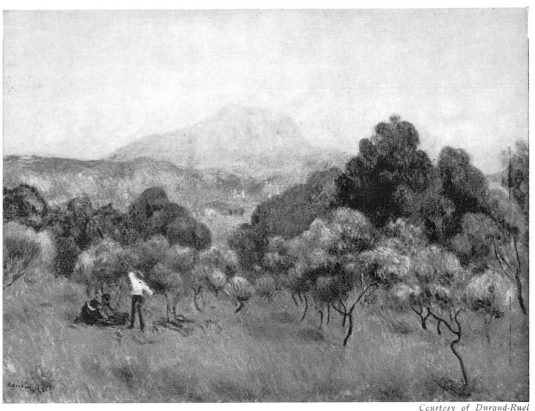

Courtesy of Durand-Ruel

PLATE XXIV

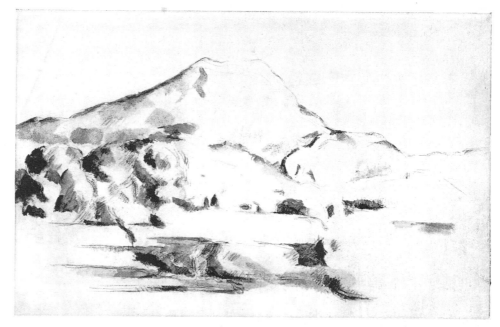

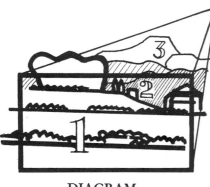

DIAGRAM

The Sainte Victoire from Bellevue. Cézanne

The photograph of the motif is technically poor; nevertheless it reveals strikingly what is the Impressionistic basis in natural light for conceiving of aerial space in terms of foreground, middle distance, and distance, as we may observe it in Renoir's painting on the opposite page. These three layers of space are indicated in the diagram and numbered: 1 for the foreground area, 2 for the middle distance, and 3 for the distance. (a) But Cézanne was not interested in imitative effects of space and he has completely disregarded the suggestion offered by the subject. (b) In his water color the distant mountain is outlined with the clarity of foreground forms, because the total space, balanced with regard for the picture plane, was his aim.

An interesting example of Cézanne's approach to scale may also be studied in this comparison. (c) The two cypress trees and house, situated directly beneath the high points of the mountain, have been kept very small in Cézanne's water color. The purpose was, of course, to make the mountain loom up majestically large by comparison.

The water color also reveals Cézanne's typical approach to painting, (d) first drawing in line, (e) then gradually constructing the outer planes of the forms from dark to light. The painting was left in an early stage of development, but even as it stands it is remarkably balanced. Its curvilinear rhythms are the dominant formal theme. (See Plate I, Diagram VII, for an explanation of this plastic element.)

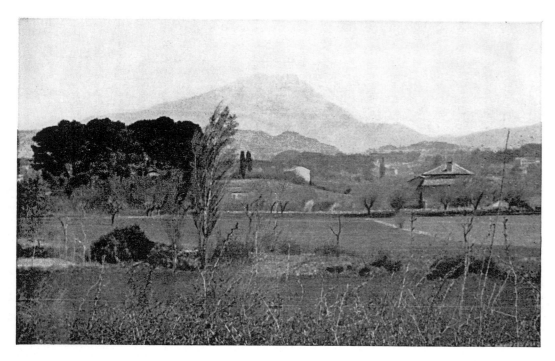

Photograph of the motif

PLATE XXV

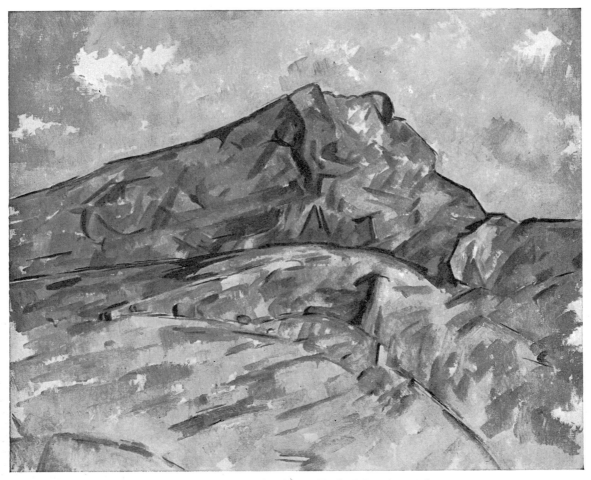

Figure 1. *The Sainte Victoire at Early Morning.* Cézanne

THIS PAINTING, which is a late work of Cézanne's, reveals great preoccupation with complex color-plane structures. Very few paintings by Cézanne appear to be more abstract. and it is now generally understood that Cubism developed from this type of Cézanne picture. Surface textures as a decorative element are totally absent from the painting. The color planes are entirely structural in purpose, giving a highly "Cubistic" appearance to the work. A painting by Picasso (Figure 3) is illustrated here to show how the system of Cubism developed. (a) Segmented lines, (b) complex gradations from dark to light (color modulations in Cézanne), (c) many "passages" (fusion of form with surrounding or background through "lost edges"), (d) strong emphasis on planes and construction lines throughout the picture—these are the earmarks of early Cubism, and they stem directly from Cézanne. (See Plate I, Diagram VII; Plate XI, Diagram V.)

The foreground-background relation is the typical Cézannean solution of space composition. (e) The foreground has been flattened out. No textural indications of the all-over heavy tree growth exist, although a few roundish tree forms can be found. The mountain is dark and heavy in form, while the foreground hills are lighter both in value and in volume weight. The photograph of the motif shows the opposite relation.

The discussion thus far has placed emphasis on the arbitrariness of Cézanne's approach to his motif and the similarity of the form in this painting to that found in Cubism. But it is important to ascertain exactly what the relation between subject and painting is. (f) Actually, Cézanne has given us a remarkably faithful portrait of the mountain. What the photograph of the motif does not show is the morning light coming from the right in the painting. (The photograph of the motif was taken later in the day in direct sunlight.) The apparently arbitrary "Cubistic" facets of contrasting

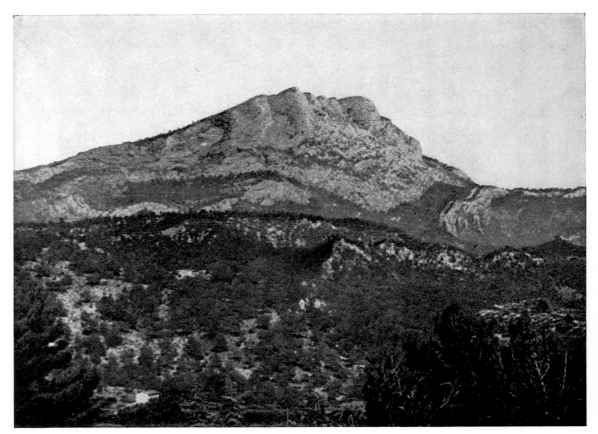

Figure 2. *Photograph of the motif* (later in the day)

PLATE XXV
(*continued*)

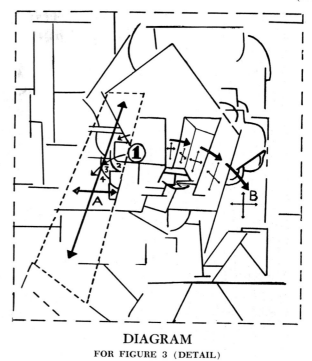

DIAGRAM
FOR FIGURE 3 (DETAIL)

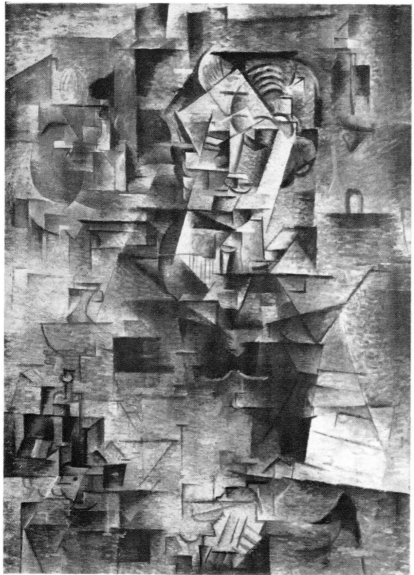

Courtesy of Mrs. Charles B. Goodspeed

Figure 3. *Portrait of Kahnweiler.* Picasso

light and dark planes are quite definitely the result of a close observation and analysis of the early morning sunlight on the mountain. It is not to underestimate the abstract meaning in Cézanne's picture that the foregoing observation is made, but simply to indicate that Cézanne's form grew out of the experience of nature and that it was not entirely an intellectual preconception. His unchanging ideal was to create in contact with nature, and even his most formal and abstract landscapes are a testimony of his adherence to this principle.

Picasso's portrait of Kahnweiler, Figure 3, also gives evidence of having been painted directly from the subject. Just as we observed in comparing Cézanne's painting with the motif, a right-hand light source no doubt provided the original suggestion for the synthesis of "Cubistic" light and dark planes. The model is quite recognizable, and it may be, as in Picasso's portrait of Vollard, that a definite likeness or characterization of Kahnweiler has been achieved. I shall never forget, upon first meeting Monsieur Vollard, how impressed I was with the fact that he seemed familiar to me through Picasso's Cubist portrait of him. The more specific title of Analytical Cubism[1] thus proves clearly descriptive of the phase of Picasso's (as well as Braque's) painting that is illustrated in our Figure 3, the factor of light source and the character or caricature of the sitter being the more obvious indications that the painter keenly analyzed the subject.

The discussion of Picasso's portrait has so far suggested a further basis for the close relation between Analytical Cubism and Cézanne's approach to form. But even when a painting like Cézanne's (Figure 1) is compared with a Cubist work, the differences are great. In spite of the complexity of the planes in Cézanne's mountain, and their tend-

ency to intersect and fuse as in Cubism, the final result is a solid-volume effect. Cézanne never disintegrates the objective form and space of nature; he expresses their essence. But Picasso deliberately breaks up the entire pictorial surface with intersecting planes that fuse the volumes of the figure with the surrounding negative spaces. A rather mysterious quality of space is thus effected and the picture itself becomes an "object" the volume structure of which cannot consistently be judged by reference to the original subject. The small planes sometimes overlap in consistent series, making it possible for the eye to follow a definite recession into depth. But then the last plane in a series "returns" to the level of the picture plane as the volume effect is purposely disintegrated.

A diagram of the head and surrounding planes has been drawn in order to make this complex phenomenon more understandable. Starting with the plane of the left cheek bone, marked with a large numeral 1, a series of planes marked, 2, 3, and 4 overlap and move into depth. Plane 4, however, is "brought back" to the level of plane 1 by being merged with the large "subjective" plane defined by broken lines and the double-pointed axis bars marked A.

The planes on the right side of the head, quite to the contrary, combine in such a way as to build up a solid-volume structure that is inconsistent with the rest of the painting. Starting with the nose, the planes move downward and to the right, as indicated by arrows in the diagram, constructing objectively recognizable planes for nose, cheek, and jaw. The movement continues downward and into the deeper layer of the plane, marked B, with vertical and horizontal axis bars. The volume of the head remains solid on the right and the planes of the nose and cheek are not fused with plane B as they are with plane A on the left side of the head. Part of the head thus comes out as a recognizable volume. In fact, it separates rather disturbingly from the rest of the space, and it may be said that the two-dimensionality of the picture plane is not nearly so well maintained as in Cézanne's painting of the Sainte Victoire.

Paradoxically, then, it turns out that, although Cézanne has produced a moving document of nature, he has also fused the purely plastic means of line, plane, and volume into an abstract synthesis of a far more perfect order than Picasso has achieved in his intentionally Abstract portrait. (The inconsistency analyzed in Picasso's portrait should not be taken as a typical characteristic of this great artist's work; the picture is shown here because of its close resemblance to the plane facets in Cézanne's "Sainte Victoire.")

[1] Barr, *Cubism and Abstract Art*, p. 29. Criticism and illustrations of this phase of Cubism are provided in Mr. Barr's book.

PLATE XXVI

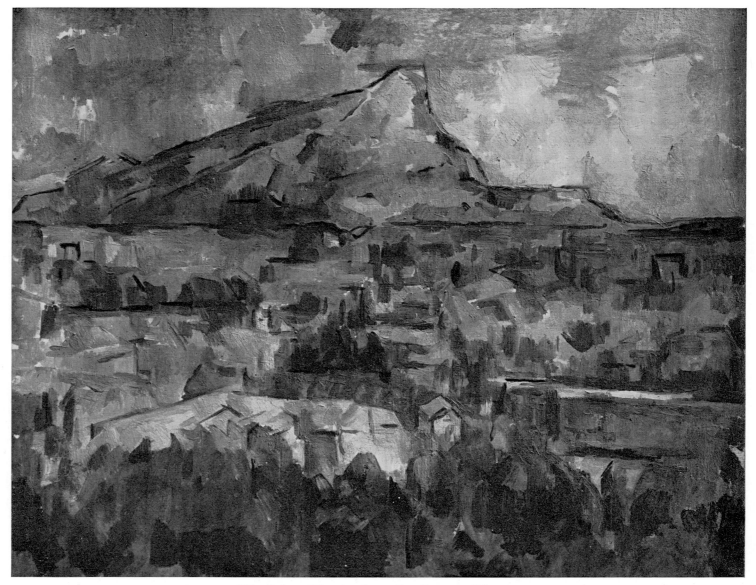

The Sainte Victoire from Les Lauves. CÉZANNE

HERE IS ONE of the last paintings Cézanne made of the mountain, and without the accompanying photograph of the motif it might be considered highly abstract. Definite transformations have certainly been made and the arbitrariness of the individual color planes is typical of the series of late paintings done from this location, Les Lauves, a vast terraced slope above the studio in which Cézanne last painted.

In spite of Rewald's clear photograph, probably taken with a telescopic lens, (a) the motif reveals typical aerial perspective or fading away of the mountain, which is seen here from a distance of eleven miles or more; (b) but although Cézanne has eliminated its details he has given the mountain an intensity almost equal to that of the foreground forms and has emphasized its height. (c) The photograph shows a gradual diminishing and fading away from the immediate foreground toward the distant mountain that is consistent with the actual depth suggested by the converging "picture box" of Diagram II. (d) Cézanne, on the contrary, has kept this vast space comparatively shallow, as is indicated in the "picture box" of Diagram I, (e) without losing the effect of planes stepping back into the distance. In fact, Cézanne's painting actually involves more distance than Rewald's photograph shows. The large shaded area of trees, marked B in Diagram I, is almost entirely missing in the motif photograph.

In order to clarify this fact, a protruding "picture box" or negative-space area is shown in Diagram II, marked with brackets and the letter A. In this space the trees found in Cézanne's painting have been drawn. (Several of my own photographs of this motif, taken prior to Rewald's photographic expedition to Aix, supply the information recorded in Diagram II.) By means of the perspectival "picture box," the diagram as

a whole should illustrate the effect of the unlimited deep space of nature that is present in the photograph, plus the foreground trees included in Cézanne's painting. Cézanne has made use of all these elements of deep space, but he has organized them and confined them within a seemingly shallower depth of total space, as is indicated in the "picture box" of Diagram I. (f) Three-dimensionality is clearly established; yet in this painting, as in the entire series to which it belongs, (g) the all-over patchwork of color planes produces a pronounced two-dimensionality. The individual planes are definitely flat and the line drawing is more segmented and ragged than usual, making the larger divisions less clear in space. (h) Strong construction lines that "carry

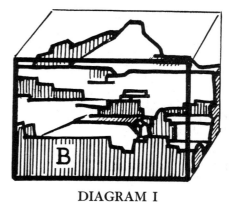

DIAGRAM I

PLATE XXVI
(*continued*)

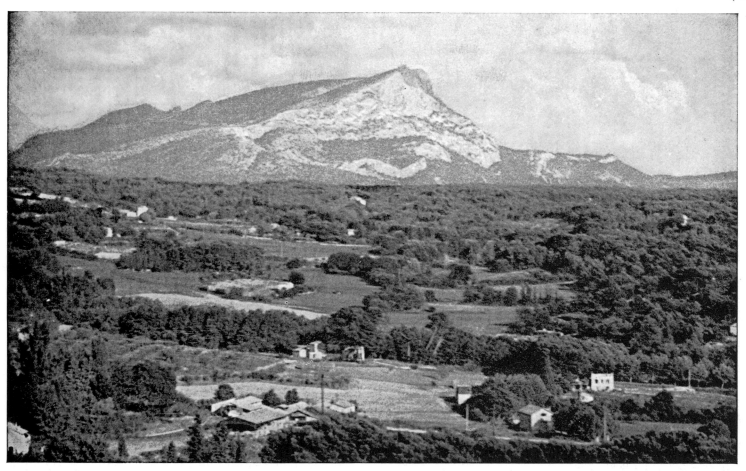

Photograph of the motif

through" vertically, diagonally, and horizontally afford still more two-dimensionality. Notice the strong horizontal directions that carry across the peak of the mountain, bordering the clouds to the right.

I think it is valid to point out, in connection with a good number of late pictures such as this one, that the color-plane-modulation system was perhaps getting too strong a hold on Cézanne. (i) Many of these late pictures have a "spottiness" that resulted from breaking up the surface into too many small planes. They become somewhat overladen with minute structures and take on a slightly baroque quality. (See Nos. 799 to 805 in the Venturi catalogue.) The individual "patches of color" are so prominent in pictures like this that one can find the basis at least for the critical legend of Cézanne's dependence on color and "lack of linear content." And yet, even in this picture, the larger plane divisions—that is, the separation of foreground from background and the smaller divisions within both these two vast masses—are so obvi-

ously dependent upon heavy superimposed lines that one can only marvel at critical interpretations that deny the structural importance of line and contend that "the individual patches of color, as small constructional parts of the picture, are the real supports of the pictorial structure in Cézanne's painting."[2] I do not see how a more concrete admission of the specific importance and function of the color modulations could be offered than that found in our Plate XIII, Diagram III. Conversely, I do not see how anyone could possibly visualize the shapes of trees and rocks in that picture without the bold outlines that define and enclose these shapes. Likewise, in the "Sainte Victoire" shown here, if the outlines were removed, the remaining color patches would add up to an almost completely abstract relationship of shifting color planes. Weight and solidity would be there in terms of rich, translucent color. But no space drawing that would explain the forms of nature would remain without the important though segmented outline drawing.

The foregoing statements are particularly related to some of the latest works, such as the "Sainte Victoire" shown here. Were there not linear demarcations in Cézanne's painting, it would have been very difficult, if not impossible, to visualize the planes shown in Diagram I. However, firm outline drawing does begin to dissolve in these late works in favor of a more dominant and free play of the color planes. Matisse and the great Abstract artists finally rejected Cézanne's modulations altogether and showed their revolt by painting in the most completely flat areas of color that had been seen since Egyptian mural painting and Persian miniatures.

In connection with the diagrams shown here, as well as those for Plates XXIII and XXIV, it is suggested that the same type of "picture-box" analysis could be applied to a large number of the paintings previously analyzed. With the concept of negative space as described in Diagrams II and III of the Glossary, Part One, and the explanation of uncompensated perspective, as illustrated in Diagram V of the Glossary, Part Two, Plates I, II, III, IV, V, VI, VII, and many others, should be reviewed and reconsidered from the same point of view.

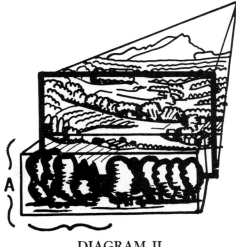

DIAGRAM II

[2] Novotny and Goldscheider, *Cézanne*, p. 12.

PLATE XXVII

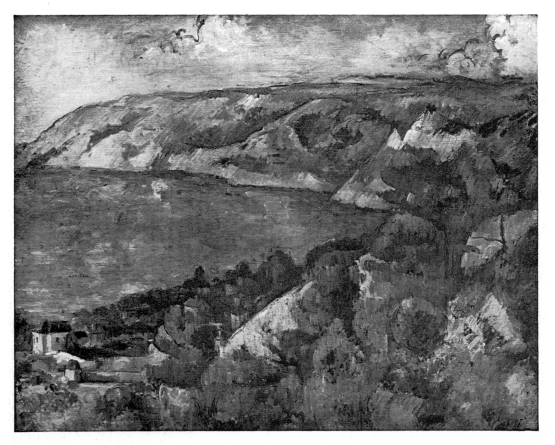

L'Estaque. CÉZANNE

A TYPICAL example of the problem presented by dominant foreground and faded background planes can be studied in this comparison of painting and motif. New buildings in the foreground alter the motif somewhat, and a railroad line with bridges has been cut through the distant hill, but the identity of the motif is otherwise quite clear. (a) The photograph presents an excellent example of a split between foreground and background; the background mountains fall away into one plane of faded values, while the entire foreground area is in full black-and-white intensity. (b) Cézanne's painting, on the contrary, is completely unified; the foreground leads directly into the background without a break, the space moving in an arc from the foreground into the upper right-hand space and then along the mountains across the top to the left. The background is stepped up in intensity, so that it holds its place with the foreground. Unity and two-dimensional balance are thus achieved, (c) but the effect of three-dimensional movement into space is nevertheless portrayed with great power.

Again Cézanne is shown to be out of harmony with the fundamental precepts of Impressionism, for "we feel the representation of the country in the distance as if it were near, without ever losing awareness that it is far," [3] and such effects preclude the use of aerial perspective, which is generally fundamental to Impressionism.

[3] Venturi, *Cézanne,* p. 56.

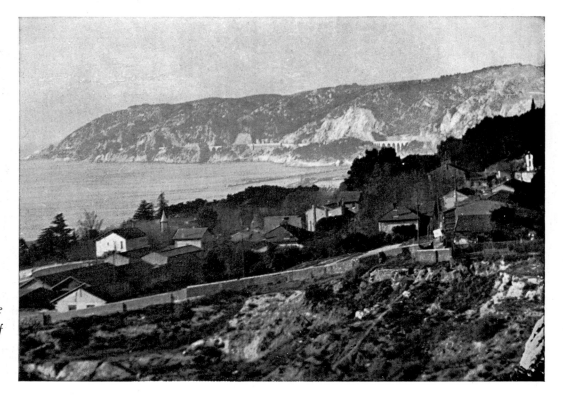

Photograph of the motif

PLATE XXVIII

View of L'Estaque.
CÉZANNE

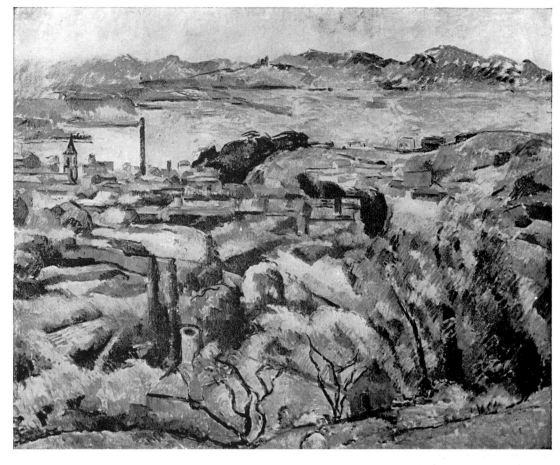

THE AVOIDANCE of aerial perspective is to be noted in this painting by Cézanne, though perhaps it is not so emphatic as in the comparisons thus far made. The distant mountains across the bay of Marseilles are somewhat atmospheric in Cézanne's painting, although not to the degree present in the photograph of the motif. (a) But these distant hills, the water, and the sky are unified more or less into one large plane of color that seems to have just the right amount of weight to hold the upper areas in proper balance with the compactly organized foreground forms.

(b) Cézanne displays his great skill in organizing the decorative elements in this picture. Strong rhythmic movements "carry through" from one part to another. (See also Plate I, Diagram VII.) (c) Likewise, a strong pattern of construction lines gives a unifying two-dimensionality to a composition that is rather dangerously complex. (See Plate I, Diagram V.)

(d) The large house in the foreground is held back by a plane of loosely hatched trees that rises up toward the right, tending to embrace the entire area of land surface, up to the water, in one plane. (d) The deep space moves back into the left-hand part of the picture and is continued upward by the overlapping planes of cliffs that carry the movement across the top toward the right. The space thus moves in a continuous curving path from foreground into depth and back to the foreground area again.

(f) It is interesting to study the top of the round smokestack of the foreground house. It has been tipped up to a position more nearly parallel with the picture plane, as if seen from a higher eye level than the rest of the composition. (See Plate XIV.) This device is extremely important for holding the lower part of the house up and in relation to the picture plane. The protuberance of the large house has otherwise been strongly suppressed, partly by the transparent plane of leafy trees that comes in front of it.

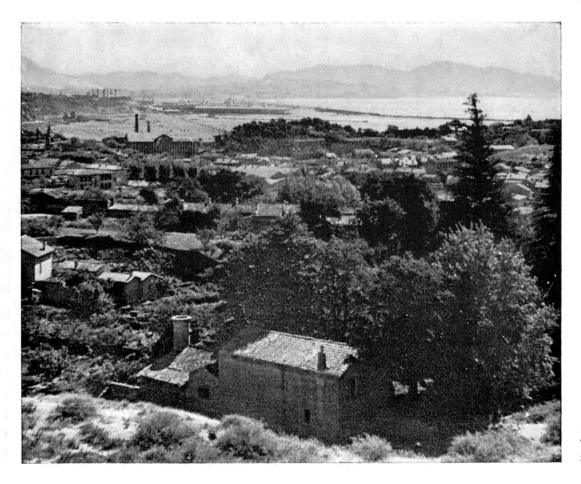

Photograph of the motif

PLATE XXIX

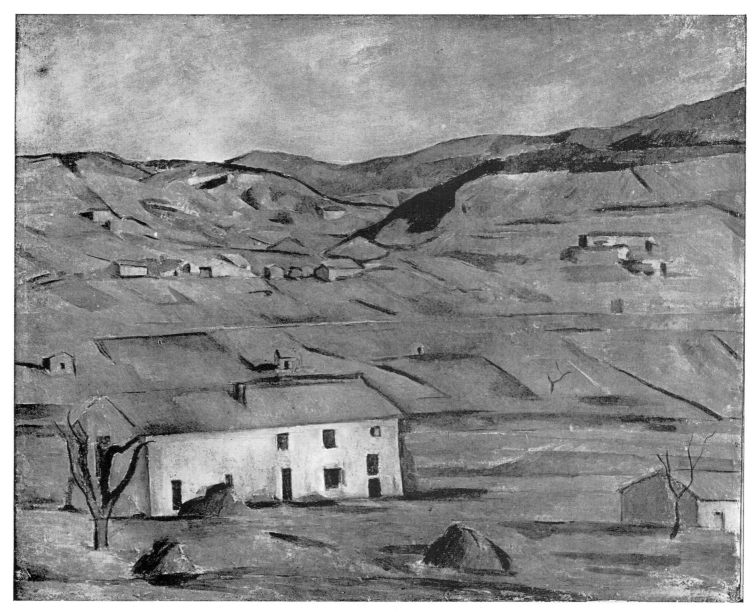

Provençal Mas near Gardanne. CÉZANNE

EXCEPT THAT the photograph of the motif was taken in summer (the painting was obviously done in winter, when trees and bushes were leafless—as is shown in earlier photographs which I have made from this motif), the comparison here shows Cézanne unusually close to his subject even in most of the details. And it is worth our while to identify in the painting the various buildings, fields, and hills that appear in the motif, because Cézanne's painting is constructed out of geometric elements of form so austere as to suggest a Cubism unrelated to specific and detailed forms in nature.

Extremely important alterations have been made, however. (a) The entire plane of fields and distant hills has been enlarged and tilted upward.

PLATE XXIX
(*continued*)

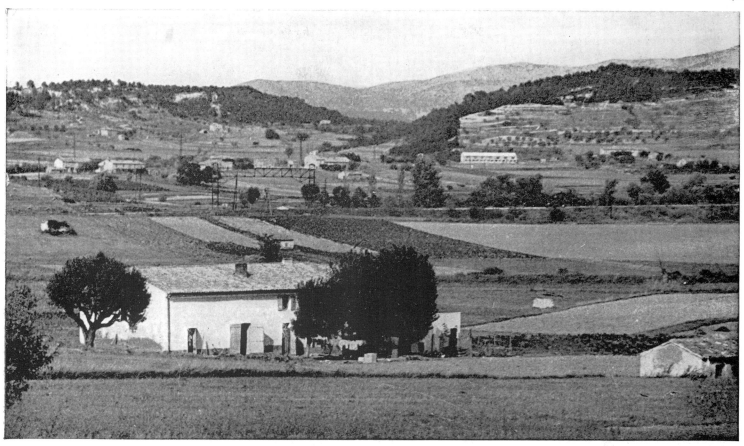

Photograph of the motif

(b) Shifting the contours of the austere fields (just behind the farm-house—the *mas*) to a more vertical position has been important in effecting this new position. (c) The ridge of hills in the far distance (actually the Sainte Victoire) has been brought forward in intensity. In the photograph of the motif the natural fading away is pronounced.

(d) By the two means mentioned, that is, the avoidance of aerial perspective and the forward tilting of the entire plane of the earth and hills, Cézanne has achieved a mural quality that is an essential element of the monumental austerity characterizing this great painting. And yet, very few paintings by Cézanne demonstrate more obviously the element of three-dimensional solidity, which he always aimed to achieve. (e) The textural character of trees and plants has been avoided completely. Austere and naked form alone has been expressed. One may even say that the form of houses, fields, and hills has a solidity comparable to the three-dimensionality of a sculptured relief. But of course the painting is anything but an imitation of sculpture, and all the form-space effects are ideally related to the picture plane.

Cézanne's method of locating the building in space is particularly to be noticed. His *mas* shows a slight convergence, as if he were drawing according to mechanical perspective; but the building in the photograph is actually larger on its downhill side. (The heavy foliage of the tree at the right of the *mas* obscures the full revelation of this increase, but other photographs which I took make it quite clear.) The foundation or base line of the *mas* is parallel to the roof line, and it is this parallel which Cézanne has chosen for the ground level in his painting, adding the slight convergence mentioned before. The result is that the house turns in space more positively in the painting than in the photograph. The narrow ground plane, extending from one end of the *mas* to the other, is thus tipped up, as are all the other planes in the subject; hence the consistent relation of all the planes to the picture plane.

XIII

REALISM AND ABSTRACTION

BETWEEN paintings and motifs, comparisons are made that determine the degree

of faithfulness to nature in pictures that appear to be highly abstract.

Related problems of composition are considered.

PLATE XXX

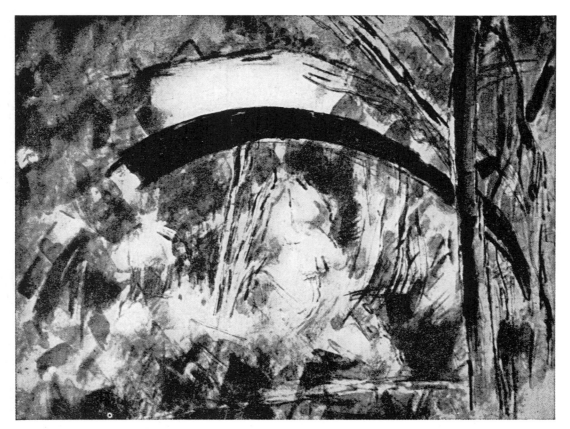

*Le Pont des
Trois Sautets.*
Cézanne

THE PHOTOGRAPH was taken in winter, when foliage was absent from the trees, but Cézanne's picture was obviously painted in summer. The painting is among those which had always appeared highly abstract to me until I came upon the motifs. Here, the forms, when compared with the photograph of the motif, became disarmingly simple.

(a) Cézanne has made his painting so purely a problem of form and color, the emphasis upon line and plane is so extreme, that the subject matter is lifted out of its naturalistic context. (b) The foliage forms have been rendered in terms of bold areas of flat color; plane is superimposed over plane in a rather abstract manner. (c) Form and space are defined to some degree by the strong light-and-dark pattern; but without the arbitrary line drawing over the color planes, the space would be vague, to say the least. (d) Dufy must certainly have derived his systematic approach to painting from similar pictures by Cézanne. Line over open color is now a familiar approach in contemporary painting and it should be understood as one of the outgrowths from the fountain source, Cézanne.

(e) The most obvious rearrangement of the composition is seen in the exaggerated arching of the bridge. A continuous circular movement from the top around the borders of the frame is thus achieved. (f) The planes of trees and foliage, made clear with arbitrary outlines, overlap and move into deep space from left to right, under the bridge. (g) The heavy vertical tree at the right, which intersects the bridge and a part of the deepest space, provides a means of "return" from depth to foreground, as well as a clarification of the spatial location of the bridge. (h) In design, the tree provides the necessary opposition of a static straight line to the overpowering curve of the bridge. Realistic and perspectival effects of depth have been modified, and Cézanne has "filled," in the painting, the vacuum of space seen behind the bridge in the photograph of the motif. Three-dimensionality is thus accommodated to the basic flatness of the picture plane.

*Photograph of the
motif*

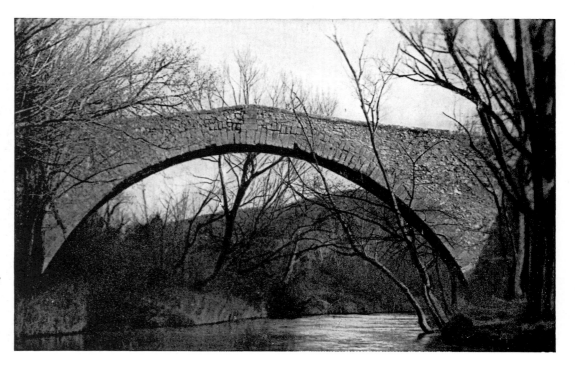

PLATE XXXI

*Trees and Rocks
at Bibemus.*
Cézanne

Here is an example of a water color that appears to be somewhat abstract until it is compared with the photograph of the motif. The space is quite clear even though the line drawing is rather summary.

An interesting conjecture may be made with respect to a number of water colors developed to about this stage of completeness. (a) The corners are unpainted and the total design is like a large oval mass fitted into the rectangle of white paper. (b) The extremely important problem of "turning the corners," of preventing the design from "leading out of the frame" at the corners, is thus presented. (c) The obvious conclusion to draw is that Picasso and Braque found the origin for their purely abstract oval-within-rectangle compositions in paintings by Cézanne that were left in this unfinished state.

(d) Another problem is suggested by the airy, loose painting, of flat areas of color, with segments of line superimposed here and there to establish the form and space. Even though the line exists for the most part in rather short, jerky segments, it is absolutely essential for establishing the drawing, the three-dimensional space. Raoul Dufy comes to mind here for having extracted the kernel of this approach to painting from Cézanne. Stated simply, it is the system of painting in rather "open" abstract areas of color that do not always relate to the form. The form is indicated mainly with superimposed line drawing.

(e) A subtle three-dimensional effect closely related to Cézanne's system of color modulations takes on a special quality in water colors like this one. The color planes are superimposed one over the other without disturbing the under layer. (Cézanne, of course, never painted "wet in wet" in water color, but always waited for each plane of color to dry before applying another over it.) The effect of form "building up" is thus achieved without actual departure from flat planes or the employment of modeling. (See Plate XIII, Diagram III, for color modulation, and Glossary, Diagram XIX, for open color.)

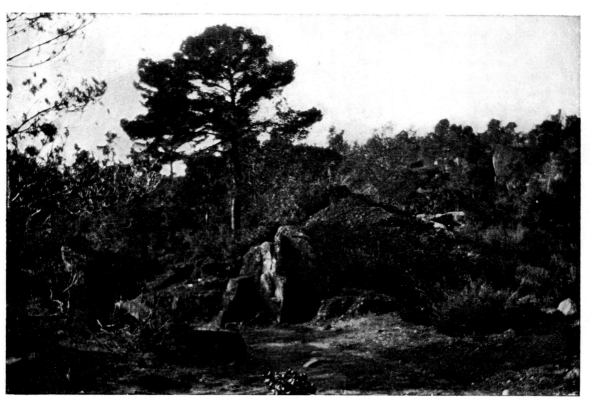

*Photograph of the
motif*

PLATE XXXII

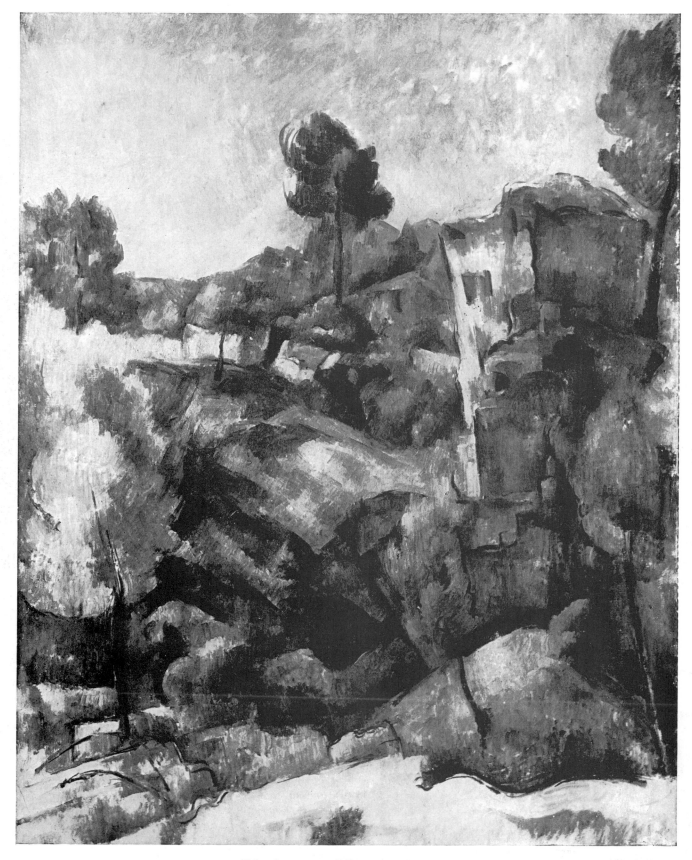

The Quarry at Bibemus. CÉZANNE

PLATE XXXII
(*continued*)

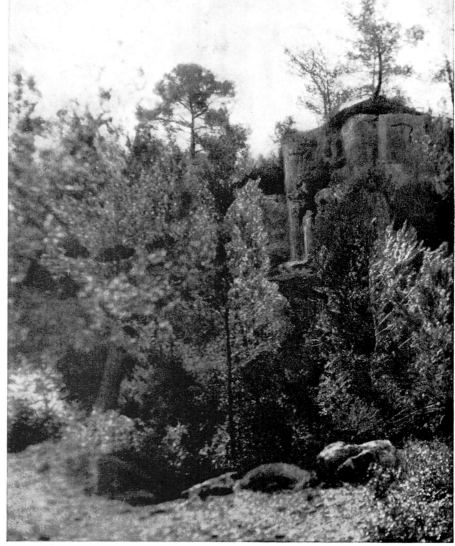

*Photograph of the
motif*

FEW OF Cézanne's paintings fascinated and yet mysti-
fied me as this one did during the years prior to
my discovery of the motif. What appeared to be a
highly abstract synthesis of planes and geometric,
linear movements, unrelated to anything I had ever
seen in nature, became quite definitely the analysis
and organization of a very specific place—as is shown
by the photograph of the motif. The trees have
grown taller, but it is still possible to identify most
of the forms, particularly the volume of the cliff
on the right.

The diagram is intended as an explanation of the
spatial organization, which remains obscure in a
halftone reproduction even when it can be com-
pared with a photograph of the motif. (a) It is par-
ticularly important to point out that the space de-
pends on the overlapping of planes and not on the modulations and grada-
tions of color and value. Indeed, the modulations and numerous "passages"
or fusions tend somewhat to obscure the clarity of the space in this halftone,
and the diagram is made entirely with planes.

(b) The heavy curved arrow moves into depth, starting from the first plane
at A. (c) Small arrows throughout the diagram indicate the general overlapping
of planes, from the front, into deep space and toward the right. (d) Above the
large cliff on the right an arrow projects from C toward B on the face of the
cliff. A small opening of space between the cliff and the frame provides room
for this "return" of movement from deep space to foreground, as symbolized
by the curved arrow pointing toward B. The cliff is drawn, with axis bars,
as a flat plane, but in Cézanne's painting the volume character of this quarry
form is fully developed.

The composition just outlined is a typical classical formula. (e) The main
volumes are placed at one side, and on the other is a thrust into deep space.
(f) The deep space appears to surround and enfold the main volume. El Greco's
"Toledo" and countless Renaissance compositions are based on this asym-
metrical arrangement of volume and deep space.

(g) The design is rich in linear rhythms and full of intricate variations of
straight and curved lines. The contours in the main cliff have the geometric
character of an abstract design, but the basis for all the formations can be
found by studying the photograph of the motif.

Another painting of this motif, No. 777 in the Venturi catalogue, is less
linear, less intellectually planned, and probably a later version.

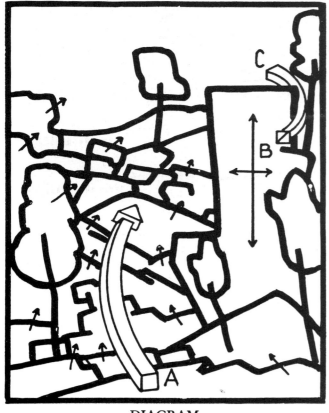

DIAGRAM

PLATE XXXIII

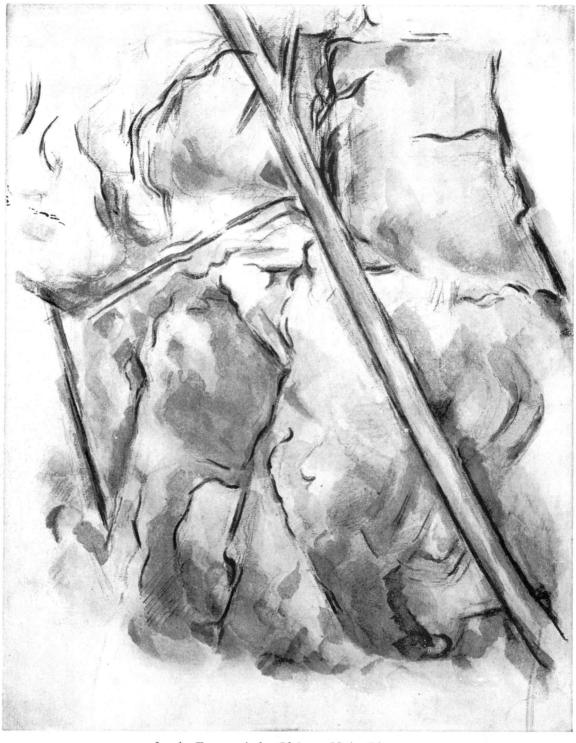

In the Forest of the Château Noir. CÉZANNE

AGAIN THE photograph of the motif supplies an unexpected explanation for a water color that appears, at first, to be entirely abstract. The origin for almost every variation in line, from straight line to sharp curve, can be discerned in the photograph.

Important transformations have been made. (a) The total effect of Cézanne's picture is two-dimensional in the extreme. The diagonal tree has been moved closer to the slabs of rock—so close, in fact, that its identity as a tree, separate from the surrounding rocks, is all but lost. (b) The drawing in the rock formations is more two-dimensional and decorative than we have previously found it to be. The lack of relationship between these rock forms and the ground plane gives the effect of abstract lines and planes being suspended into a new abstract picture space typical of recent abstract art (1962). No other painting analyzed

in this book presents quite the same problem.

In one of his most sensitive and intellectually planned little masterpieces Cézanne has first of all been impelled by the diagonal tree to establish other parallel diagonals in the rock forms. These diagonal directions produce a strong and swift movement, but they remain parallel to the picture plane. The opposing or countermovement is made of planes or rock shapes that move or shift from the lower left to the upper right. The upper right rock shape is an ideal example of an abstract shape that fits into the total so perfectly and gracefully that it seems to produce the effect of some intentional symbol.

In the motif the flat slabs of rock in the upper area dominate, but in the painting the lower rocks are brought forward. Cézanne distributes his color planes very much according to the light and dark arrangement

PLATE XXXIII
(*continued*)

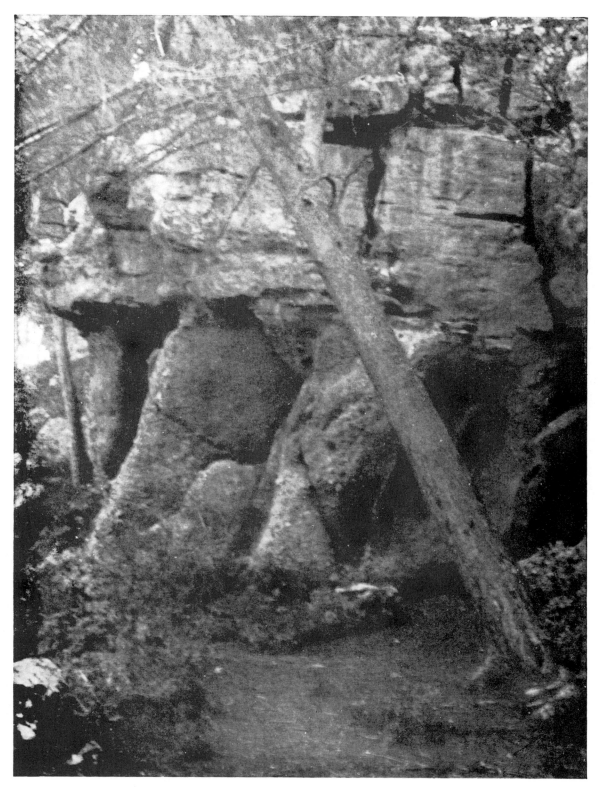

Photograph of the motif

seen in the photograph, but he does not explain the inward rotation of these planes as we see them in the motif photograph. Cézanne leaves the subject far behind as he penetrates ahead into the world of abstract space that has by now become so widespread in international art.

The life and structure in this painting depend more on line than usual. There is an unending play and variation in the directions of these lines as they move in and out, up and down, and across the space. The pure pleasure to be experienced from these linear interweavings is certainly not unusual in Cézanne's world of line and plane, but admittedly there are not a great proportion of paintings in which linear developments dominate to the extent that they do here. Especially in the late oil paintings the tendency was to suppress line in favor of open color planes, as we observed in Plate XXVI.

PLATE XXXIV

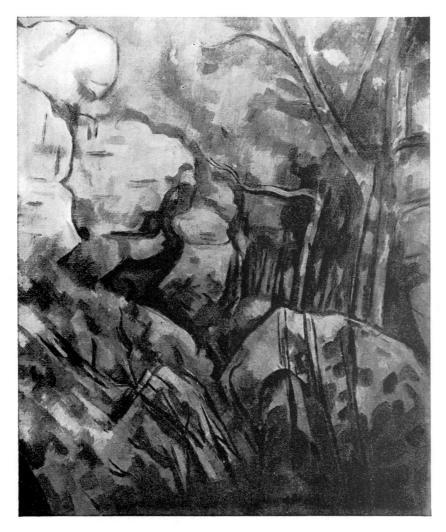

deavours to remain aloof from and inaccessible to that contemplative and re-experiencing imagination which tries to follow up the movements of space and extensions of depth in the picture and to identify itself with the perspectival sensations of the bend in a road or the view of a valley."[1] In conversation, Mr. Meyer Schapiro has expressed a similar view, maintaining that Cézanne puts up a barrier, literally as well as psychologically, against the spectator's entering into the picture. Except for pictures like the "Rocks in the Forest of the Château Noir," I have never had the experience expressed by these scholars. For me, on the contrary, Cézanne's landscapes provide the most gratifying pictorial experience of nature; atmosphere and light are expressed with a formal structure comparable to Giotto's.

[1] Novotny and Goldscheider, *Cézanne*, p. 11.

*Rocks in the Forest of
the Château Noir.* CÉZANNE

THIS PICTURE is characterized by a rather spotty effect—a quality mentioned earlier in connection with Plate XXVI. The spottiness is easily traceable to the actual rocks as shown in the motif. The austere, abstract appearance of the painting is quickly dispelled when comparison is made with the photograph of the motif.

(a) The most obvious transformation that Cézanne has made here is in the flat plane of the large rock at the lower right. In the motif this rock tends to drop downward and out of the corner of the picture. (b) Cézanne has lifted it up to a more nearly horizontal position and has increased its size. (c) A "closed" picture is thus effected, since all the other corners are also well "turned." Diagonal directions of the leafy planes also aid the turning in the lower right-hand corner. No other significant transformation of the space in the motif has presented itself in this comparison, and the only remarkable fact is that Cézanne is found to be so close to his motif in a painting that appears, at first, remote and almost abstract.

The remoteness of some of Cézanne's pictures has given rise to the statement by Fritz Novotny that "Cézanne en-

*Photograph of the
motif*

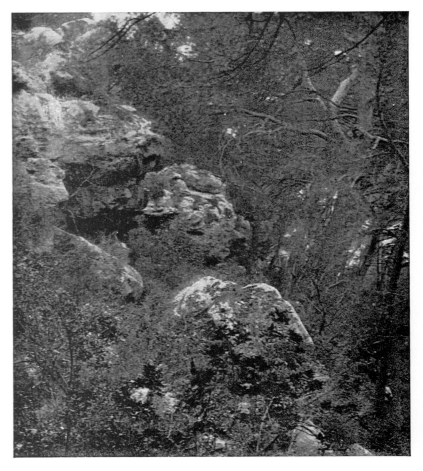

XIV

FURTHER COMPARISONS

Various problems are here considered in relation to comparisons of paintings with their motifs.

PLATE XXXV

*The Mill near the
Pont des Trois
Sautets.* CÉZANNE

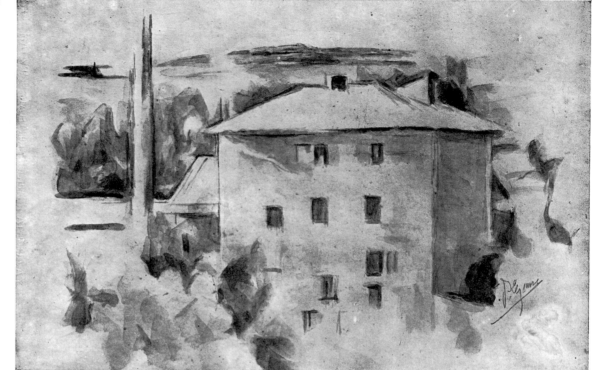

THE DEVICE of reducing the color areas to a large and irregular oval shape, a self-contained mass that fits into the rectangle of the picture plane, is presented by this water color. It brings to mind once more the familiar oval-in-rectangle motif that became familiar in the period of "Synthetic Cubism" developed by Braque and Picasso. Except for the eliminations or incompleteness inherent in the unintentional pictorial idea just referred to, Cézanne's water color is remarkably close to the subject. With respect to season and time of day, my photograph is in close accord with the painting. Even the interesting irregular shadow cast by the overhang of the roof on the front plane of the mill is similar in painting and motif. The camera was placed too low, but, except for the height of the building, which is obscured by new growth of trees, the relative proportions are almost the same.

(a) Definite changes have been made, nevertheless. First of all, we should note the usual elimination of textural varieties. The tile roof pattern is suggested only in one section of the horizontal contour along the overhang. The leafy texture of trees is also absent, and the trees have been constructed with color planes that integrate perfectly with the architectural forms of the buildings. Usually, Cézanne's trees become very leafy in texture as a result of innumerable color modulations and hatchings of brush marks.

(b) The two superstructures atop the tile roof offer yet another example of the use of more than one point of view. The triangular structure at the right has been drawn with an enlarged right-hand diagonal plane as if seen from farther to the right, while the smaller, square-shaped chimney has been drawn as if seen from a position far to the left. The entire plane of the tile roof has been tilted up to a position more nearly parallel to the picture plane, and it would be logical to regard this alteration as another shift in point of view or eye level. However, it would be wrong to attach too much significance to these phenomena of space in a painting that is comparatively a minor sketch.

Through simplification and elimination Cézanne achieves a mysterious, lyrical quality deriving from the abstract organization of static planes. In spite of the surprising similarities of painting to subject, the effect produced is anything but photographic.

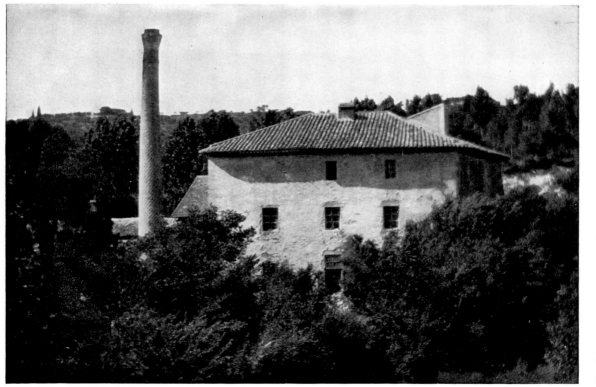

*Photograph of the
motif*

PLATE XXXVI

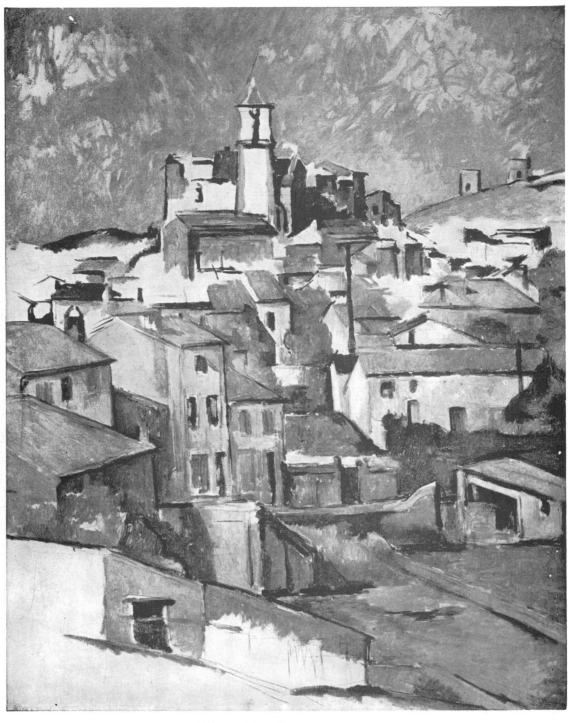

View of Gardanne. CÉZANNE

MR. ALFRED H. BARR, JR., in his excellent book, *Cubism and Abstract Art,* compares this painting by Cézanne with a typical "Analytical Cubist" picture by Picasso. But after studying the upper section of the photograph of the motif one might well conclude that the actual buildings were as forcefully and geometrically Cubistic in reality as Cézanne has made them in his painting.

The fact that the church on the farther hill was in sunlight while the lower part of the photograph of the motif was in the shade of a nearer hill, plus the fact that the camera lens was focused on the church, allows the photograph to approximate the balance between background and foreground that we see in Cézanne's painting. (a) The two-dimensional balance in Cézanne's painting, however, is the result of definite transformations of the space. (b) The left-hand foreground buildings have been elongated somewhat, and compressed into a considerably shallower volume of space. (c) In the motif the roof lines and front planes of these houses are parallel to the roof lines and walls bordering the street at the right. But Cézanne has dropped the road to a more nearly horizontal position, and consequently the stone walls bordering the street, and the front plane of the long house situated in the right-hand central area, become more nearly parallel to the picture plane. It is essential that the plane of this house be parallel, because if it turned back diagonally into space, as the new structure now showing in the photograph of the motif does, there would be movement beyond the right-hand border of the picture. We cannot accurately credit Cézanne with having thus transformed the particular building now seen at right center in the photograph, because the latter is obviously a new structure.

PLATE XXXVI
(*continued*)

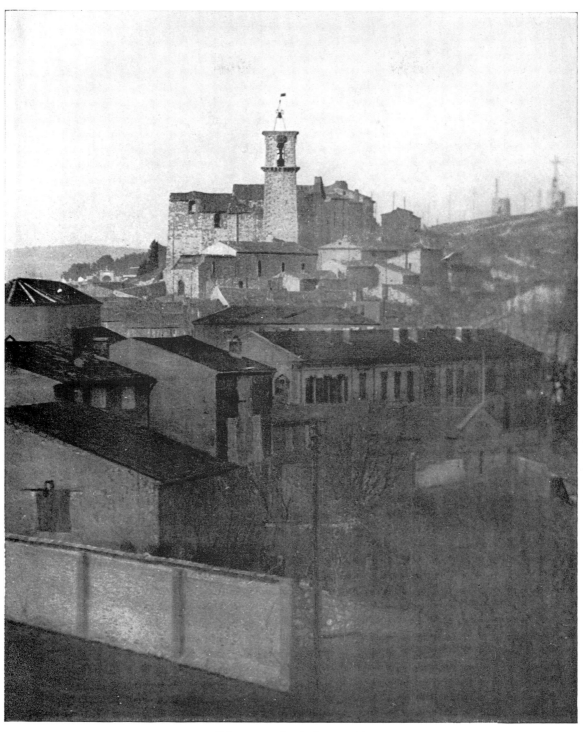

Photograph of the motif

(d) The planes move into space past the gardens on the right. Then the eye is led upward to the church, with a clear illusion of space surrounding it. The movement then comes forward again into the volume complex of the buildings on the left. (e) The contours of the hills, on either side of the church, have been made distinct, thus preventing the fading away seen in the photograph of the motif. (f) The composition is a typical, classical device based on circular movement, with large volumes protruding on the left and deep space pushing off at the right.

(g) The diagonal building in the extreme lower left foreground is worth analyzing, for it is the most radically transformed shape in the whole picture. It has been drawn in three planes, with a window in the center, the two side planes turning away slightly. The window seems to have been borrowed from the building next above at the left. It is drawn as a plane parallel to the picture plane even though the wall to which it belongs is diagonal. As a parallel plane, this window lends a stabilizing static element to the left-hand foreground area. Several light lines in paint and pencil indicate that other solutions for this area had been considered, but Cézanne apparently became bored with his picture and put it aside. (h) The lower right garden area tends to be a dropping weight, and diagonal lines add to a disturbing tendency of the picture to "run out" at the lower right-hand corner. The lower part of the picture must therefore be regarded as unsatisfactory at both right and left, although the decreased size and flattened position of the structure at the left afford the logical answer to the problem there.

PLATE XXXVII

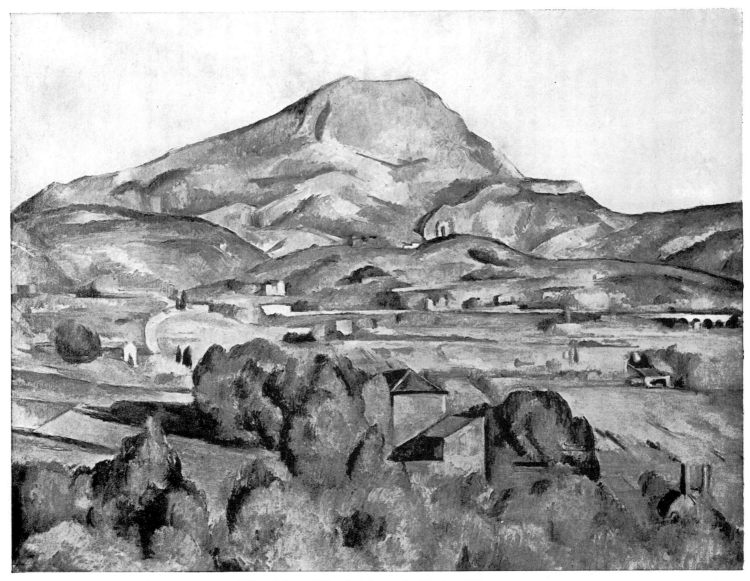

The Sainte Victoire from Bellevue. CÉZANNE

THE PHOTOGRAPH of the motif, the Sainte Victoire, is presented mainly to offer documentation for the large number of paintings made from approximately this same spot, a hilltop property called Bellevue. In the Venturi catalogue the paintings numbered 452, 453, 454, and 455, 456, 457, 488, 661, 662, may be compared with Mr. Rewald's photograph shown here. For the person interested in Cézanne the paintings of the Sainte Victoire have a very special place, and with the presentation of this and the next view our documentation for the many angles from which Cézanne painted it becomes fairly complete.

The house in the foreground of the painting exists today and looks very much like Cézanne's painting of it, but trees obscure it from the view shown here, and besides, the camera was placed far to the right in order to show the fields of the valley of the river Arc. The deeper layers of space, including the mountain, may profitably be compared with all the paintings listed above from the Venturi catalogue. It will be interesting to see how Cézanne has altered the design of the mountain in every painting, according as the linear and spatial rhythms presented new pictorial problems to be solved. The significance of this change, from picture to picture, can hardly be overestimated, since Cézanne, who knew and loved this mountain with an inexhaustible passion, might be expected to paint it as he knew it to be; but with each new canvas its glorification became a new problem, and the contour and surface shapes change with each new painting.

The particular quality of Mr. Rewald's photograph of the mountain introduces an important argument that has not heretofore been developed. The prominence, clear focus, and strong contrast of light and dark that characterize the mountain belie the distance of some fifteen miles from which the photograph was taken. The complete

(In Diagram I, many of the planes are shown with their axis bars in order to emphasize again that volumes are the sum of related planes, as first shown in the Glossary, Diagram VI. The rotating volumes of trees, hills, and mountain are thus differentiated from the planes of the plateau and sky.)

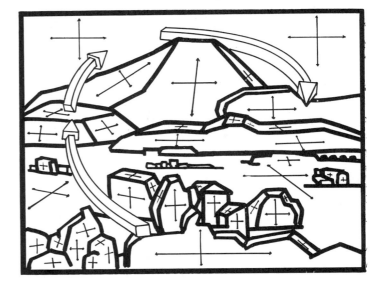

DIAGRAM I
VOLUMES MOVING IN SPACE

PLATE XXXVII
(*continued*)

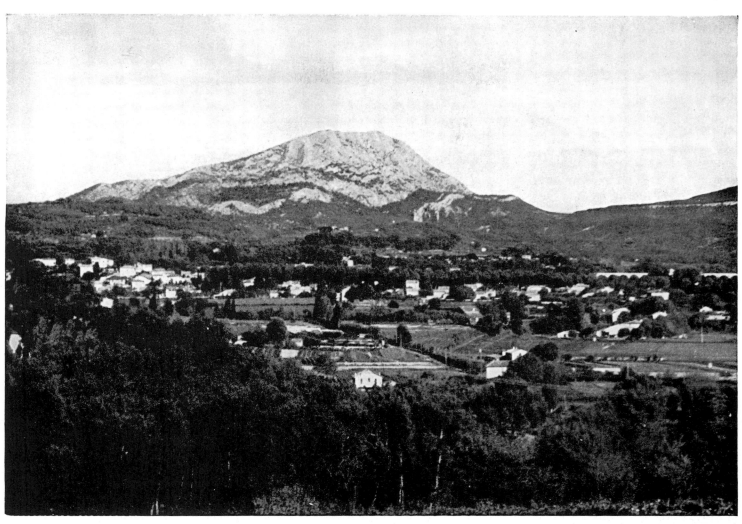

Photograph of the motif

absence of aerial perspective and the enlargement of the mountain are alterations of nature which thus far we have observed only in Cézanne's paintings; here, the same effect has been achieved in a photograph. In order to achieve this effect, Mr. Rewald used a telescopic lens "purchased especially for this purpose," and he remembers having used, also, a color filter to cut out the haze that produces the effect of aerial perspective for the human eye. In other words, the photograph presents a somewhat false impression—one which the observer, standing before the scene, does not have with normal vision except on rare days of absolute atmospheric clarity.

The significant fact to observe here is that, even when a photograph eliminates aerial perspective and approximates the uniformity of light and dark from foreground to background which we have so often observed in Cézanne's paintings, the result is still anything but a duplication of the form of the painting. The space in the photograph is difficult to comprehend. Indeed, it is flat, in the negative sense that it simply does not come to life three-dimensionally at all. The distant foothills have merged with the adjacent values of the mountain; there is no differentiation, there are no dividing lines, there is only a confusing flatness in this area.

DIAGRAM I. Turning to Cézanne's magnificent painting, we find a quite different situation. From the foreground, and moving into the deep space, there is a progression of overlapping planes and volumes the location of which in the "picture box" is infallible and unmistakable. First, the large three-dimensional arrow at the lower left indicates the movement into space toward which the foreground houses and tree volumes have given so powerful an impetus. (This foreground area may be apprehended as one large mass or complex.) Then comes the plateau of the valley of the Arc; and finally the foothills, so clearly defined and rendered into positive volumes that build up in a crescendo toward the grandiloquent mass of the Sainte Victoire, as suggested by

the second arrow rising at the left. There is not a line or color plane that does not add to the total orchestration of three-dimensional space. But at the same time the picture attains balance and poise by remaining faithful to its true structure, its fundamental two dimensions. As shown by the arrow at the upper right, the eye is led forward again, thus establishing a closed unit of space.

Perhaps too little emphasis has been placed on the fact that Cézanne's paintings have generally proved infinitely more clear and understandable in their spatial locations, even without the color of the originals, than the photographs of the motifs. The problems of space control that affords the necessary two-dimensional balance has possibly been overemphasized; but if so, it is excusable on the ground that very little criticism explaining this complex phenomenon has been published.

Aside from the fact that Cézanne's painting of the mountain attains so profound an effect of three-dimensional space at the same time that it is unified and stabilized in relation to the picture plane, the forms have been rendered in a manner that transcends the imitative appearance of nature in the highest sense of the word. The large tree forms of the foreground area have a rather leafy texture that grows out of the color-plane modulations, but otherwise there is no concern whatever with textural qualities. The plateau, the foothills, and the mountain are executed with the sole aim of creating solid form and space effects. A powerful structure of two-dimensional construction lines, forming a classical diamond shape, far more perfect than the one shown in Diagram VI of Plate I, affords solidity and cohesion to the design. It should be mentioned, however, that on viewing the original painting one finds an unexpected delicacy of color, by which the formidable austerity of the forms is effectively tempered. Certain areas of green in the foothills give an illusion of grass and foliage that is not apparent in the black-and-white photograph. Cézanne rarely reached greater heights of perfection; surely in this painting he has achieved the atmosphere of nature with the form of a Giotto.

PLATE XXXVII
(*concluded*)

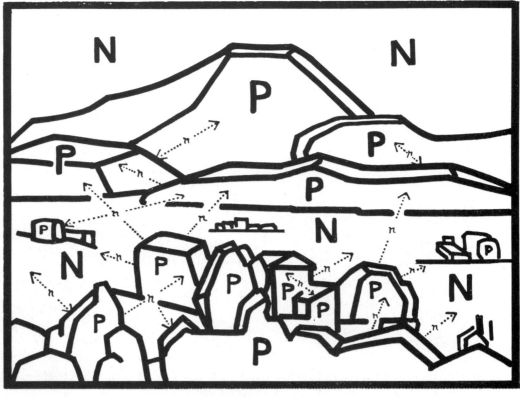

DIAGRAM II

DIAGRAM II is offered as a summary of the concept of positive volumes and negative space, previously diagrammed by other methods. The units lettered P are the obvious positive volumes; the large letters N indicate the negative flat shapes or two-dimensional spaces, as described in the Glossary, Part One, Diagram III. The less clearly understood three-dimensional negative space or air that surrounds the positive volumes is indicated by the double-pointed, dotted lines, centered by the small letters n. The painting provides a superb illustration of both kinds of negative space, and the diagrammatic method used here may be applied to most of Cézanne's pictures as well as to those of the great Renaissance painters. (What is here indicated as negative space between volumes was first introduced in the Glossary, Part Two, Diagram XIV, where the broken lines between volumes were intended as an explanation of the concept of tension between volumes. The total negative space or "picture box" was first described in the Glossary, Part One, Diagram II. Further descriptions of total space were introduced in Plates XXIII, XXIV, and XXVI.)

When a composition attains unity, the volumes and planes have been organized and related; the negative spaces between them are in-finitely varied—some wide, some narrow,—and a kind of magnetism or tension exists between them. Thus negative space, when understood as three-dimensional space *between* volumes, is a term that may be used interchangeably with the word, tension. When the theoretical distance between the volumes and the plane of the picture is considered, one may speak of tension in relation to the picture plane itself. All the "picture-box" diagrams previously mentioned were conceived in terms of space and tension in relation to the picture plane. When, as in Renoir's painting, compared with the Cézanne in Plate XXIII, a form like the mountain is faded out in realistic aerial perspective, the two-dimensional character of the picture plane is disturbed, since the form of the mountain is out of harmony with it. An effect of limitless realistic space, receding beyond the picture, develops, as when one looks out of a window. Leonardo da Vinci, in his *Trattato della pittura,* advocates this kind of spatial effect; but fortunately his own painting hardly achieves it. Cézanne's painting of the Sainte Victoire from Bellevue magnificently renounces these dubious goals, and, together with the greater part of his mature production, restores to the modern painter a classical ideal that is manifest in masterpieces of the past.

PLATE XXXVIII

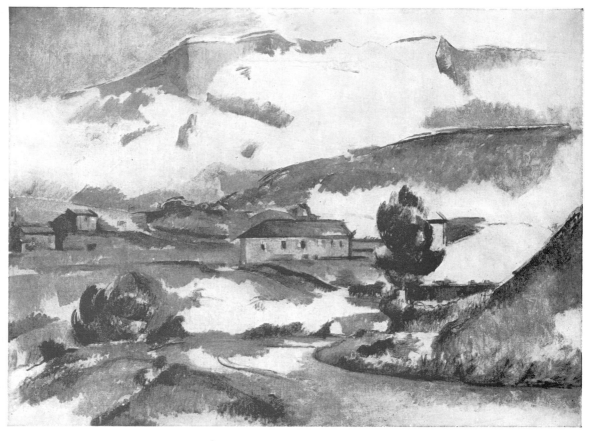

*The Sainte Victoire
from Beaureceuil.*
Cézanne

THIS UNFINISHED paint-
ing is one of the most
successful examples of an
organization essentially
complete just as it stands,
with all its planes clearly
established in space. Cé-
zanne's method and pro-
cedure are here fully revealed. (See first two subsections of Section IV
for a detailed description.) No better proof could possibly be offered to
support his assertion to Gasquet: "I advance all of my canvas at one
time—together." [1] The picture is completely balanced; no single area or
shape has been carried to completion without due consideration for
other areas and for the organization of the total space.

A comparison of the photograph of the motif with Cézanne's picture
indicates that drastic and far-reaching alterations have been made by
Cézanne. But I hesitate to maintain that the photograph was made
from the exact spot where Cézanne painted his picture. The compres-
sion of foreground and expansion of background are the obvious spatial
problems involved, and they would be present to a somewhat compara-
ble degree even though
one stood closer to the dis-
tant mountain.

It seems fitting to end
our comparisons with this
unfinished painting, which
brings us back to the be-
ginning of our search and
demonstrates again how
Cézanne developed his
drawing and composition
with the plastic means of
line, plane, and volume.

[1] Gasquet, *Cézanne*, p. 130.
(See p. 15 above.)

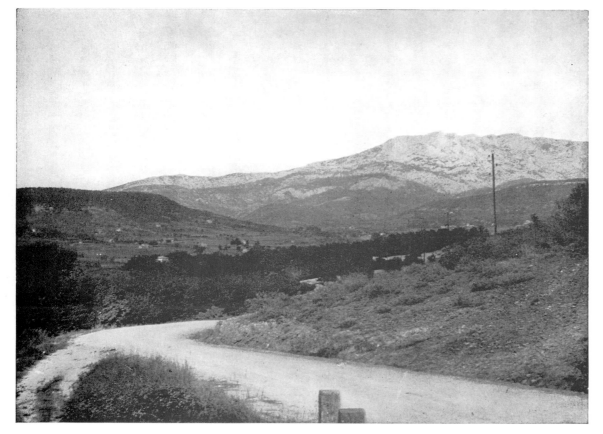

*Photograph of the
motif*

PLATE XXXIX

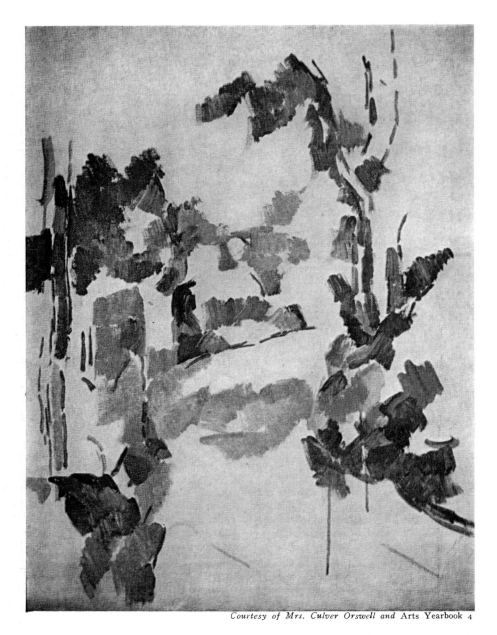

Landscape. CÉZANNE

IMPORTANT CLUES to Cézanne's final statement about painting may be found in this landscape reproduced in color. His remarkable achievement was to make the unpainted areas or negative space seem active and interchanging with the positive planes of green and blue. The effect of density, of activating the total volume of space, occurs even at this early stage of developing a painting. The color is derived from what he saw in the motif, but his concept of compositional form demanded that every slice out of nature be put down in a relational order. In the diagram, the planes form an open yet dense mass or complex on the left where we feel a downward thrust, as indicated by the dotted lines of the large rectangle and the arrow at the bottom. An opposing mass moves upward at the right, again indicated with dotted lines and arrow. In the painting, the two opposing tree-trunk forms are delicately outlined to enforce the dropping and rising vertical forces. Again in the diagram, planes moving on diagonal axes slide across, tying the two sides together, as indicated by dotted lines.

All the color planes are suspended in an abstract relation that emphasizes the verticality of the painting surface. The axes constantly tip and turn to construct an effect of movement in and out of depth.

Aside from the outlines around the tree trunks, the most recognizable

PLATE XXXIX
(continued)

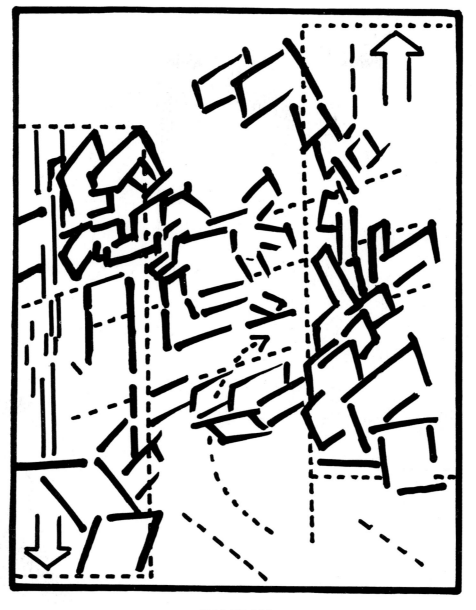

DIAGRAM

attribute of the real space of the subject is felt in the road, indicated by the dotted curved arrow in the diagram.

In this final diagram, Cézanne's typical color planes have been exaggerated and enlarged in an effort to illustrate their maximal structural and spatial force. In a number of late paintings of this kind the usual sketchy outlines of large silhouette shapes seem to be absent. The sensation of volume is produced almost entirely by the little planes as they slice up the space, sometimes overlapping, occasionally remaining parallel to the picture plane. What makes the painting exceptional, however, is the large number of dynamic planes that tip and turn on diagonal axes. Certainly in this example it can be said that the effect of density and volume depends almost entirely upon activity of these color planes. Their function here has extended far beyond that of being a mosaic of rich modulations occurring within the large planes traditionally clarified with a powerful outline drawing. Activity takes place without describing any complete objects in nature. For the time at which it was painted, it was the most intellectualized and abstract form of art that had ever been developed.

XV. CONCLUSION

SIGNIFICANCE OF THE PHOTOGRAPHS OF CÉ-
ZANNE'S MOTIFS. The photographs of Cézanne's motifs
have proved to be of incidental rather than primary impor-
tance in our analysis of his form and composition. How-
ever, in regard to the problems of perspective, we have
seen many comparisons of paintings with photographs
of the scene which demonstrate in a factual and measur-
able way how far Cézanne avoided or disregarded all ideas
of vanishing point, convergence, and diminishing sizes
(Section VII). We have seen that he disregarded the per-
spectival precept of a single, fixed point of view for the
artist-observer, and that, on the contrary, many of his
pictures were drawn as if seen from several eye levels and
different points of view (§ IX). Another important canon,
that of aerial perspective, he quite consistently disregarded
also; as most of the comparisons show, particularly those
illustrated in § XII. It is important to emphasize that in
discarding aerial perspective Cézanne was showing his
radical divergence from the principles of Impressionism
(see Plate XXIII).

The photographs of motifs have supplied factual evi-
dence to support the contention that Cézanne did not al-
ways permit his volumes to expand according to nature,
but almost invariably controlled and flattened foreground
volumes in order to maintain balance on the picture plane
(§ VIII). (The question of volume control may also be re-
garded as part of the problem of perspective.) We have
seen that Cézanne would tip vertical volume axes in order
to achieve tension and dynamic effects (§ X). Most of the
problems of extreme distortion in drawing have been dis-
cussed in § XI without the help of photographs of motifs,
but Plate II and Plate VII, Plate XII, and many more,
might have been used to supply factual support for the
analyses in § XI. Distortion was analyzed as a positive,
"form-conditioning" ingredient of Cézanne's composition,
although caution was observed against attributing to
Cézanne a theoretical and intellectual awareness of some
of the more intricate problems that develop in his paint-
ings.

The question of Cézanne's regard for the subject—that
is, the realism, objectivity, or abstractness of his form—has
been answered in large measure in every photographic
comparison in earlier sections of the book. Particular em-
phasis was given to this question in § XIII, where it was
shown that, even when Cézanne appears to be most theo-

retical and abstract, he has actually followed with un-
expected faithfulness a motif as it occurs in nature.

CÉZANNE'S THEORIES OF ART. Cézanne's own
theories about his work and aims are not always in accord
with the foregoing conclusions. As for the problem of per-
spective, it was seen in § II that Cézanne's letters and state-
ments were of a rather conventional sort, and that he
seemed, in fact, to accept the precepts of scientific perspec-
tive. Similarly, the famous statment that "when one knows
how to render the cube, the cylinder, the sphere, in their
form and their planes, one ought to know how to paint,"[1]
cannot be taken as an adequate teaching program if Cé-
zanne's own synthesis of form is to be the final aim. For al-
though Abstract art has made a wise use of Cézanne's
dictum, in the art academies the recommendation has per-
haps served as an excuse to continue the practice, which
was laid down in Leonardo's *Trattato* (482—492), of draw-
ing from casts as isolated objects. The same program per-
sists in the life class, where the approach to drawing the
isolated object without concept of picture plane, picture
format, or surrounding space goes on year after year. As
long as the rendering of individual forms or objects is done
without regard for the total space, it makes little difference
whether the object copied be an abstract shape, a geo-
metric form, or a Roman cast. No one of these will lead to
an understanding of the space composition found in Cé-
zanne.

THE MISUNDERSTANDING ABOUT CÉZANNE'S
COLOR MODULATIONS. The importance of Cézanne's
color modulations has been considered from many angles.
First of all it was observed that Cézanne himself attached
supreme significance to his discovery of modeling in color
planes. Many of his statements and letters have led to the
critical error of assuming Cézanne's theories to be in accord
with his actual work. Nothing could be more mistaken
than to believe, for example, that the color modulations or
"the individual patches of color are the real supports of the
pictorial structure in Cézanne's painting."[2] But the excuse
to be offered for such an analysis of Cézanne's form can be
found in numerous statements of his that reveal virtually

[1] Bernard, *Souvenirs sur Paul Cézanne*, p. 116. (See "The Cylinder, Sphere, and
Cone," pp. 9–10 above.)
[2] Novotny and Goldscheider, *Cézanne*, p. 12.

the same idea. Besides, Cézanne expressed contempt for all flat surfaces—so much so that he was unable to appreciate the work of many early Italian masters to whom he is really closely bound in relation to the far more important and permanent values of space organization.

Cézanne often did make pungent statements that reveal genius and coincide in meaning with the form he developed in his paintings. For example: "I advance all of my canvas at one time,"[3] and "Drawing and color are not separate. . . . During the process of painting, one draws."[4]

CÉZANNE'S COMPOSITION. Line must be understood as the basic instrument for Cézanne's construction of form and space. He began with sketchy lines that were later often altered and then reinforced as the color organization progressed. His color-modulation system is of primary importance in this process. Cézanne did not start a painting by filling large areas of light and dark as did the masters of the Renaissance, nor with light washes of flat color as Matisse and other modern painters do. His system of building up the form with tiny planes or color modulations was infinitely complex, and can often be blamed for the failure or spottiness of some of his works. Among some of his followers it has been a dangerous procedure, and I am convinced that it is an unsatisfactory method for students who are only beginning to paint. However, the method produced a remarkable luminosity and richness of surface and was important in giving the weight and solidity that characterize his form. He was able to build up solid-volume effects through these modulations and gradations of warm-to-cool color, and thus avoided the black-and-white effects that result from over-modeling and chiaroscuro. It was Cézanne's methodical system for "making out of Impressionism something solid and durable, like the art of the museums."[5] There are factors of both two- and three-dimensionality in Cézanne's color modulations, but the most important thing to remember is that, with Cézanne, color is always dependent upon line drawing. He did not avoid line, nor did he base his compositional structure solely upon the minute color planes. In typical pictures the color planes are loosely painted, but powerful lines are superimposed upon them in order to maintain spatial clarity.

CHARACTERISTICS OF CÉZANNE'S LINE. Cézanne's line is usually segmented rather than continuous; hence, probably, the underestimation of its importance. At those sections of a contour where the line tends to be lost, a *merging* of object with adjacent negative space occurs.

It is an integrating factor of organization contributing to the unity of positive and negative space and to the total balance of deep space in relation to the two-dimensionality of the picture plane. ("Passage" is Lhote's term.)

No specific significance should be assigned to the unusual parallelism or repetition of lines around objects. It is merely a spontaneous and accidental feature that developed as a result of a constant reaffirming of the need for a strong linear element to complement the openness of the color planes.

In some pictures the line builds up to a relief that is higher than the adjacent color area; conversely, the line often sinks below the surface of thickly painted areas. No intentional purpose could wisely be assigned to these phenomena. They are accidents that reveal the struggles he suffered in bringing a painting to completion.

PLANES. The small color planes provide a two-dimensional structure that can be called the secret of Cézanne's art. However, it is the large plane masses that give to his paintings their space and power. Diagrams I and II of Plate I tell, better than words, this story about planes.

VOLUME. Cézanne's unique preoccupation with volume structure or volume solidity is the most easily understood characteristic of his art. The danger that so many of his minor followers have fallen into is based on a failure to understand the absolute *inseparability of volume from the surrounding negative space*. Although Cézanne spoke of the importance of learning how to render individual cubes, cylinders, and cones, in his paintings these elements are always integrated with the negative space and with the picture plane.

COLOR. To approach the color problem in Cézanne exclusively with reference to his invention of the warm-to-cool modulation system would be a serious mistake. Cézanne's importance as a master of color organization may be established without any particular regard for this method. It is the relation between the large color areas (for example, the amount of bright reds or yellows in opposition to the quantity of bluish colors), the balance of the color in its relation to the form and space;—it is the mastery of these larger aspects of color composition that makes Cézanne one of the great colorists in painting. To this broader problem the small color planes are merely incidental. It should be said again that Cézanne's color is dependent on his draw-

[3] Gasquet, *Cézanne*, p. 130. (See p. 15 above.)
[4] Bernard, *op. cit.*, p. 37. [5] Rewald, *Cézanne, Sa vie* . . . , p. 283.

ing. The idea that Cézanne supplanted drawing with his color modulations is almost without foundation.

Cézanne's color creates light that emanates from the picture itself and bears only incidental relation to light and shade in nature. It is an abstract orchestration of warm and cool, light and heavy, saturated and neutral elements of color, transcending the appearances of the objective world and giving us a new vision, a new reality.

SPACE ORGANIZATION. Cézanne's genius in organizing three-dimensional space is the basic foundation of his composition. We have said, using many different examples, that space organization is something other than three-dimensional volume-building in a sculptural sense. To quote again the words of André Lhote, "It is necessary to repeat it: the picture, regardless of the exigencies of the subject represented, *must remain faithful to its own structure, to its fundamental two dimensions.* The third dimension can only be suggested; it is from this double necessity that most of the inventions in the art of painting are born." [6]

Cézanne is essentially a classcist, then, for having "rediscovered this science of the compensation of volumes." [7] He has appeared in the role of a revolutionary because so vast a heritage of misconceptions and bad taste about painting had to be overcome. A blind acceptance of scientific perspective, plus the invention of photography, brought all but complete death to painting in the nineteenth century. Insipid imitation and inartistic illustration held sway when Cézanne and others appeared on the scene with their new concepts of painting. By this time we are likely to forget the great change that had been wrought when Cézanne could say: "The transposition that a painter makes with an original vision gives to the representation of nature a new interest; he unfolds, as a painter, that which has not yet been said; he translates it into absolute terms of painting, that is to say, something other than reality. This, indeed, is no longer shallow imitation." [8] Cézanne has turned the attention of artists in many fields to the necessity of reëstablishing that formal structure which is so pronounced in the greatest art of the past.

While Cézanne has been regarded here as the greatest artist of modern times, it should not be assumed that he was greater than many of his illustrious contemporaries only because of his superior composition and the accompanying problems of form which he brought to consciousness. To-day it is possible to teach these principles to entire classes of art students. But only a hopeless academician of the modern breed would suggest that the cold presence of these elements of composition alone makes for artistic importance in the ultimate sense. Art is, fortunately, a little more mysterious than that. The message I do hope to give is that the problems of composition that can be found in Cézanne should become the elementary foundation for every kind of art training.

Since Cézanne died in 1906 the world has seen a fantastic succession of art movements, from Abstraction and Non-objectivity to Dada, Social Realism, Surrealism, Abstract Expressionism, and many others. The place of Cézanne has certainly not diminished in all this frantic search. The most daring explorations of American abstract painters have generally been achieved within what seems like the continuing tradition of great painting. No one has provided a more inspiring source of possibilities for the continuation of this tradition than Cézanne. If the present book has given the impression of being a search for a set of values leading to the expression of any *one* type of art form, it has failed in its purpose. Insistence on the importance of classical structure and a recognition of the fundamental precepts of picture plane and picture format cannot properly be interpreted as the emphasis of a narrow and exclusive point of view.

In our search for standards by which to evaluate the importance of the basic fundamentals of composition it is unquestionably wisest to turn to the high periods in art, Egyptian, Early Greek, Oriental, Byzantine, Renaissance, with names like Giotto, Piero della Francesca, Giorgione, Bellini, Titian, El Greco, Rubens, and many more, standing out as the brilliant stars. Cézanne's historical role has been that of a regenerator. He has brought back into consciousness the basic principles that have given the eternal qualities to the art of his great predecessors. The value of understanding these principles seems obvious. The art of the future cannot fail to be better for learning and accepting them. From murals to miniatures, from Proletarian Art to Abstraction, the artistic values are likely to be better for this understanding. It offers an unlimited scope for artistic expression. It imposes no restrictions that repress artistic values. Let us hope for a new era in the teaching of art.

[6] *Traité du paysage*, pp 30–33. [7] *Ibid.* [8] Bernard, *op. cit.*, p. 114.

BIOGRAPHICAL NOTE

PAUL CÉZANNE was born on January 19, 1839, in Aix-en-Provence. His father, Louis-Auguste Cézanne, was a hardheaded businessman and banker whose standards of value were based primarily on money and accumulation. Cézanne was close to his mother, and we may safely reconstruct the classical pattern so typical of creative men—that of identification with the mother and hostility toward the father. His school days were rather successful and he was the recipient of numerous prizes in mathematics, Latin, and Greek. At the Collège Bourbon in Aix, Cézanne and Zola began an intimate friendship which lasted until 1886. Upon his father's insistence that he take up some respectable profession, Cézanne entered the Faculté de Droit at Aix in 1859. He struggled with legal studies for two years, always against his will. Meanwhile, Zola was in Paris, and he kept urging Cézanne to defy his father and come there to study painting, since painting had for many years been Cézanne's constant dream and preoccupation.

Finally, in 1861, young Paul won his way; he was escorted to Paris by his father, and studied for a while at the Académie Suisse. His first experience with Paris was disillusioning and he returned to Aix before the year was out. His lack of immediate success, plus his father's continuing disapproval of the unrespectable profession of painting, no doubt combined to make him think of giving up painting altogether. Upon returning to Aix, he entered his father's bank as a clerk. Banking, as we might expect, proved more displeasing to him than the law, and soon he returned to Paris.

About 1863, he applied for admission to the Ecole des Beaux Arts and was rejected. In 1866 he submitted two canvases to the Salon and both were rejected by the jury. The crudeness of Cézanne's early work is such that we may well understand why he failed to be accepted by the reactionary Salon of those days. The subject matter of his paintings up to about 1870 was literary and historical, and since he had developed neither his skill nor his understanding of the plastic elements of art it was inevitable that his early work should be judged unsuccessful. It remains so today, and except for the underlying fury and latent power revealed by the blackish color and brutal handling it has interest principally as a historical curiosity; and much of it seems out of place in our museums. Toward 1872, largely under the direct influence of Pissarro, Cézanne abandoned literary subjects and began painting landscapes and still lifes. It is the beginning of the emergence of the great painter whose works are analyzed in the present volume.

In 1871 Cézanne began living with a model, Hortense Fiquet, and their only child, Paul, was born January 4, 1872. With this union begins what Marcel Provence calls the "drama of the life of Paul Cézanne."

Cézanne exhibited publicly for the first time in 1874 with the Société Anonyme des Artistes-Peintres, Sculpteurs et Graveurs. Many of the great Impressionists who participated in that exhibition were damned by the critics; but Cézanne was savagely attacked. He exhibited with the Impressionists again in 1877, but for many years following he remained aloof, no doubt in self-protection against further insults from the public and from official critics. Ironically enough, he persisted in sending pictures to the Salon; and each year he was refused. We may see in this persistence his deep need of being accepted by respectable and official forces in society, although intellectually he despised them. Finally, in 1882, one of his pictures was hung in the Salon through the kind efforts of Guillemet, who was a member of the jury. Again in 1889 a painting of his was hung in the Exposition Universelle, but only because of the maneuverings of the influential collector Choquet.

Cézanne married Hortense Fiquet on April 28, 1886. The most dramatic and complex element in Cézanne's relations with her is seen in Louis-Auguste's opposition to the marriage. We might reasonably suppose that the bourgeois father opposed the marriage on the grounds that Hortense was too common to become a member of the Cézanne family and that he wanted to release his son from an annoying entanglement; but we should probably come closer to the truth in assuming that there was a deep hostility between the two men. It was an occasion for the father to wield his power and control; for Cézanne it threatened the fatal danger of being dominated. The father cut down the son's allowance, once the secret affair became known to him; and during this period Cézanne was forced to rely on financial aid from his closest friend, Zola. Cézanne very likely had feelings of responsibility and guilt toward Hortense, and this, together with his father's disapproval of the affair, drove him into a marriage which he could certainly not have wished to contract at that late date out of love for his mistress. The biographies by Mack and Rewald supply evidence for such assertions. Nothing but frustration ever

developed out of the marriage, and poor Cézanne suffered many persecutions and exploitations at the hands of this woman, who was nicknamed La Boule by the Impressionist painters who knew her well.

In the same year, 1886, Zola published *L'Œuvre,* and, as with every publication, he sent a copy to his oldest friend. Cézanne acknowledged the gift with a short letter, but never again did he write to Zola, nor did the two men ever meet again, so far as is known. In *L'Œuvre* Zola reconstructed the character of Cézanne in the figure of Claude Lantier, and it seems obvious that he revealed there his disillusionment about the painter for whom he had once had such high hopes. Even with due regard for Gerstle Mack's well-developed opinion to the contrary, there need be little doubt that Cézanne was profoundly affected by this written testimony that his oldest friend and champion had no faith in his ability. Everything in Cézanne's character points to this natural interpretation. From this period to the end of his life he became more and more a recluse and misanthrope. His fear that people would "get their hooks in him" so far possessed him that he would fly into a rage upon being touched accidentally. Emile Bernard and other writers such as Rewald have supplied evidence of the tragic disintegration of Cézanne's personality. I knew M. Girard (Cézanne's neighbor on the Avenue Paul Cézanne) for more than two years and there was no doubt whatever in his mind that Cézanne was unbalanced. The painter would often forget his key to the roadside gate, and would then go through the Girard property in order to reach his studio; and in walking through he would constantly look over his shoulder as if in fear of being pursued. During the later years of his life he avoided his friends on his visits to Paris, even going to such lengths as crossing the street to avoid an encounter.

We need not be too much confused by Cézanne's paranoic tendencies; great men are usually not famous for normal behavior. That he really was persecuted and exploited is not nearly so important to us as the fact that he *felt* persecuted—in fantasy. On the other hand, the fact that he really was the greatest living painter does not justify his flying into occasional rages to affirm it. He was a tragic figure, beset by fears and doubts and personal frustrations. During these last years his painting grew in stature even as his personal misery increased. His lack of worldly success, his weakness of character, and his need of self-punishment that made him easy prey for his exploiting wife and other associates provided a factual structure of defeat and persecution for a man who desperately needed affection, reassurance, and fame. When, toward the end of his life,

he began to receive evidence that his own opinion about being the greatest living painter was shared by other people, it was too late. As Gerstle Mack relates: "He was morbidly sensitive and suspicious, and in certain moods was apt to misconstrue the most innocent and well-meant gestures. An anecdote related by Madame Marie Gasquet, widow of Joachim Gasquet, illustrates this tendency. Monet and several other Impressionist painters, all good friends of Cézanne's, once conceived the idea of giving a luncheon in his honour. When Cézanne arrived, the others were already gathered around the table, and Monet began a little speech of welcome in which he expressed the deep admiration and affection that all of those present felt for their colleague. Cézanne listened with his head bowed and his eyes full of tears; and when Monet had finished he said: 'Ah, Monet, even you make fun of me!' To the consternation of everyone, and in spite of all protests, he rushed from the room." [1]

Cézanne's career provides an eloquent example of the function that creative activity plays for modern man. While the striving for success and fame and the love of women figure as cornerstones in the character structure of most artists of modern times, the factor of psychological healing and integration is perhaps the most important of all.[2] The need for order and wholeness in the mental life of creative men is sometimes their only apparent reason for going on with work that brings them no material reward, no success and no fame. It was certainly so with Cézanne. As he stated in a letter to his son on October 13, 1906, "Nervous system very much weakened, nothing but painting in oil can keep me going." [3] On October 15, 1906, he said, "I repeat, I have a good appetite and some mental satisfaction,—but work is the only thing which can give me that,—and it is a great deal for me. All my compatriots are asses compared to me." [4]

In 1895 Vollard held the first one-man show of his work in Paris, and Cézanne was delighted and impressed that all the pictures were framed. Sales were occasionally made, and Vollard showed the vision of a great speculator in buying all the paintings he could lay his hands on. In 1904 nine paintings were exhibited at La Libre Esthétique, Brus-

[1] Gerstle Mack, *Paul Cézanne,* pp. 289, 291.

[2] See Otto Rank, *Art and Artist,* New York, Knopf, 1932; also Harry B. Levey, "A Critique of the Theory of Sublimation," *Psychiatry,* May, 1939, and "A Theory Concerning Free Creation in the Inventive Arts," *Psychiatry,* May, 1940. In the latter article Mr. Levey says (pp. 280–281): "The free artist is one who, because he is always in danger of being overwhelmed by intense anxieties, is compelled by an urgent inner need to achieve peace within himself, and who is able to do so through the invention of personally significant forms. . . . his creativeness . . . serves to enrich his spiritual experience by facilitating the restoration of inner harmony. . . . his cardinal aim is the relief of anxiety."

[3] Rewald, *Paul Cézanne. Correspondence,* p. 297. [4] *Ibid.,* p. 298.

sels. In 1905 and 1906 ten pictures were exhibited at the Salon d'Automne. Cézanne's fame was rising. Since that time, Vollard and other dealers have made fortunes by the sale of his work.

On October 15, 1906, he stayed out in a rainstorm for several hours while painting "on the motif" and later collapsed by the roadside, from exhaustion and chill, before he could get home. The next day he arose early, went to his studio at Les Lauves, and continued work on a portrait of Vallier, only to return home again in a state of collapse. On October 22 he died, having very nearly realized an ambition that he professed to friends on numerous occasions: to "die while painting."

Today he is already regarded as an "Old Master," and museums acquire his work in order to reach a dignified and respected place in the art world.

INDEX